12/31/96

Happy Anniversary ~ fulfilling

twenty first ~ of saying yes

and inspired years of ~ spread ...

God grant you many, many more

Lovingly,

Jim, Clare + Lauren and Johnny

The Life of
CHRIST
in Art

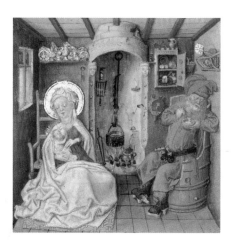

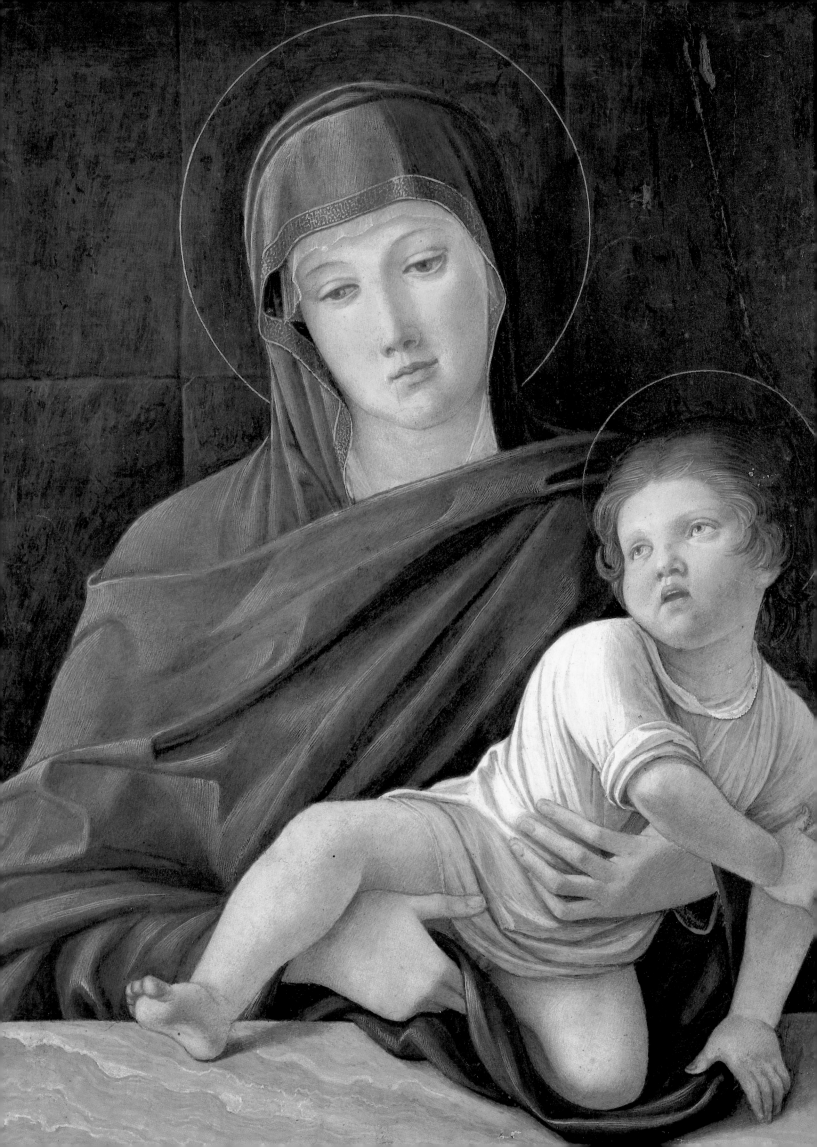

The Life of
CHRIST
in Art

NANCY GRUBB

ARTABRAS

A DIVISION OF ABBEVILLE PUBLISHING GROUP

NEW YORK LONDON PARIS

To my parents, with much love

FRONT COVER: Detail of *Initial E with Christ Sending out the Apostles*,
from an Italian antiphonary, 3d quarter of 15th century. See page 67.
BACK COVER: PERUGINO (1445/50–1523). *The Ascension of Christ*, 1496–98.
Oil on canvas, 10 ft. 7⅞ in. x 8 ft. 8⅜ in. (3.25 x 2.65 m). Musée des Beaux-Arts, Lyons, France.
SPINE: Detail of *Madonna Enthroned with Four Angels.*
Byzantine mosaic, c. 520. San Apollinare Nuovo, Ravenna, Italy.
PAGE 1: MASTER OF CATHERINE OF CLEVES. *Holy Family at Supper*, from the *Hours of Catherine of Cleves*, Dutch, c. 1440.
7½ x 5⅛ in. (19.2 x 13 cm). The Pierpont Morgan Library, New York.
PAGE 2: GIOVANNI BELLINI (1430–1516). *Madonna and Child (Madonna Frizzoni)* (major portion), 1470–75. Oil on
canvas, 18½ x 13⅜ in. (47 x 34 cm). Galleria dell'Accademia Carrara, Bergamo, Italy.

EDITORS: Mary Christian and Nancy Grubb
DESIGNER: Celia Fuller
PRODUCTION EDITOR: Owen Dugan
PICTURE EDITOR: Alysia Kaplan
PRODUCTION MANAGER: Lou Bilka

FIRST EDITION
10 9 8 7 6 5 4 3 2 1

Library of Congress Cataloging-in-Publication Data
Grubb, Nancy.
The life of Christ in art / Nancy Grubb.
p. cm.
Includes indexes.
ISBN 0-89660-059-9
1. Jesus Christ—Art. 2. Christian art and symbolism. I. Title.
N8050.G77 1996
704.9′4853—dc20 96-7613

CONTENTS

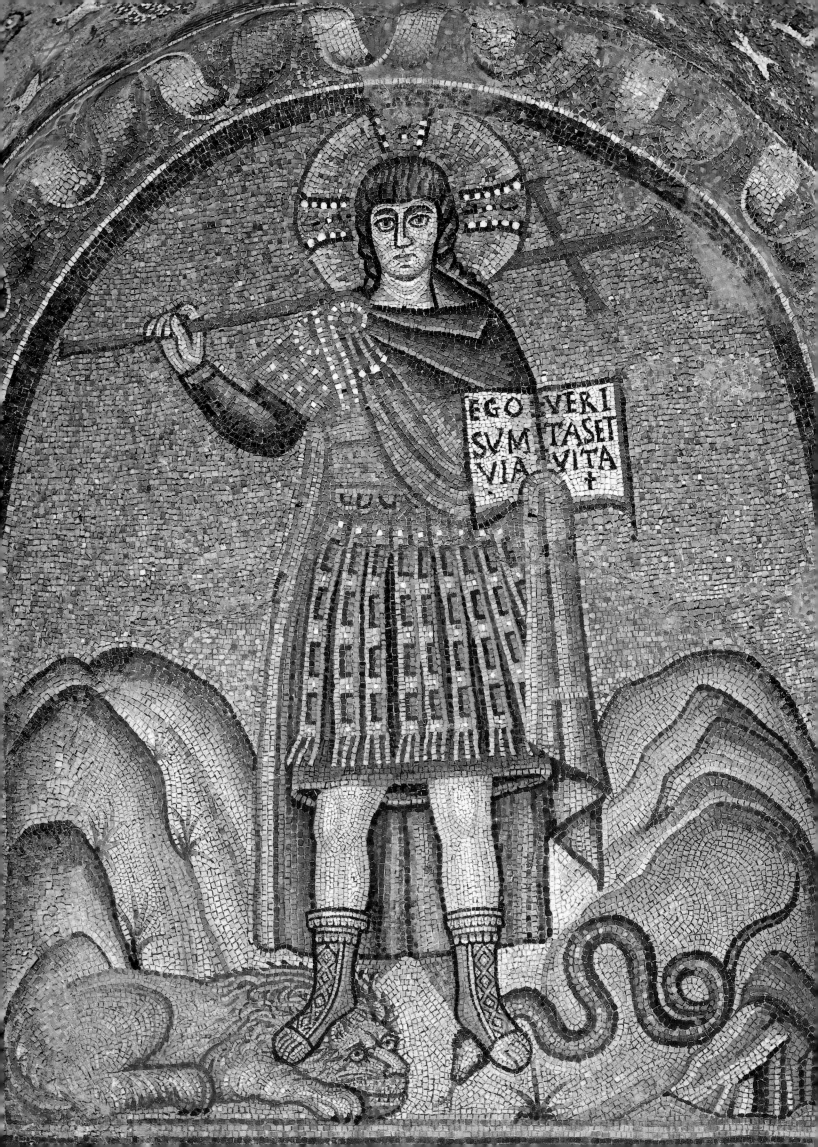

INTRODUCTION:
PORTRAITS OF CHRIST

His dear Son . . . who is the image of the invisible God.

COLOSSIANS 1:13, 15

*T*here is no portrait of Jesus Christ painted or drawn from life; not even a brief physical description of him appears in the Bible. Nonetheless, for nearly two millennia artists have been portraying Christ in loving detail. Some have shown him in settings and costumes from their own period, others have attempted to present him with historical accuracy; some have aimed for instructive realism, others for emotional intensity. Although artists were strictly guided by Church doctrine, many of them—from Giotto and Lucas Cranach to El Greco, Rembrandt, and William Blake—infused their images with a persuasive sense of personal faith as well as an inventive originality in staging familiar scenes.

Different visions of Christ have prevailed at different times and in different places. The earliest Christians—many of whom came out of the Judaic tradition, with its explicit prohibition against making or worshiping idols—used only the simplest of visual symbols. Marked in their secret meeting places and on their tombs were visual codes decipherable only by believers, such as the outline of a fish or the acronym ICHTHYS (the Greek letters for Jesus Christ, Son of God, Savior, which spell *fish* in Greek). Early depictions of Christ embodied in human form were generally based on types adopted from the pagan world; the mythical Greek poet and musician Orpheus, for example, became a prototype for gentle images of Christ as the Good Shepherd (page 8). After the Roman emperor Constantine converted to Christianity and, with the Edict of Milan in 313, decreed it a "permitted" religion, one favored image was Christ Pantocrator ("all-sovereign")—a stern judge and ruler intended to inspire fearful obedience (page 8).

Images of Christ helped satisfy the desire of the faithful to know more about Jesus than was spelled out in the Gospels. Every aspect of his existence, from conception

*C*hrist Militant. Byzantine mosaic, c. 520.
Museo Arcivescovile, Ravenna, Italy.

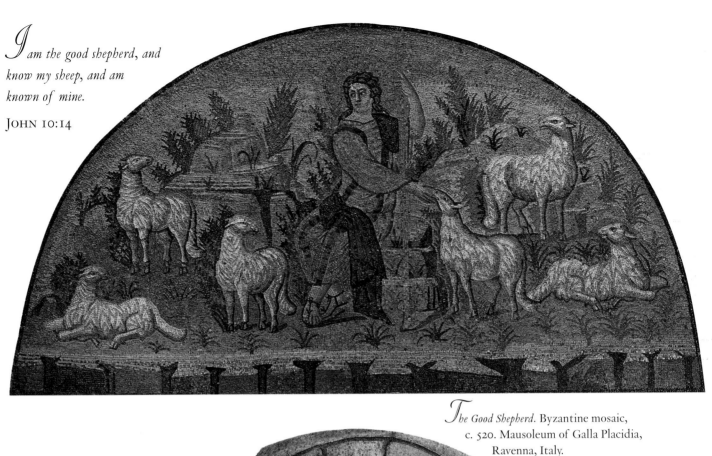

I am the good shepherd, and know my sheep, and am known of mine.

JOHN 10:14

The Good Shepherd. Byzantine mosaic, c. 520. Mausoleum of Galla Placidia, Ravenna, Italy.

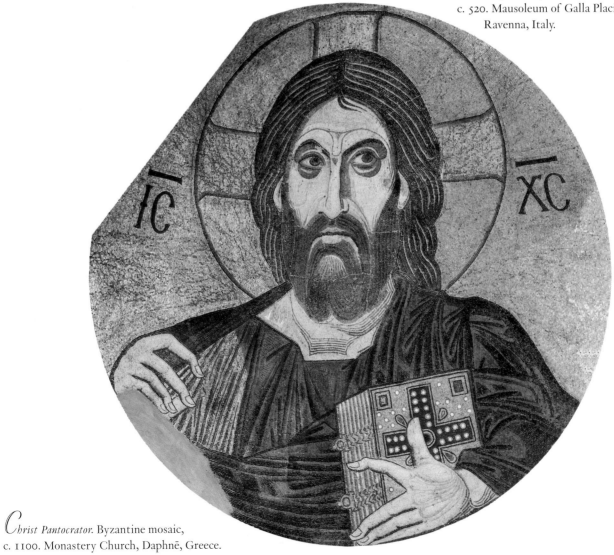

Christ Pantocrator. Byzantine mosaic, c. 1100. Monastery Church, Daphnē, Greece.

INTRODUCTION

to birth to death to resurrection, was of fervent interest to believers, and they looked to art for both inspiration and instruction. By the Middle Ages, Christianity had become so dominant in the West that most people of all classes were devout churchgoers, and as a result they would have encountered depictions of Christ in many forms. Pilgrims and local worshipers attending Mass in a cathedral would likely have passed under a sculpted figure of Christ as they walked through the church doors; inside, there would no doubt be a crucifix on the altar as well as scenes from the life of Christ painted on the walls or on a multipaneled altarpiece, woven into tapestries, or rendered in stained glass. The clergy and the few literate men and women wealthy enough to own manuscripts would have known other images of Christ in the form of the illuminations decorating their Bibles, missals, psalters, books of hours, and other written aids to public worship and private meditation.

Medieval art was conservative; most artists relied on the forms and conventions established by their predecessors, and innovations in basic form or content were rare. With the advent of the Renaissance, artists expanded the repertory of their sources, consulting not only their forebears among the Christian painters but also reaching further back in time to the idealized realism of classical sculpture. In addition, the Renaissance emphasis on individuality shaped the portrayal of Christ and of his followers. Each saint or disciple came to have a distinctive personality in addition to the standard attributes (for example, Peter's beard, bald spot, and set of keys) traditionally used to identify him.

Interpretations may have varied with the artist and the era, but little personal inspiration was allowed in creating most medieval and Renaissance images of Christ. Content was determined by precedent and by the specific patron commissioning the work—usually a branch of the Church, but also civic or trade organizations and wealthy individuals. Whatever form Christ took—whether innocent child (page 42), militant soldier (page 6), or suffering man of sorrows (pages 12–13)—the primary purpose of his image was to inspire worship, not admiration for the artist's skills. The colors that Jesus wore, the position of his hands, the type of halo or nimbus that radiated around him all had meaning that contemporary Christians would have understood from sermons, liturgical dramas, and the many other sources of religious education that pervaded daily life.

Even abstract theological concepts could be illustrated in ways intended to make them more widely comprehensible and persuasive. The Trinity, for example, is a central doctrine of Christianity that has been made visible in significantly different ways over the centuries. Some images emphasize the distinct identities of the Father, Son, and Holy Spirit by portraying them as three unmistakably unique beings (page 10, left); others (page 10, right) emphasize their sameness and hence their equality—a point much debated in the early days of the Church.

Another recurring controversy centered on the propriety of making any sacred images at all. The veneration of icons (the word *icon* simply means "image" but came to mean specifically holy images of Christ, Mary, and the saints) has become an integral part of the worship service in the Orthodox church; see, for example, the striking—and very dissimilar—Russian icons on pages 48 and 120. But in the early days of Christianity bitter and prolonged debate raged over the distinctions between such icons and the earlier pagan idols. In certain periods and places (particularly eighth- and

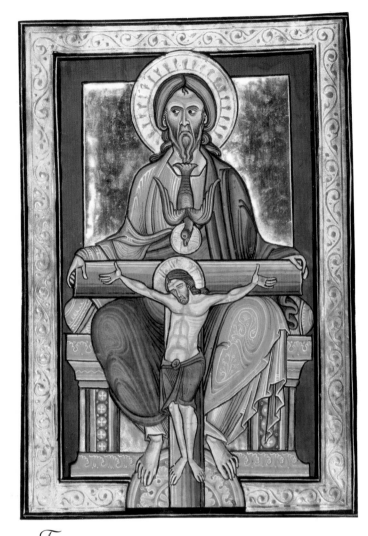

The Trinity, from the *Berthold Sacramentary*. Abbey of Weingarten, Germany, 1200–1232. The Pierpont Morgan Library, New York.

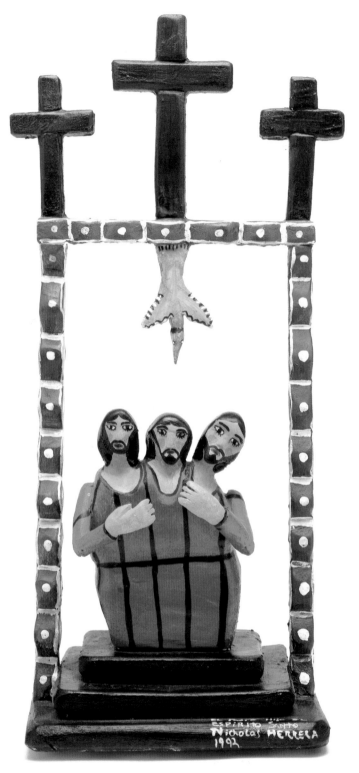

Nicholas Herrera (b. 1964). *Trinity*, 1992. Painted wood, 24 x 13 x 6 in. (60.9 x 33 x 15.2 cm). Chuck and Jan Rosenak.

ninth-century Byzantium) the iconoclasts—i.e., those who considered religious images to be sacrilegious—prevailed, demolishing religious paintings, sculptures, and manuscripts. As a result, some facets of Christ's identity in art have been lost forever. Iconoclasm flared up again after the reforms of Martin Luther led to a split within the Church, and the sixteenth-century religious conflicts between Protestants and Catholics resulted in much destruction.

The strife between these two branches of Christianity also yielded a new vitality in the depiction of Christ. Northern artists such as Lucas Cranach and Albrecht Dürer (who were profoundly affected by their friendships with Luther) developed vividly realistic imagery to communicate the beliefs of the Protestant reformers. At the same time, the Roman Catholic artists of the Counter-Reformation—notably Peter Paul Rubens—responded with avid creativity to Rome's commands to use their art as a force for the faith by intensifying the emotional impact and the theological content of their increasingly theatrical paintings. In contrast to the exuberantly muscular bodies and unabashedly luxuriant settings depicted by Rubens are the more mystical compositions by another Counter-Reformation artist, El Greco, who infused his elongated, ethereal figures with a profound sense of ecstatic faith. Compare, for example, Rubens's *Deposition* (page 120) with El Greco's *Resurrection* (page 134).

The evolution of Christ's image over the centuries has reflected changes not only in Church doctrine but also in the social and cultural conditions under which artists have created and sold their work. In modern times, with art patronage less dependent on the Church and personal expression more highly valued, artists have been free to represent Christ in their own ways. Nineteenth- and twentieth-century painters such as Paul Gauguin, Georges Rouault, Emil Nolde, Stanley Spencer, Henri Matisse, and Salvador Dalí have brought a spirit of innovation to depicting the life of Christ, interpreting it in visually sophisticated ways. Contemporary folk artists including William Edmondson, Charlie Fields, and Howard Finster have created idiosyncratic works that often reflect their own experiences and personal beliefs rather than traditional iconography.

"Jesus Christ the same yesterday, and today and for ever" (Hebrews 13:8) may be theologically true, but it has certainly not been true in terms of art. Surveying the myriad images of Christ created during the past two millennia inspires the deepest respect and admiration for the emotional, conceptual, and visual variety that artists have brought to this topic—the most passionately and persistently depicted subject in the history of Western art.

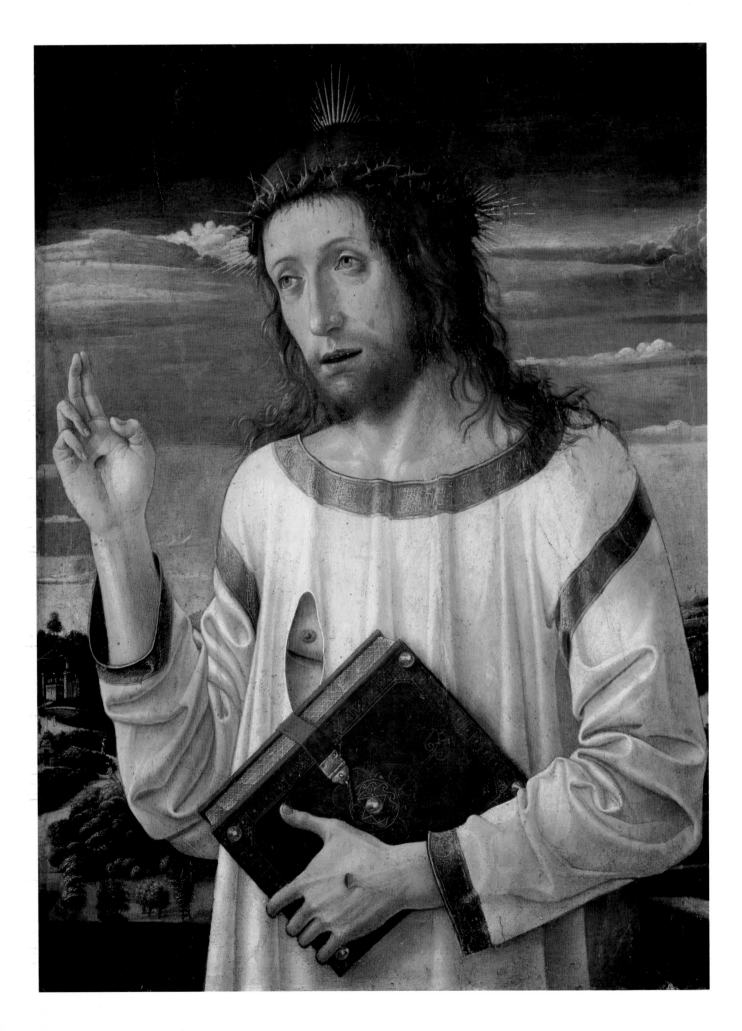

INTRODUCTION

He is despised and rejected of men; a man of sorrows, and acquainted with grief. . . .
He bare the sin of many, and made intercession for the transgressors.

ISAIAH 53:3, 12

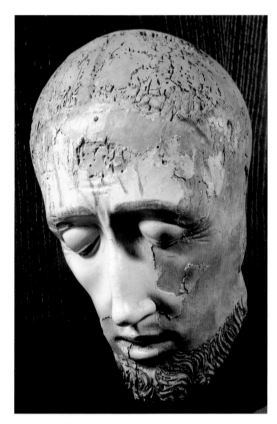

Head of Christ. Frankish, c. 1470.
Painted limewood, 12½ x 7 x 5⅛ in.
(32 x 18 x 13 cm). Musée National du Moyen Age,
Thermes de Cluny, Paris.

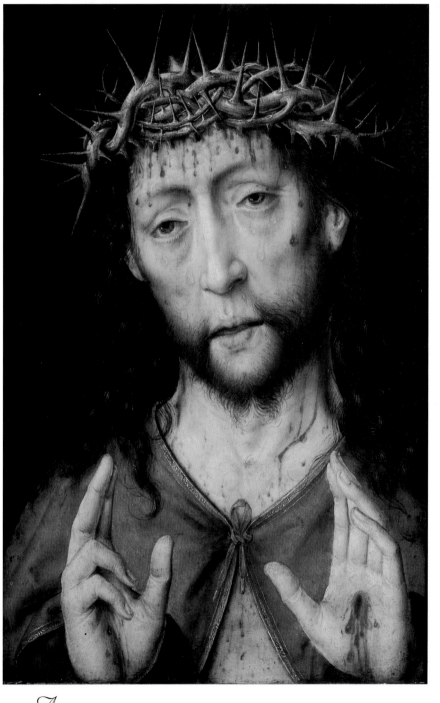

AELBRECHT BOUTS (c. 1452/60–1549). *Man of Sorrows*, n.d. Oil on wood,
13⅞ x 9¼ in. (35.5 x 23.5 cm). Musée des Beaux-Arts, Lyons, France.

OPPOSITE
GIOVANNI BELLINI (1430–1516). *Christ's Blessing*,
c. 1460. Oil on wood, 22¾ x 18⅛ in. (58 x 46 cm).
Musée du Louvre, Paris.

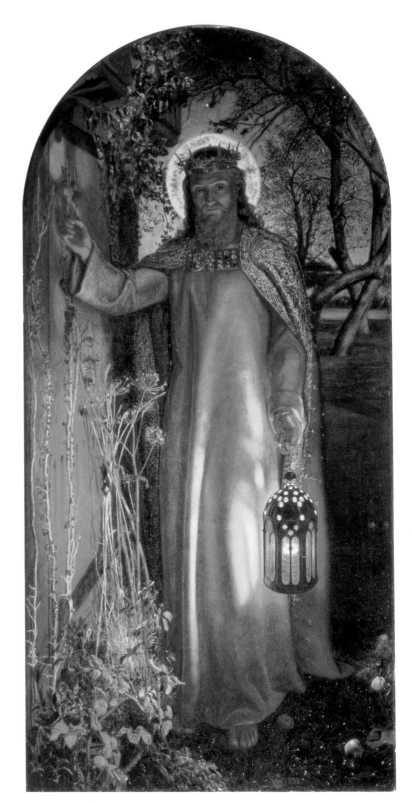

HOWARD FINSTER (b. 1915). *God Is Love*, n.d.
Enamel on wood, 80 x 20 in. (203.2 x 50.8 cm).
Private collection.

WILLIAM HOLMAN HUNT (1827–1910). *The Light of the World*, 1853–56.
Oil on canvas over wood, 49⅜ x 23½ in. (125.5 x 59.8 cm).
Keble College, Oxford, England.

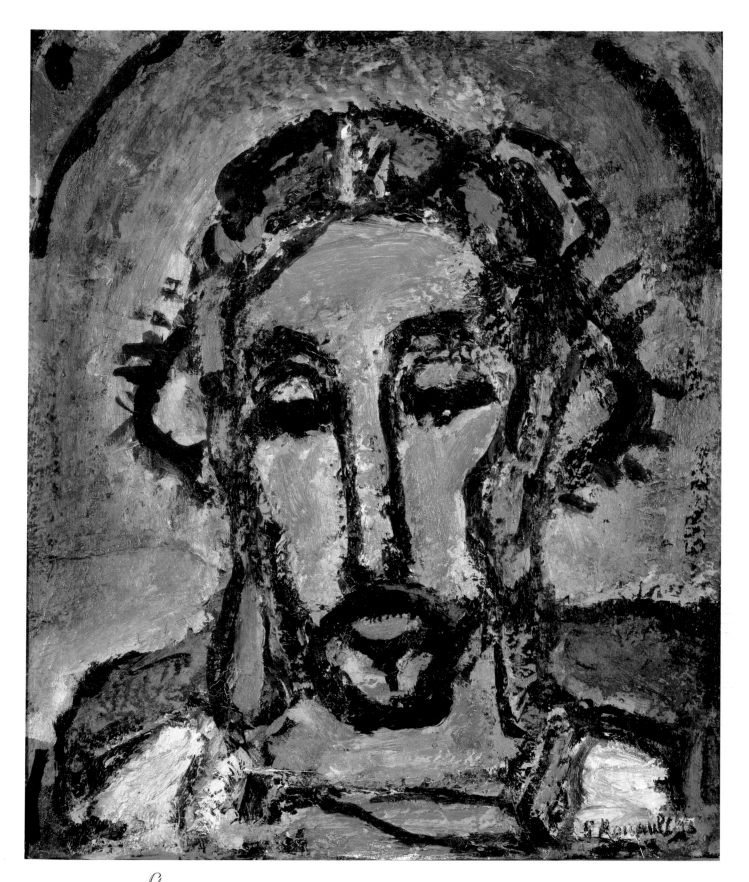

GEORGES ROUAULT (1871–1958). *Ecce Homo*, 1952. Oil on canvas, 31⅜ x 29⅛ in. (80 x 74 cm).
Collection of Modern Religious Art, Vatican Museums, Vatican City.

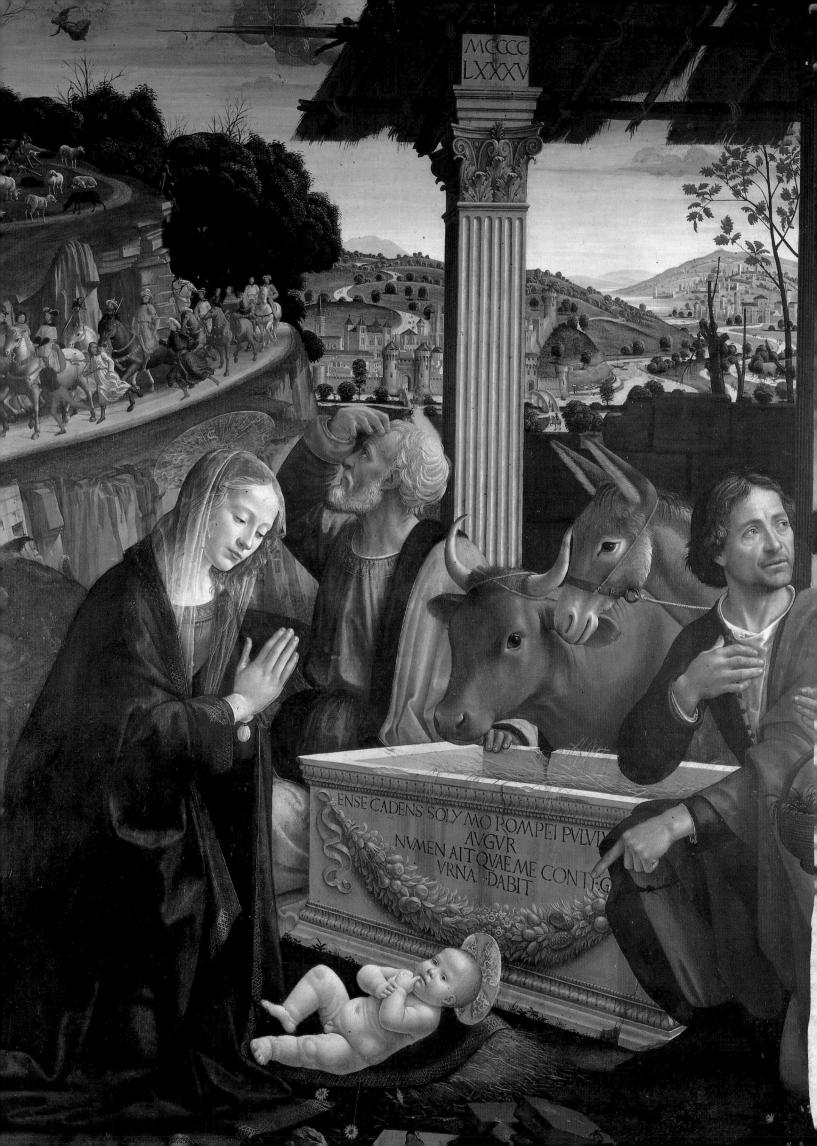

THE NATIVITY

Behold, I bring you good tidings of great joy, which shall be to all people.
For unto you is born this day in the city of David a Saviour, which is Christ the Lord.

LUKE 2:10–11

*T*he meager but colorful details specified by Matthew and Luke in their chronicles of the nativity have given artists unending inspiration. The bright star over Bethlehem, the three magi who followed it out of the East, the angelic annunciation to the shepherds in the fields, and the Christ Child "wrapped in swaddling clothes and placed in the manger" have all been depicted with enthusiastic inventiveness.

Other details, often elaborately specific, have been added over the centuries from nonscriptural sources such as the thirteenth-century *Golden Legend* and *Meditations on the Life of Christ*. From the former came the charming story of the ox and the ass that bowed down before the young Savior, who shared their rustic stable; rare is the Renaissance nativity scene without these two animal companions. Medieval morality plays, performed throughout Europe to celebrate and to explain Christmas and other holy days, also elaborated on the gospel accounts of the nativity. They were one source of the expanded identities for the anonymous magi who became known as the three kings: Balthazar, the gray-haired and gray-bearded man bearing gold, who almost invariably is shown kneeling nearest to the Child; Caspar, the middle-aged, clean-shaven giver of frankincense; and Melchior, the dark-skinned young man who offers the bitter myrrh. In the Renaissance and later, Benozzo Gozzoli, Domenico Ghirlandaio, Paolo Veronese, Peter Paul Rubens, Giovanni Battista Tiepolo, and many others portrayed these men as extravagantly attired kings whose retinues of brightly clad servants and lavishly caparisoned horses crowd the landscape.

The shepherds, too, figure frequently in images of the nativity—shown either at watch over their flocks, listening in awe to the angel's message, or shyly kneeling in

*D*OMENICO GHIRLANDAIO (1449–1494).
Detail of *The Adoration of the Shepherds*, 1485. Tempera on wood, 65⅝ x 65⅝ in. (167 x 167 cm), overall.
Sassetti Chapel, Santa Trinità, Florence.

adoration before the Child. Their rough clothing and homely, emotion-struck faces seem to have held particular appeal for northern European artists, from Robert Campin to Jacob Jordaens (pages 25 and 27).

Nativity scenes may be as simple as Lorenzo Costa's fifteenth-century tableau of Mary and Joseph worshiping the sleeping Child and Mamie Deschillie's contemporary folk art *Crèche* (page 23). Or they can incorporate an almost theatrical cast of characters, as in Hugo van der Goes's crowd of interacting figures, both human and angelic (page 22). In many nativity adoration scenes Christ—whether swaddled in white or shown naked to demonstrate his innocence and perfection—is surrounded by radiant beams of light that direct the viewer's eye to the divine infant.

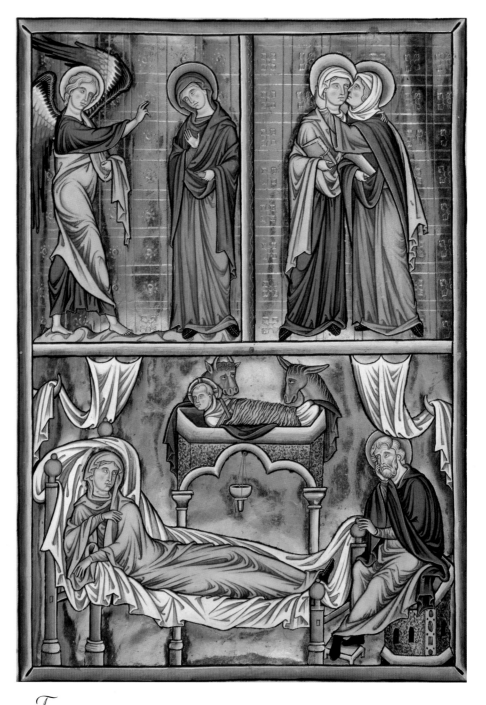

The Annunciation, the Visitation, and the Nativity, from *The Psalter of Ingeburg of Denmark*, French, 13th century. Musée Condé, Chantilly, France.

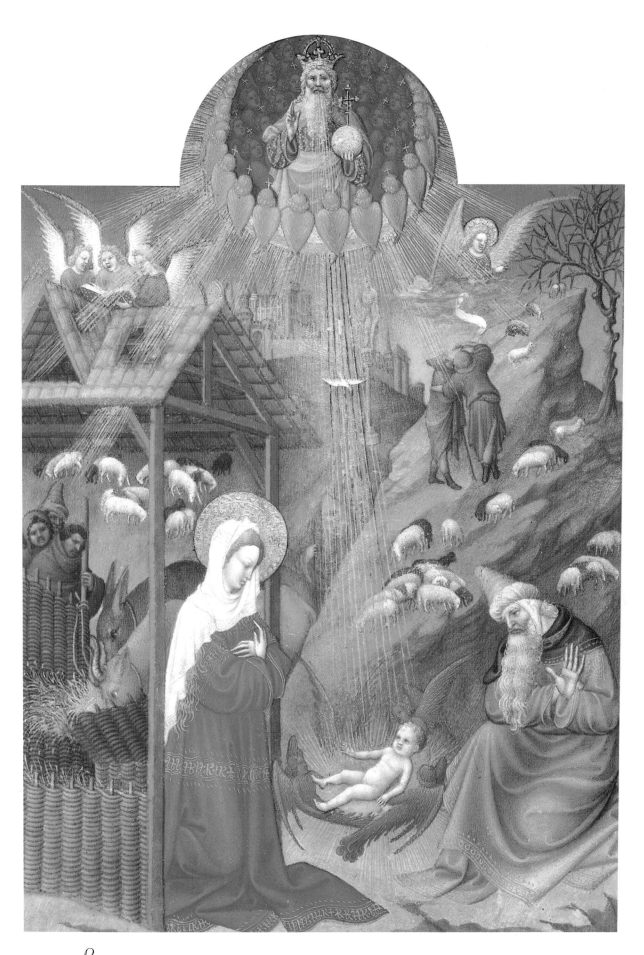

\mathcal{L}IMBOURG BROTHERS (15th century). *The Nativity*, from *Les Très Riches Heures du Duc de Berry*, c. 1413. Musée Condé, Chantilly, France.

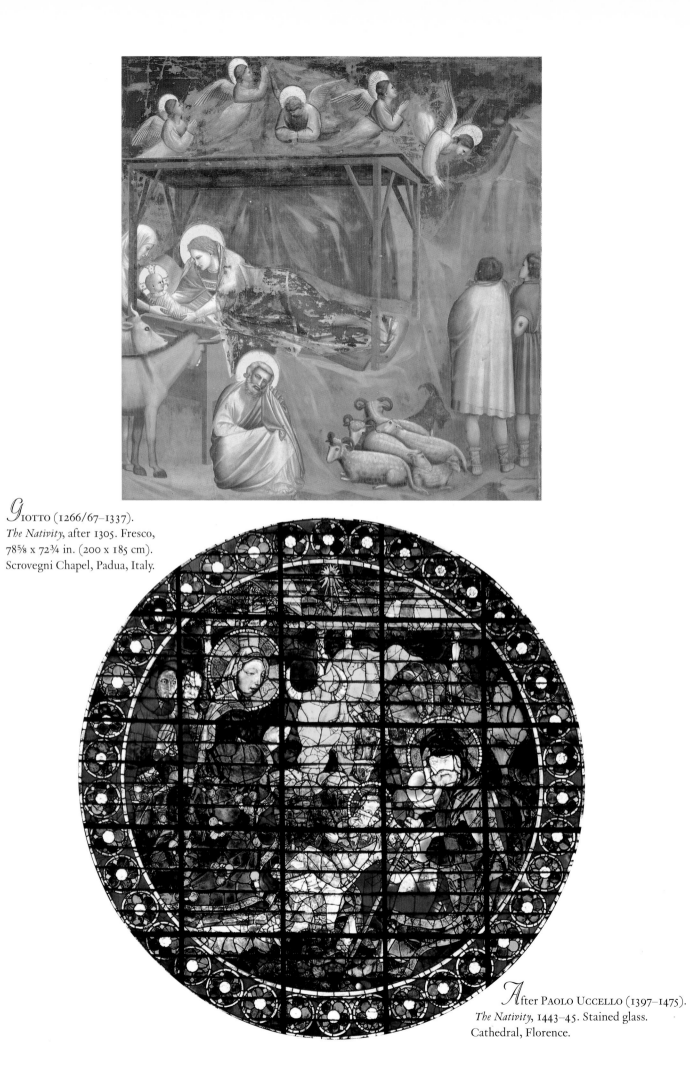

GIOTTO (1266/67–1337).
The Nativity, after 1305. Fresco,
78⅝ x 72¾ in. (200 x 185 cm).
Scrovegni Chapel, Padua, Italy.

After PAOLO UCCELLO (1397–1475).
The Nativity, 1443–45. Stained glass.
Cathedral, Florence.

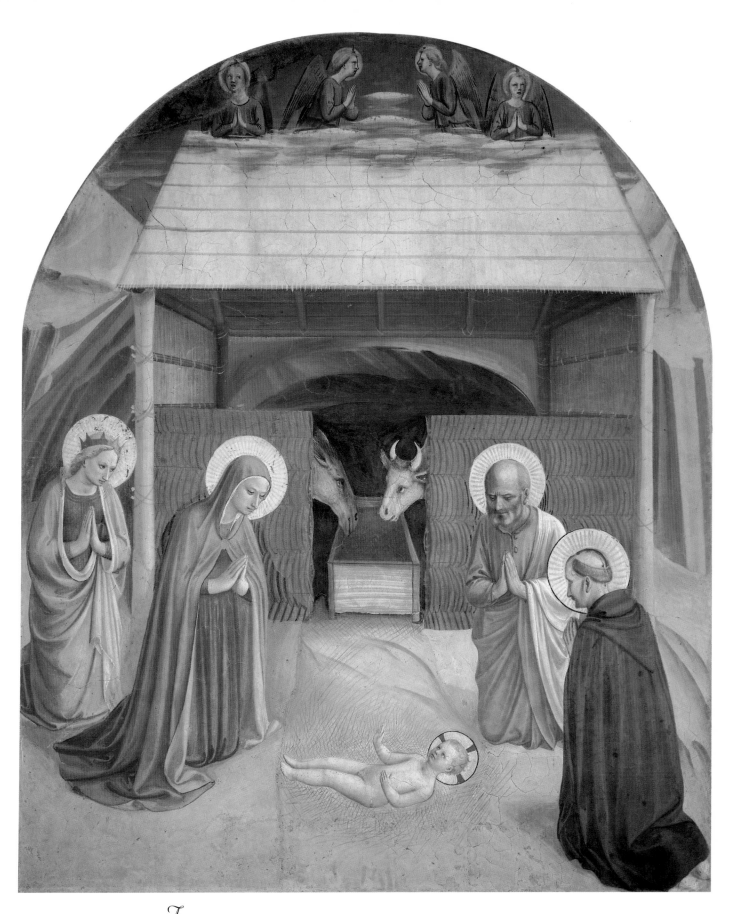

F𝑅A Angelico (c. 1400–1455) and workshop. *The Nativity*, late 1430s–early 1440s.
Fresco, 59 x 35 in. (150 x 89 cm). Monastery of San Marco, Florence.

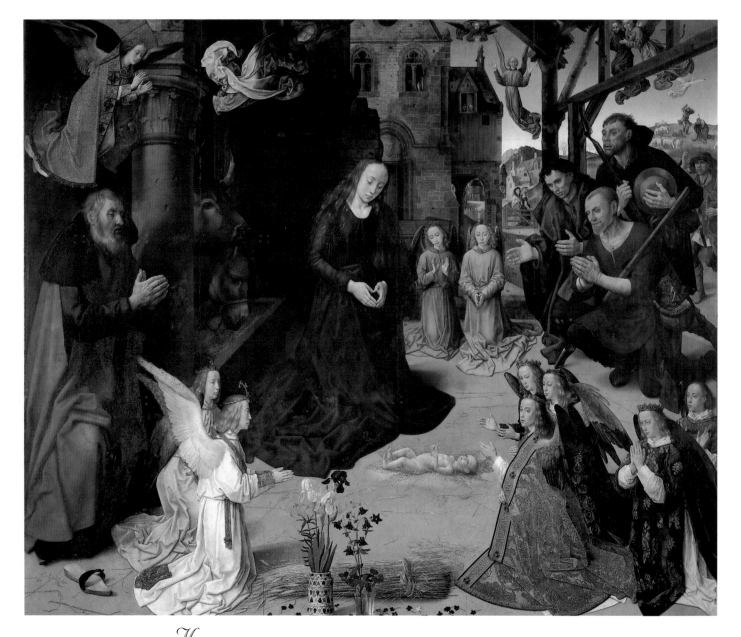

\mathcal{H}UGO VAN DER GOES (c. 1440–1482). *Portinari Altarpiece* (central panel), c. 1475.
Oil on wood, 115⅝ x 119⅝ in. (294 x 304 cm). Galleria degli Uffizi, Florence.

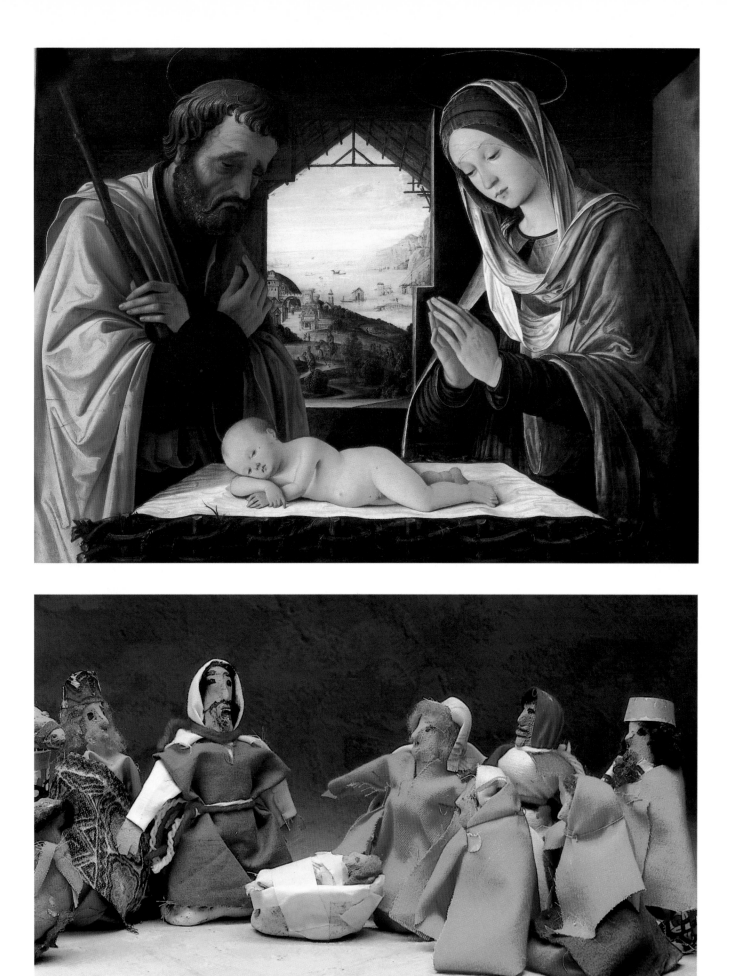

And there were in the same country shepherds abiding in the field, keeping watch over their flock by night. And, lo, the angel of the Lord came upon them, and the glory of the Lord shone round about them, and they were sore afraid. And the angel said unto them, Fear not.

LUKE 2:8–10

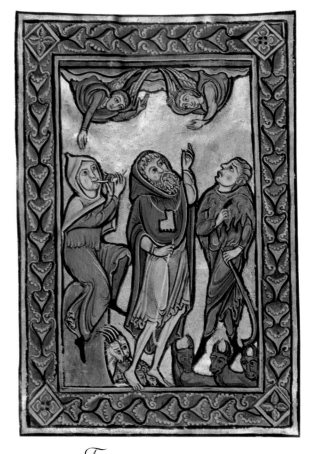

The Annunciation to the Shepherds.
From a French manuscript, 12th–13th century.
The Pierpont Morgan Library, New York.

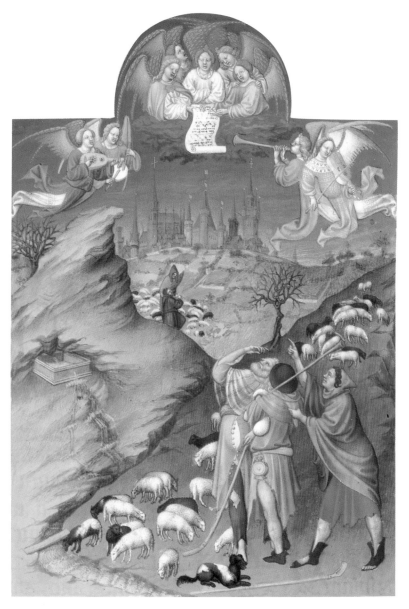

LIMBOURG BROTHERS (15th century).
The Annunciation to the Shepherds, from *Les Très Riches Heures du Duc de Berry,*
c. 1413. Musée Condé, Chantilly, France.

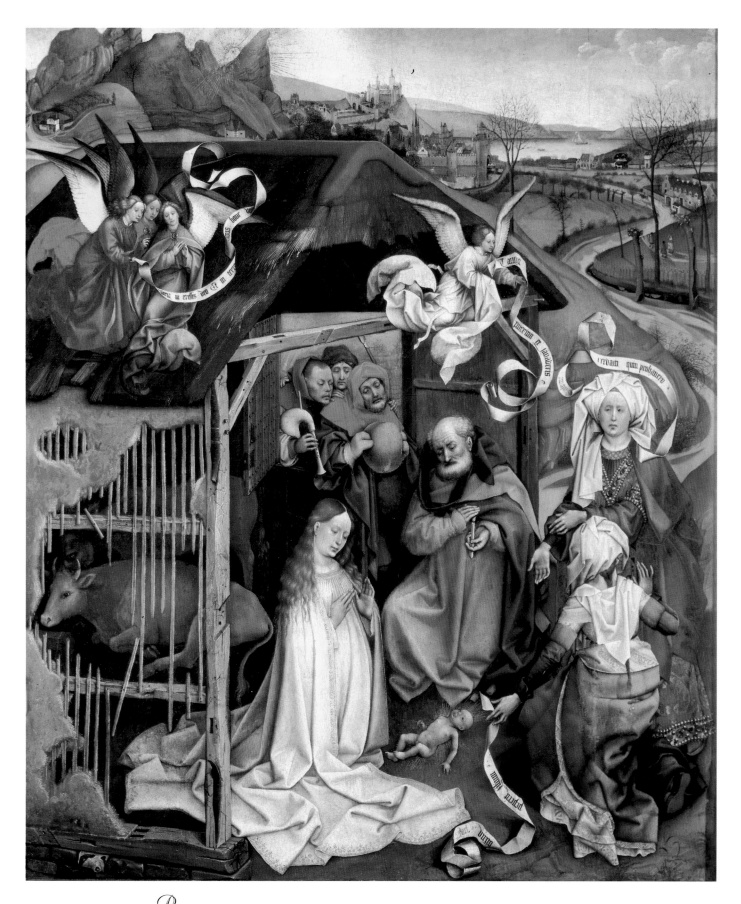

ROBERT CAMPIN (c. 1375–1444). *The Adoration of the Shepherds*, 1st half of 15th century.
Oil on wood, 33¾ x 28⅜ in. (86 x 72 cm). Musée des Beaux-Arts, Dijon, France.

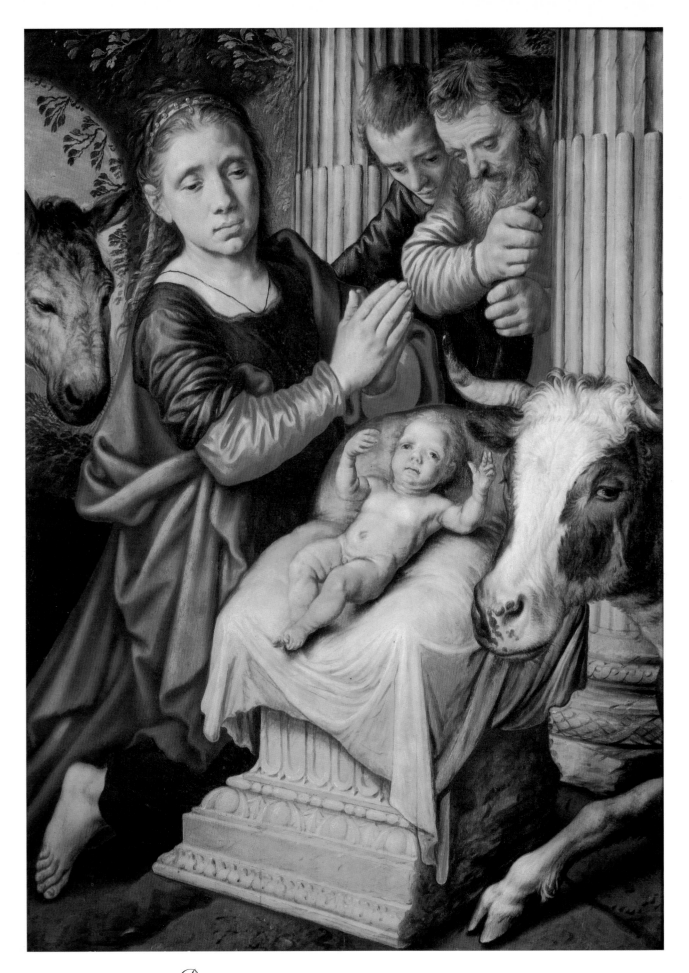

*P*IETER AERSTEN (1508–1570). *The Adoration of the Shepherds*, n.d.
Oil on wood, 34¼ x 24¾ in. (87 x 63 cm). Musée des Beaux-Arts, Rouen, France.

THE NATIVITY

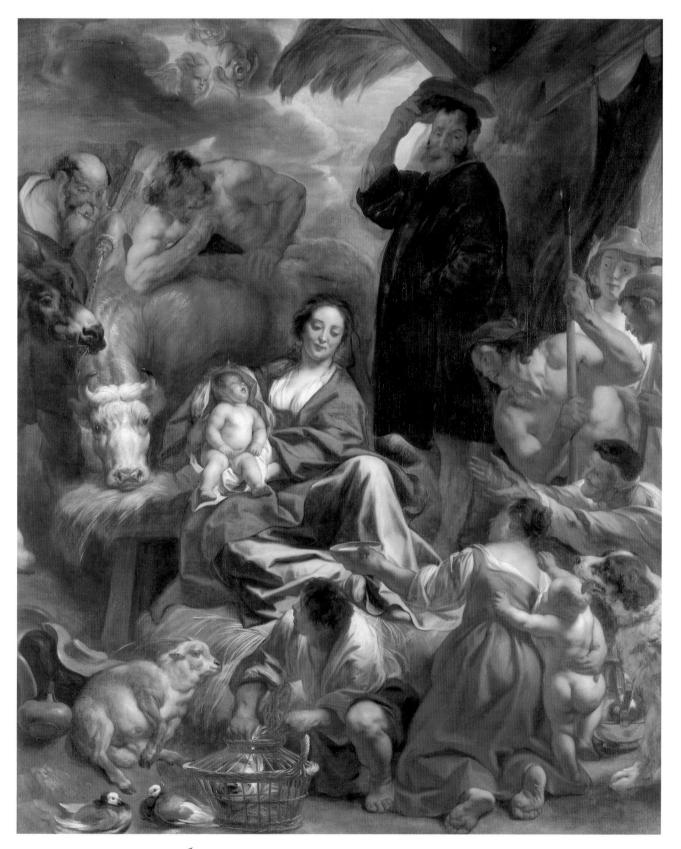

JACOB JORDAENS (1593–1678). *The Adoration of the Shepherds*, 1644.
Oil on canvas, 99¾ x 81¾ in. (251 x 208 cm). Musée des Beaux-Arts, Lyons, France.

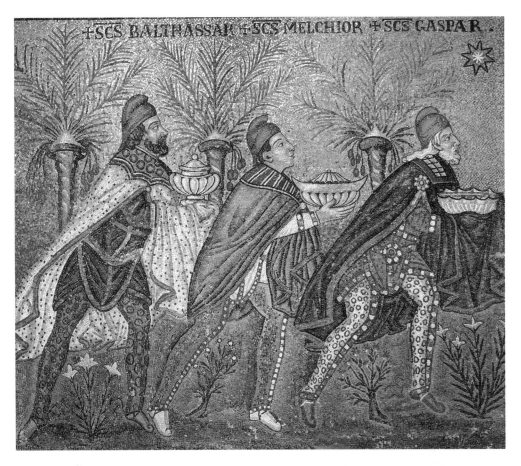

+SCS BALTHASSAR +SCS MELCHIOR +SCS GASPAR.

LEFT

The Three Magi on Their Way.
Byzantine mosaic, c. 520.
San Apollinare Nuovo,
Ravenna, Italy.

BELOW

The Voyage of the Magi,
mid-13th century. Mosaic.
Baptistery, Florence.

THE NATIVITY

Now when Jesus was born in Bethlehem of Judaea in the days of Herod the king, behold, there came wise men from the east to Jerusalem, Saying, Where is he that is born King of the Jews? for we have seen his star in the east, and art come to worship him.

MATTHEW 2:1-2

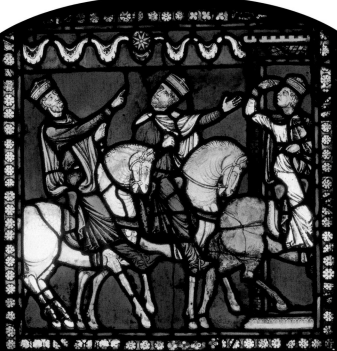

The Magi Led by a Star on the Ride to Jerusalem, c. 1200. Stained glass. Cathedral, Canterbury, England.

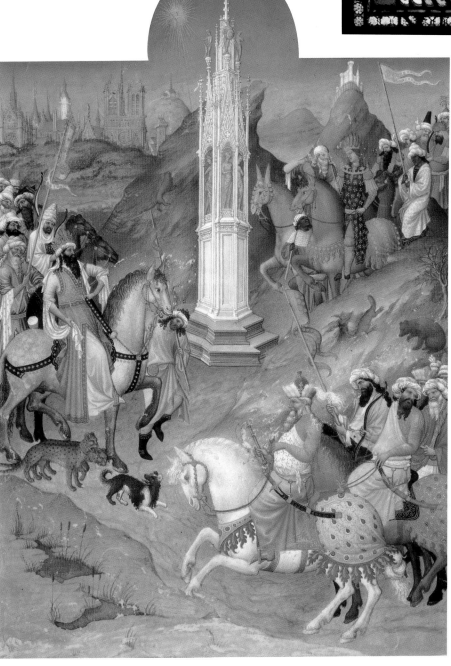

LIMBOURG BROTHERS (15th century). *Meeting of the Magi at the Crossroads*, from *Les Très Riches Heures du Duc de Berry*, c. 1413. Musée Condé, Chantilly, France.

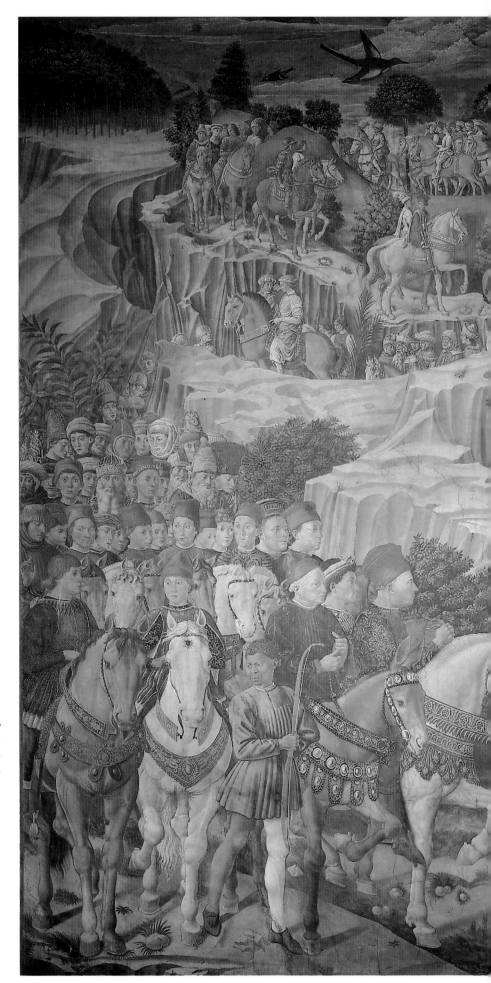

*B*ENOZZO GOZZOLI (1421–1497).
The Procession of the Young King,
from *The Journey of the Magi,* 1459–61.
Fresco, length: 24⅝ ft. (7.5 m), overall.
Chapel, Palazzo Medici-Riccardi, Florence.

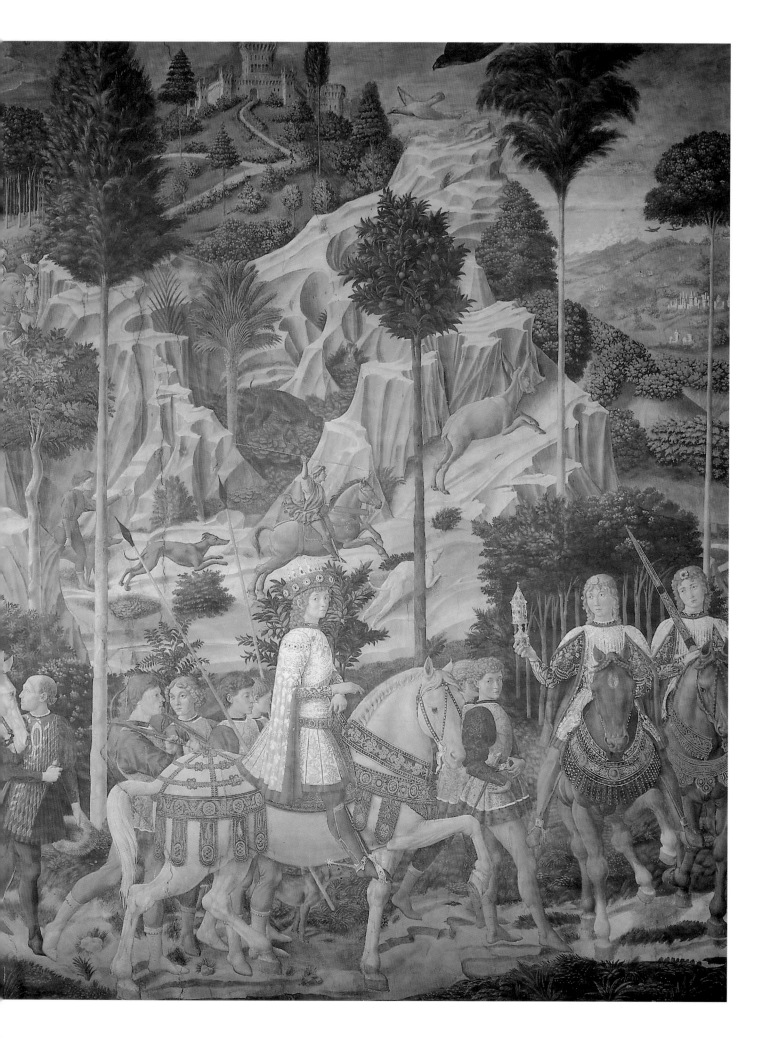

THE NATIVITY

And when they were come into the house, they saw the young child with Mary his mother, and fell down, and worshipped him: and when they had opened their treasures, they presented unto him gifts; gold, and frankincense, and myrrh.

MATTHEW 2:11

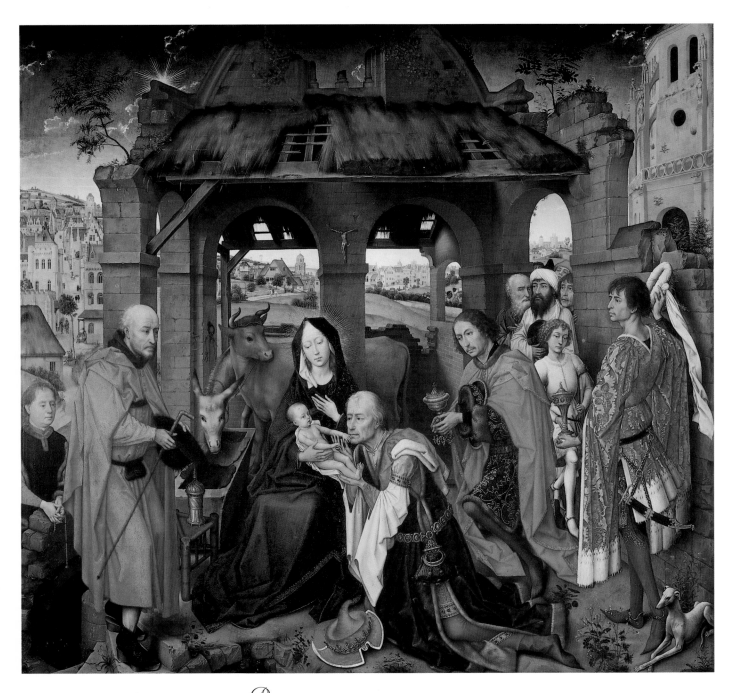

ROGIER VAN DER WEYDEN (1399/1400–1464).
Three Kings Altar (*Columba Altar*), c. 1455. Oil on oak, 54⅜ x 60 in. (138 x 153 cm). Alte Pinakothek, Munich.

OPPOSITE
HIERONYMUS BOSCH (c. 1450–1516).
The Adoration of the Magi (central panel), c. 1510.
Oil on wood, 54⅜ x 55 in. (138 x 140 cm), overall.
Museo del Prado, Madrid.

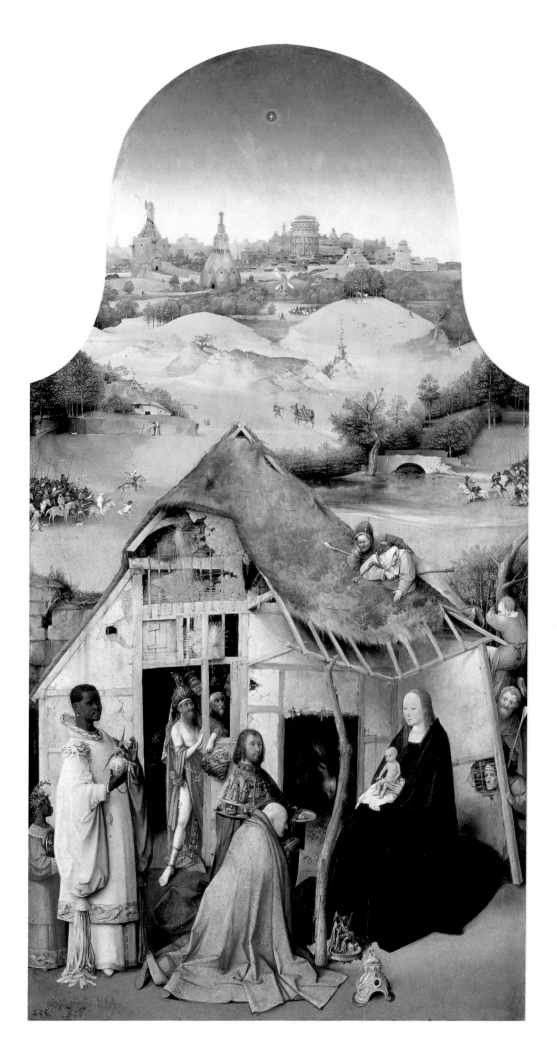

THE NATIVITY

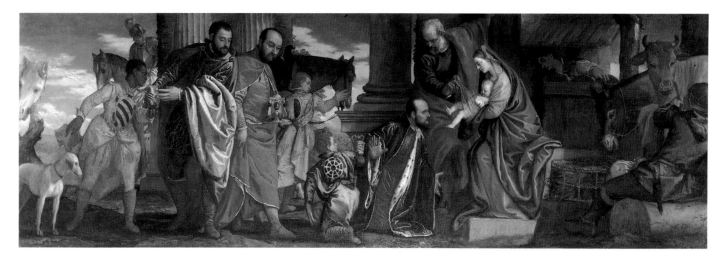

PAOLO VERONESE (1528–1588). *The Adoration of the Magi*, c. 1583–84.
Oil on canvas, 52⅝ x 115⅝ in. (134 x 294 cm). Musée des Beaux-Arts, Lyons, France.

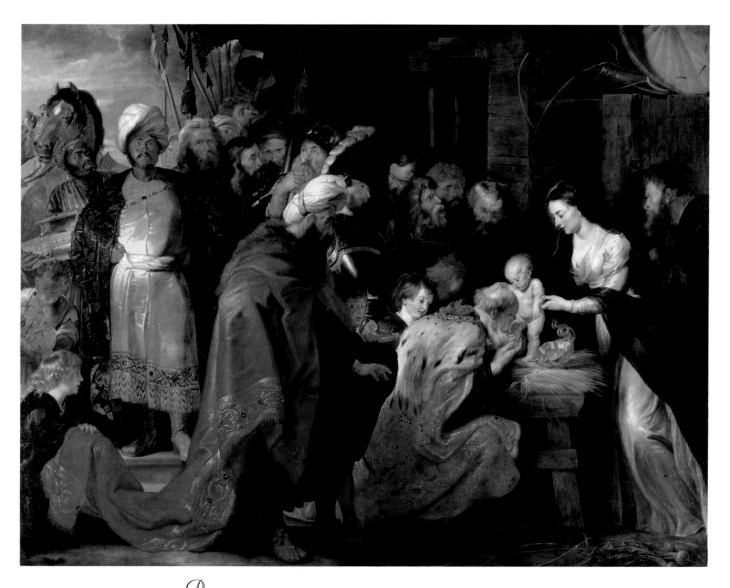

PETER PAUL RUBENS (1577–1640). *The Adoration of the Magi*, c. 1617–18.
Oil on canvas, 98¾ x 129⅛ in. (251 x 328 cm). Musée des Beaux-Arts, Lyons, France.

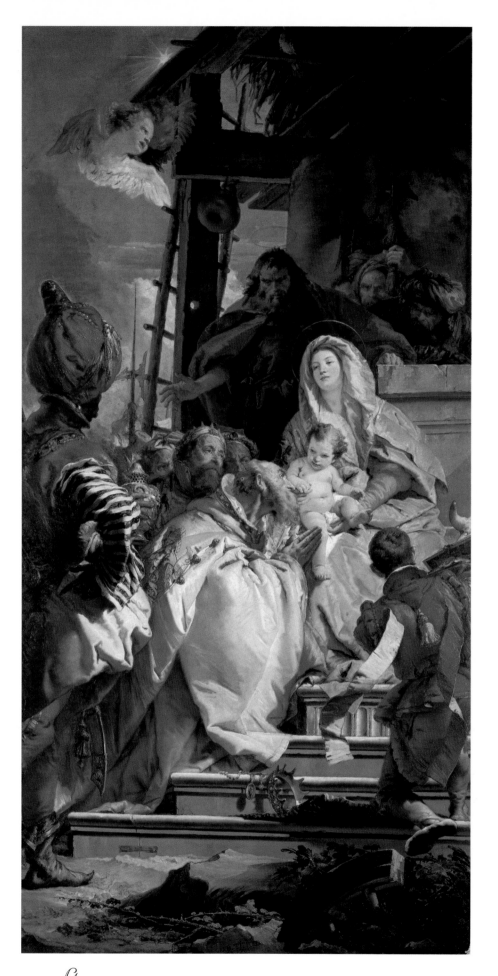

𝒢ɪᴏᴠᴀɴɴɪ Bᴀᴛᴛɪsᴛᴀ Tɪᴇᴘᴏʟᴏ (1696–1770). *The Adoration of the Magi*, 1753.
Oil on canvas, 14 x 7 ft. (4.25 x 2.11 m). Alte Pinakothek, Munich.

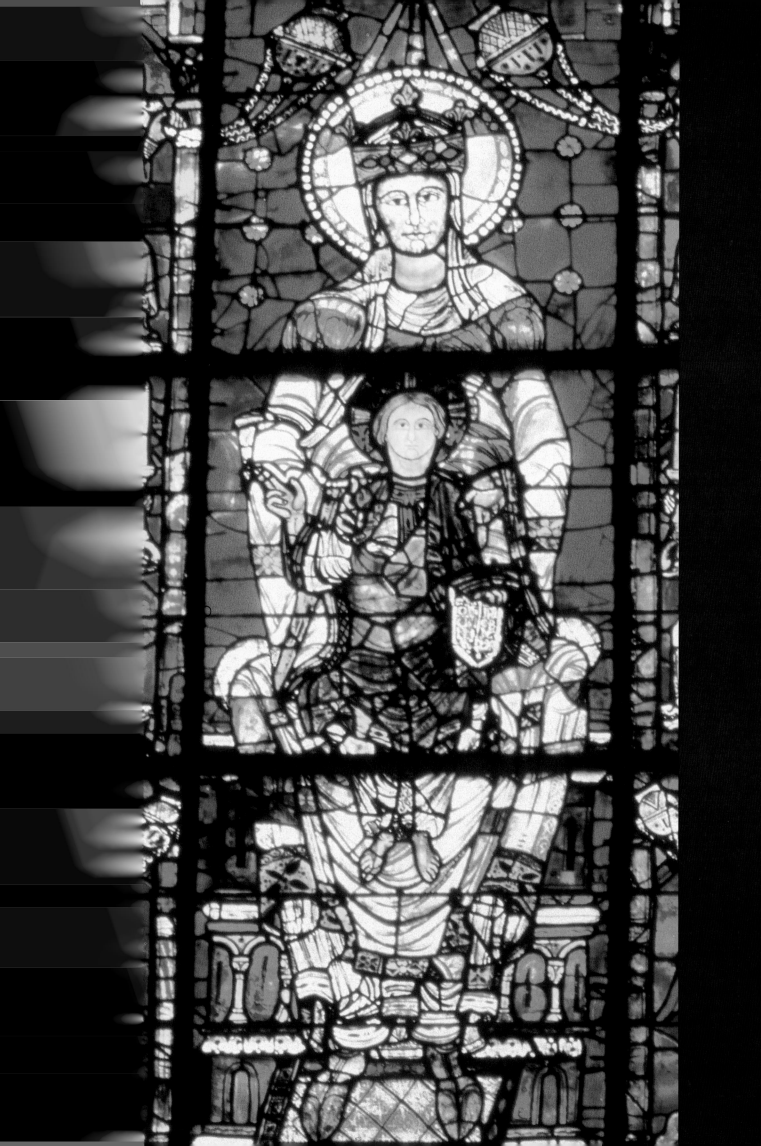

THE HOLY FAMILY

Blessed art thou among women, and blessed is the fruit of thy womb.

LUKE 1:42

The love between Christ and his mother has been celebrated in some of the most engaging paintings and sculptures ever created. Images of the Madonna and Child have been made as small, precious objects for private veneration (see the thirteenth-century French ivory carving on page 41 and the illustration from a book of hours on page 1). And they have been depicted on a grand scale for the inspiration of pilgrims who would travel many foot-weary miles to pay them homage, as with the window known as Notre Dame de la Belle Verrière (Our Lady of the Beautiful Stained Glass), at Chartres Cathedral in France (opposite).

Usually simple in composition—most often with the Christ Child sitting or precociously standing on his mother's lap—Madonna and Child images often contain symbols that enrich their meanings in ways that viewers of the period would immediately have comprehended. Christ may play with something that foreshadows his crucifixion: a bit of wood would allude to the cross; a piece of red coral, to the blood he was to shed; a goldfinch (which eats thistles), to his crown of thorns.

Telling, too, are the ways that artists expressed the beliefs of their time through the demeanor, surroundings, and costumes of the Madonna and Child. In the Byzantine and early medieval periods (from about the fifth to the twelfth century), the two figures are often regally formal, clad head to toe in rich robes and directly facing the viewer, often with the Christ Child raising his right hand in blessing—as in the solemn, angel-encircled image by Cimabue (page 40). His guise as a young ruler signified his triumph over competing faiths, such as Judaism, paganism, and later, Islam.

With the Renaissance, theological emphasis shifted from asserting Christ's divinity (a belief no longer under serious challenge in Christian society) to the miracle of his incarnation. Artists began portraying the baby Jesus, usually shown plumply naked or only

Notre Dame de la Belle Verrière, 13th century.
Stained glass. Cathedral, Chartres, France.

lightly veiled, engaged in endearingly human activities —nursing, playing, sleeping. The surroundings are no longer limited to the flat gold background and throne that had predominated in earlier centuries; the Madonna and Child may be situated in a lushly natural landscape or a detailed domestic interior.

The Holy Family extended beyond Mary and Jesus. Artists also portrayed, though less frequently, Christ's earthly father, Joseph; the Virgin's own mother, Saint Anne; and Christ's older cousin, Saint John the Baptist, often clad in camel skin and clutching a small cross. Another favored subject was the Tree of Jesse, which documents Christ's earthly family from its roots in the patriarch Jesse (father of King David) to the Virgin Mary or, less frequently, to Joseph (both are said to have descended from David).

Tree of Jesse, 12th century.
Stained glass. Cathedral, Chartres, France.

THE HOLY FAMILY

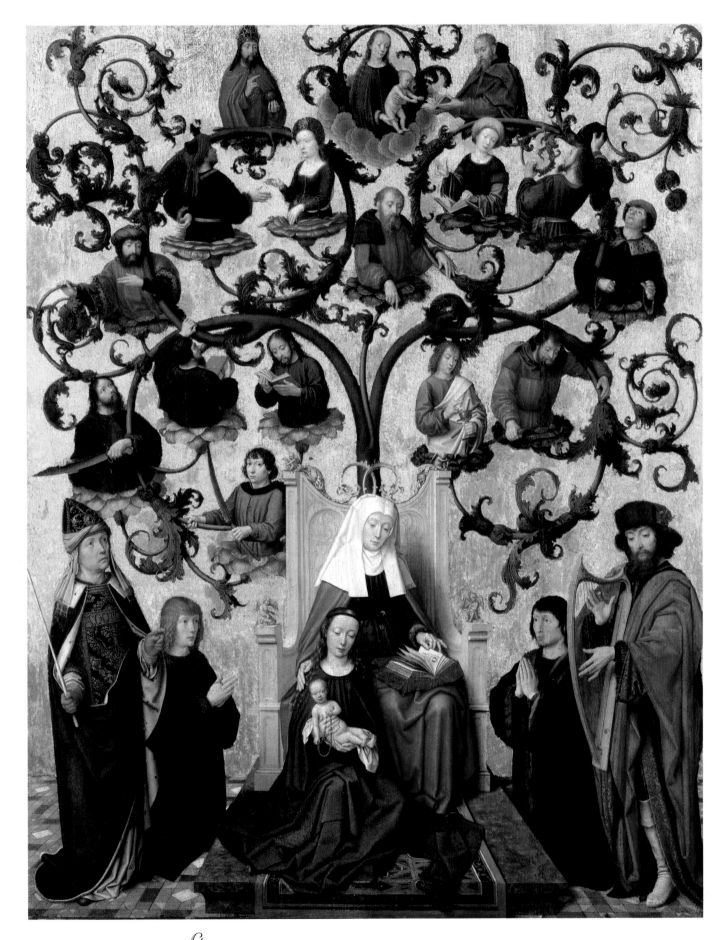

GERARD DAVID (c. 1460–1523). *The Lineage of Saint Anne*, after 1483.
Oil on wood, 34⅝ x 27⅜ in. (88 x 69.5 cm). Musée des Beaux-Arts, Lyons, France.

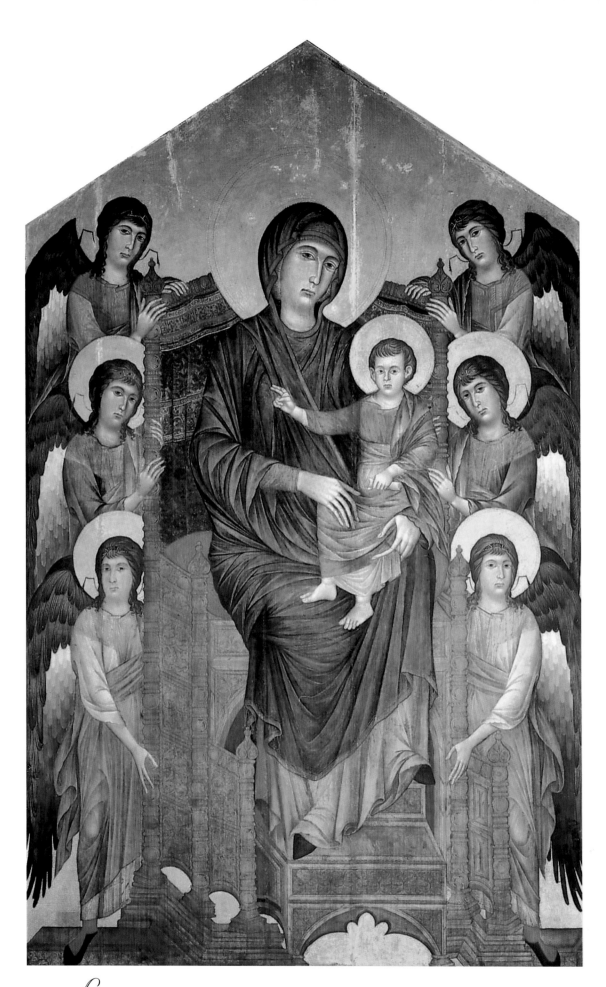

CIMABUE (c. 1240–after 1302). *Madonna and Child in Majesty Surrounded by Angels*, c. 1270(?). Unknown medium on wood, 14 ft. x 9 ft. 2¾ in. (4.27 x 2.8 m). Musée du Louvre, Paris.

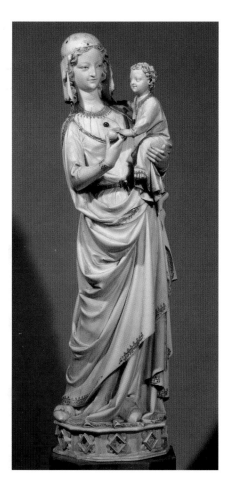

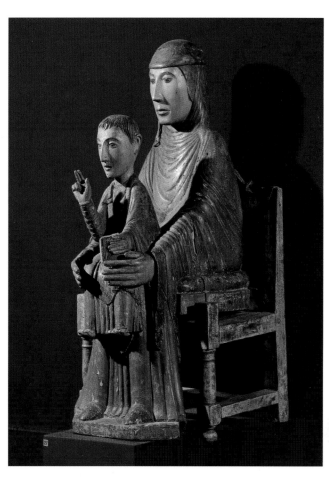

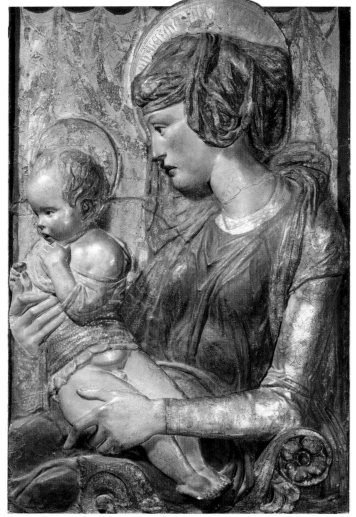

Virgin and Child.
French, 1250–60.
Ivory, height: 16⅛ in. (41 cm).
Musée du Louvre, Paris.

Notre Dame de Turlande.
French, 12th century. Painted
wood, height: 27½ in. (70 cm).
Eglise Saint Saturnin,
Paulhenc, France.

Donatello (1386–1466).
Virgin and Child, 1440.
Polychrome terra-cotta,
40¼ x 29½ x 4⅝ in.
(102 x 75 x 12 cm).
Musée du Louvre, Paris.

But Mary kept all these things, and pondered them in her heart.

LUKE 2:19

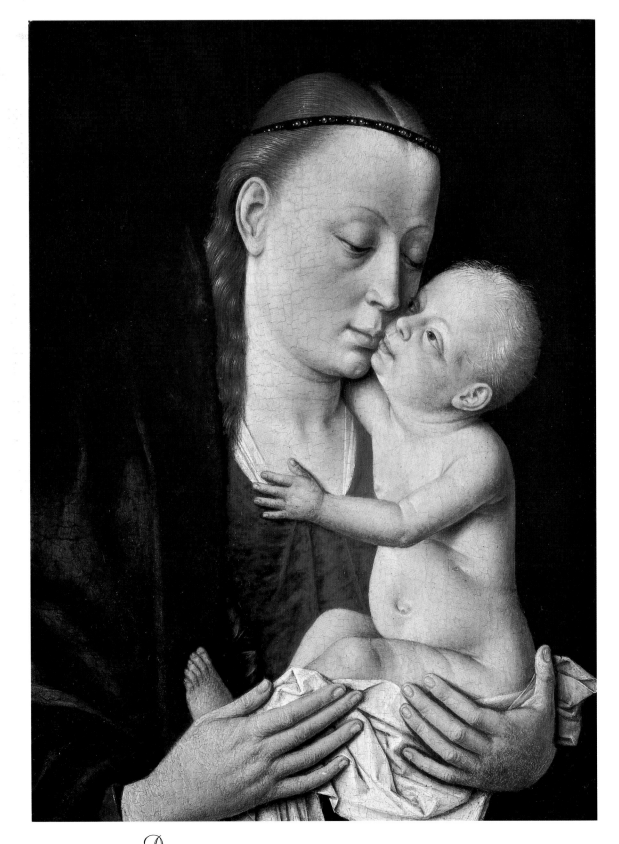

DIERIC BOUTS (1410/20–1475). *Madonna and Child*, late 15th century.
Oil on wood, 8⅛ x 6⅛ in. (20.8 x 15.5 cm). Bargello, Florence.

THE HOLY FAMILY

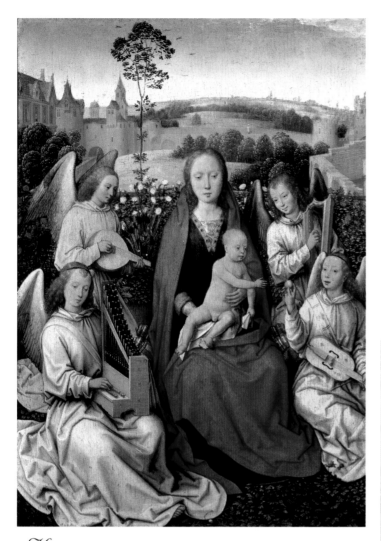

HANS MEMLING (c. 1430/40–1494). *Mary in the Rose Bower*, c. 1480.
Oil on oak, 17 x 12¼ in. (43.3 x 31 cm). Alte Pinakothek, Munich.

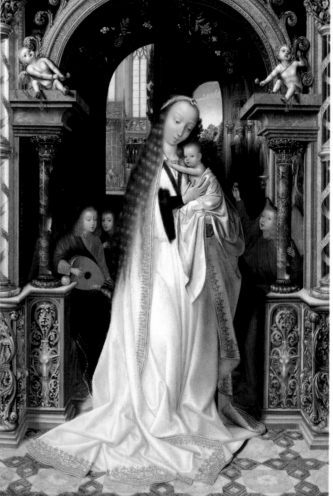

QUENTIN MASSYS (c. 1466–1530).
Virgin and Child Surrounded by Angels, n.d. Oil on wood, 21⅜ x 14¾ in.
(54.5 x 37.5 cm). Musée des Beaux-Arts, Lyons, France.

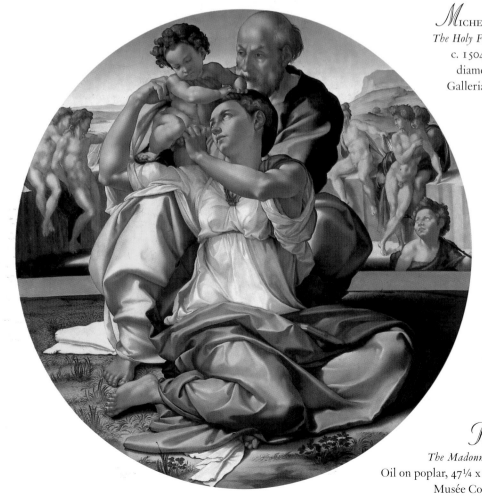

SANDRO BOTTICELLI
(1445–1510). *Madonna of the
Magnificat*, c. 1482. Tempera on wood,
diameter: 46⅜ in. (118 cm).
Galleria degli Uffizi, Florence.

MICHELANGELO (1475–1564).
The Holy Family (The Doni Tondo),
c. 1504–6. Tempera on wood,
diameter: 47¼ in. (120 cm).
Galleria degli Uffizi, Florence.

OPPOSITE
RAPHAEL (1483–1520).
The Madonna di Loreto, c. 1509–10.
Oil on poplar, 47¼ x 35⅜ in. (120 x 90 cm).
Musée Condé, Chantilly, France.

THE HOLY FAMILY

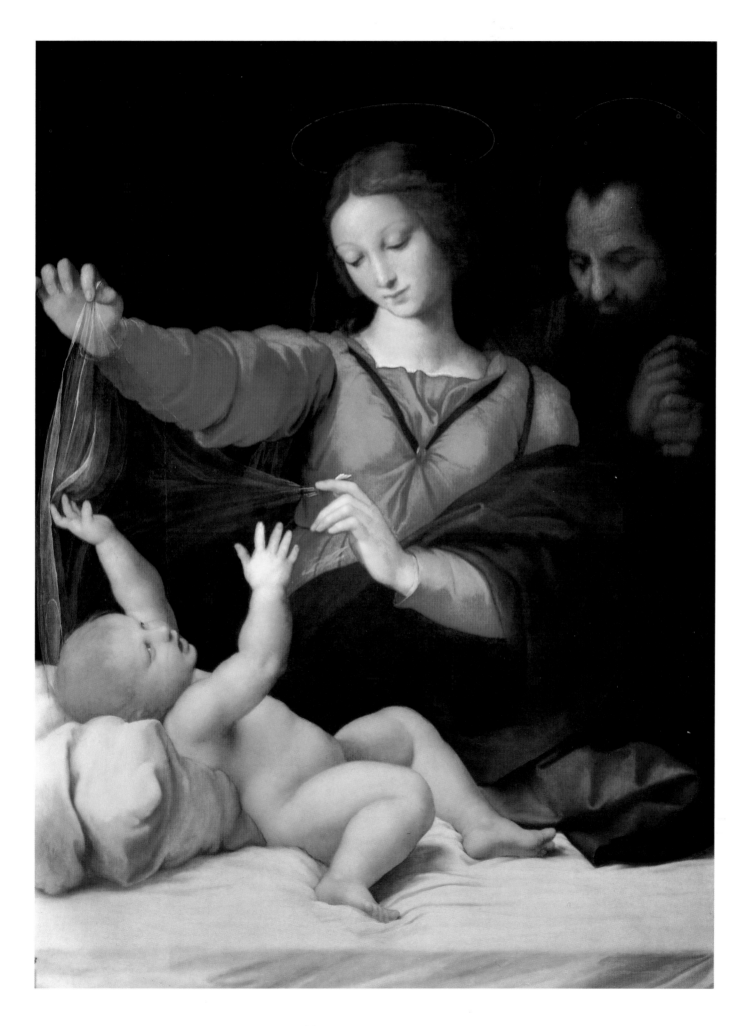

THE HOLY FAMILY

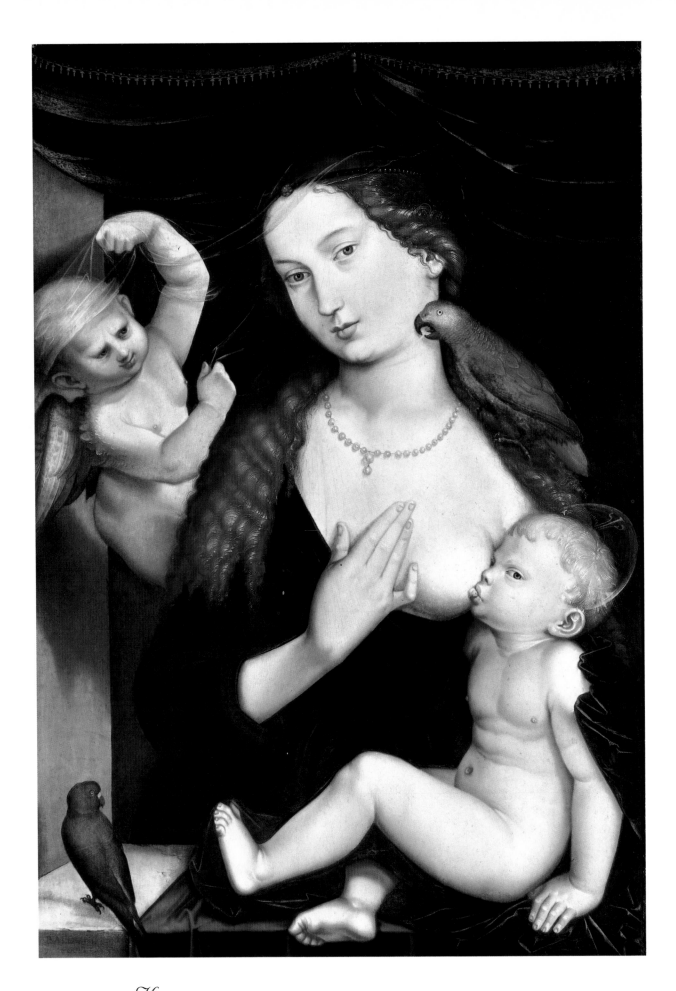

Hans Baldung Grien (1484/85–1545). *Madonna and Child with Parrot*, 1525 or 1527.
Oil on wood, 36 x 24¾ in. (91.5 x 63.2 cm). Germanisches Nationalmuseum, Nuremberg, Germany.

THE HOLY FAMILY

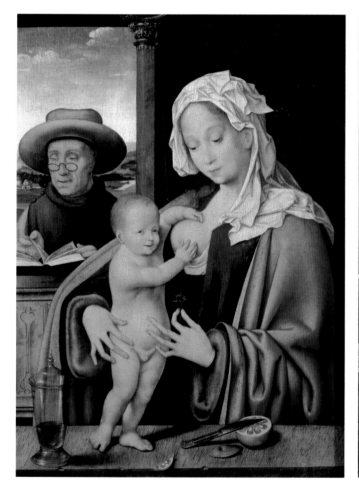

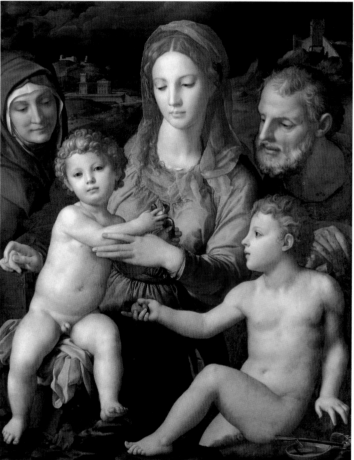

JOOS VAN CLEVE (c. 1485–1540/41). *The Holy Family*, c. 1525–30.
Tempera on oak, 20¾ x 15⅝ in. (53 x 40 cm).
Akademie der Bildenden Künste, Vienna.

AGNOLO BRONZINO (1503–1572). *The Holy Family*, c. 1550.
Oil on wood, 49 x 39⅛ in. (125 x 99.5 cm).
Kunsthistorisches Museum, Vienna.

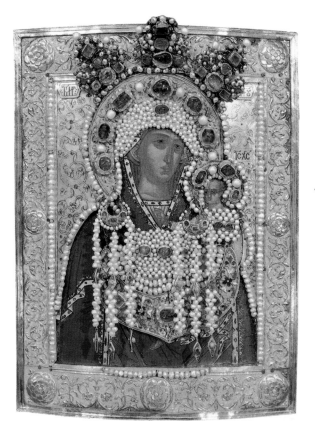

Madonna and Child.
Russian icon, c. 1580. Silver
with gilding, encrusted with
pearls and precious stones,
13⅞ x 10¾ in. (35.5 x 27.5 cm).
Residenz Museum, Munich.

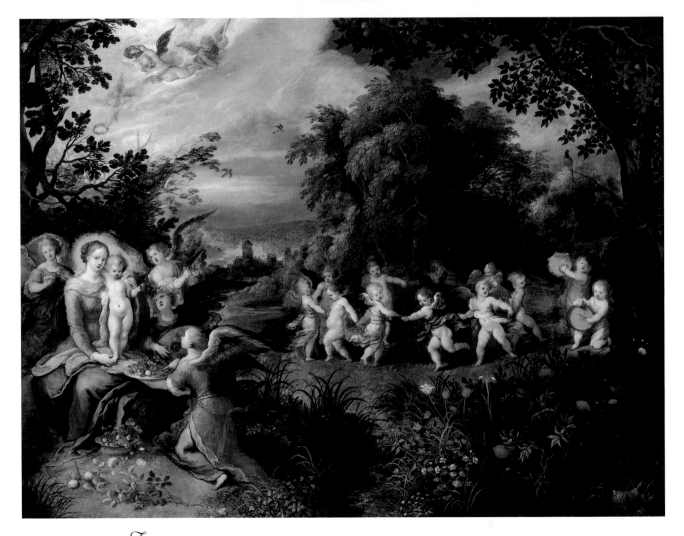

Frans Francken the Younger (1581–1642) and Abraham Govaerts (1589–1626).
Madonna and Child in a Landscape, Surrounded by Angels Making Music and Dancing, n.d. Oil on copper,
19¾ x 25⅝ in. (50.3 x 65.3 cm). Musée des Beaux-Arts, Lyons, France.

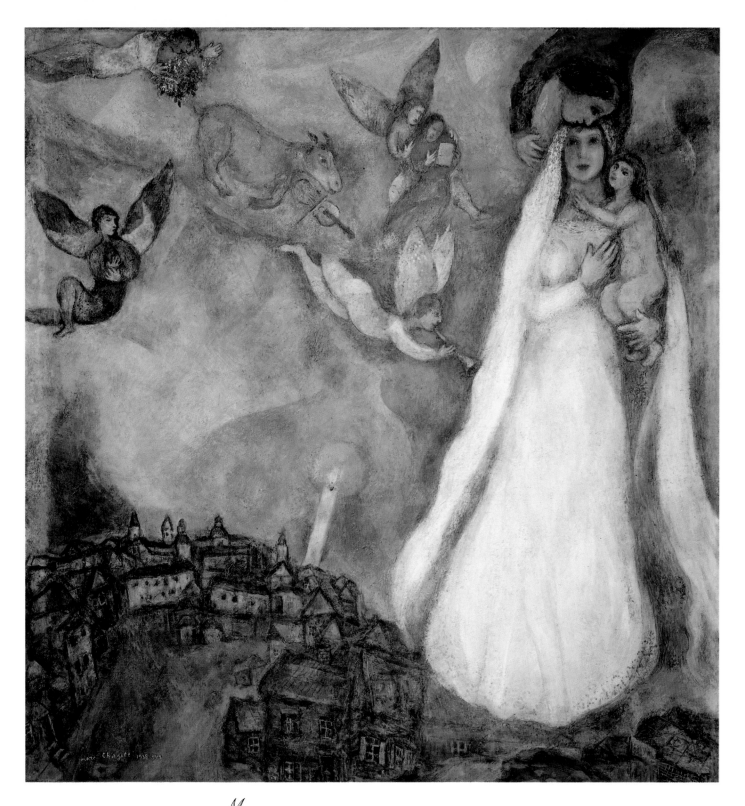

Marc Chagall (1887–1985). *Madonna of the Village*, 1938–42.
Oil on canvas, 40⅛ x 38½ in. (102 x 98 cm). Thyssen-Bornemisza Collection, Lugano, Switzerland.

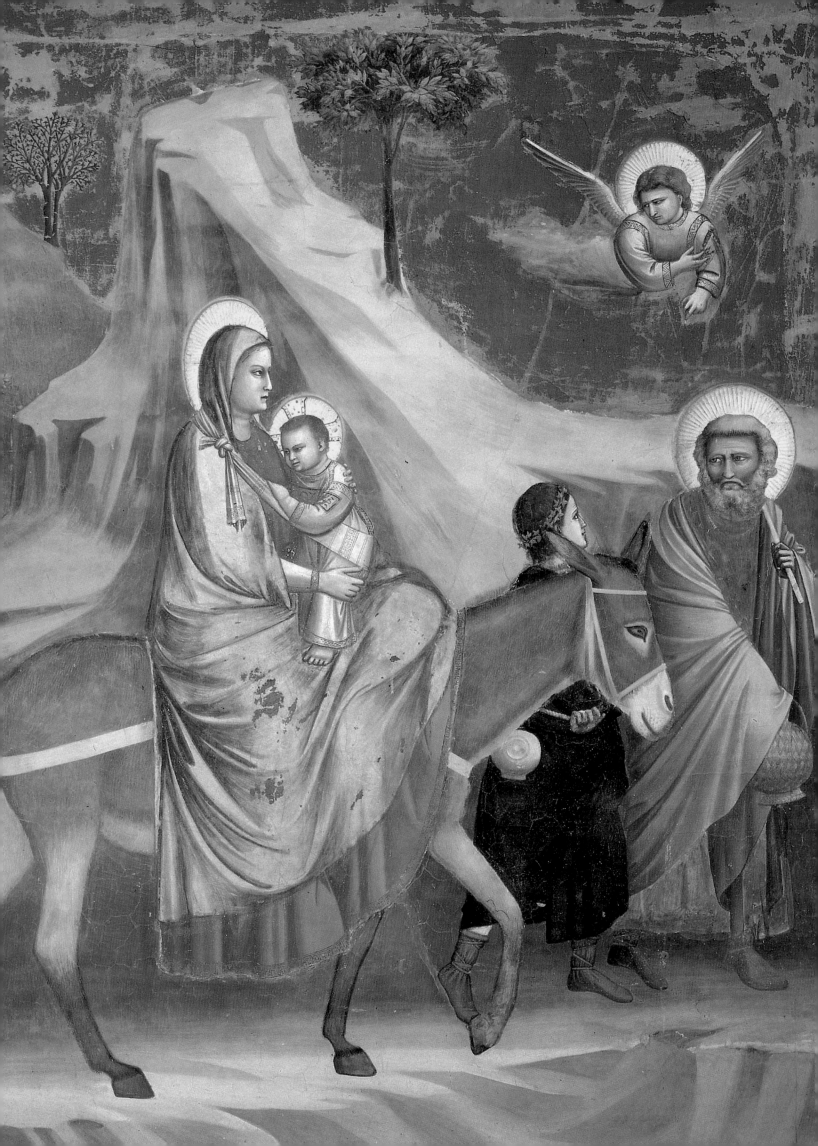

CHILDHOOD

And the child grew, and waxed strong in spirit, filled with wisdom:
and the grace of God was upon him.

Luke 2:40

*I*n contrast to the wealth of nativity scenes in Western art, depictions of Christ as a child are comparatively rare. Those that do exist focus on just a few subjects, including the circumcision, the presentation in the temple, the flight into Egypt, and Christ among the doctors. This limited repertoire reflects the content of the four gospels, which have little to say about the young Jesus. But believers were hungry for more details about his youth, and nonscriptural sources filled in some of the gaps with stories of Christ's childhood. The *Proto-Evangelium of James*, for example, tells some unlikely tales of an impetuous young Jesus, such as his striking dead a playmate who bumped into him as they were running. (No doubt this is why the book was never accepted into the holy canon.) Rarely were such apocryphal childhood scenes portrayed by artists.

Modern viewers may be surprised by the depiction of the circumcision as a sacred event, but for medieval and Renaissance audiences, this moment in the young Christ's life had profound significance. The traditional Jewish ceremony, performed eight days after Christ's birth, was also the occasion when he was given the name Jesus. As the first time that Christ's blood was shed and the first time that he suffered pain, the circumcision became a manifestation of his humanity, while also foreshadowing the deeper wounds he was to suffer on the cross.

The flight into Egypt—following the angel's warning Joseph in a dream to escape Herod's impending massacre of two-year-old boys—offered artists an opportunity to show the elderly Joseph as a guide and protector to his family (opposite). It is one of the few subjects from Christ's life in which Joseph is a central participant. In the Limbourg brothers' *Rest on the Flight into Egypt* (page 53), the artists shifted attention to the palm tree that, according to holy legend, gave its fruit to sustain the Holy Family on

*G*IOTTO (1266/67–1337). *The Flight into Egypt*, after 1305. Fresco, 78⅝ x 68¾ in. (200 x 185 cm). Scrovegni Chapel, Padua, Italy.

their journey; its fronds foreshadow the palm-strewn path of Christ's later triumphal entry into Jerusalem, again on the back of a donkey.

Joseph appears, too, in images of Christ in the carpenter's shop—notably, in John Everett Millais's precisely detailed interior (page 55). That picture exemplifies the impassioned interest of certain nineteenth-century artists in rendering religious subjects with painstakingly researched historical accuracy; several artists took prolonged trips to the Holy Land to study the local landscape and architecture and thus assure the documentary validity of their work.

*N*ICHOLAS OF VERDUN (c. 1150–1205). *The Circumcision*, from the *Verdun Altar*, begun 1181.
Champlevé enamel on gilded copper, height: 15 ft. 1⅛ in. (4.6 m), overall.
Sammlungen des Stiftes, Klosterneuburg, Austria.

The Flight into Egypt, from *Miniatures of the Life of Christ*, French, c. 1200. 13⅜ x 8⅝ in. (34 x 22.2 cm). The Pierpont Morgan Library, New York.

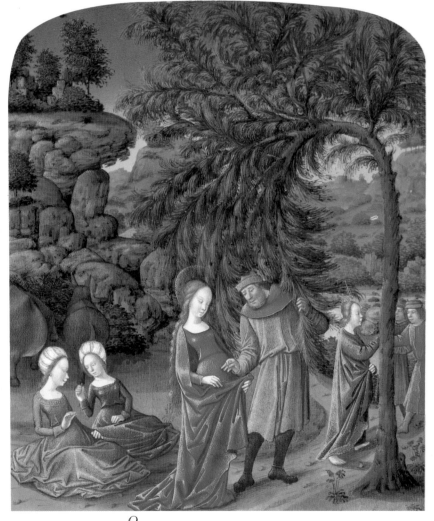

LIMBOURG BROTHERS (15th century).
Rest on the Flight into Egypt, from *Les Très Riches Heures du Duc de Berry*, c. 1413. Musée Condé, Chantilly, France.

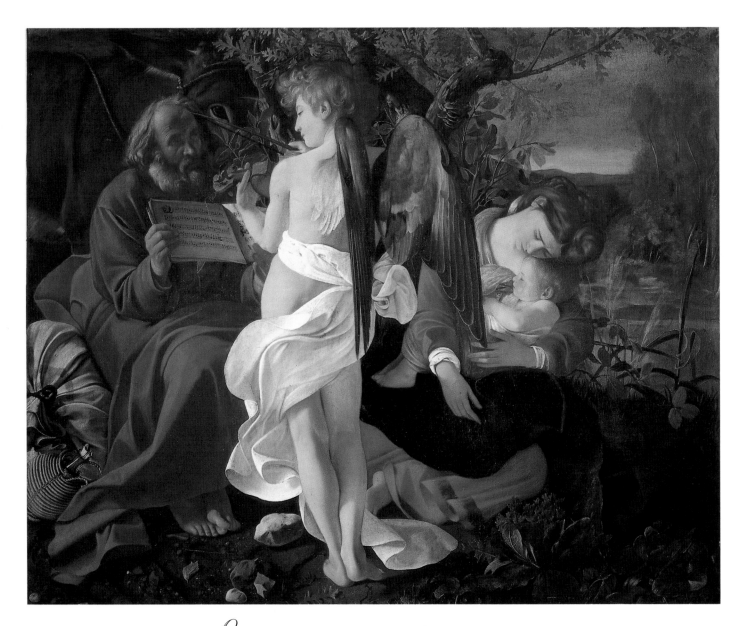

CARAVAGGIO (1573–1610). *Rest on the Flight to Egypt*, 1594–96.
Oil on canvas, 51⅛ x 62⅞ in. (130 x 160 cm). Galleria Doria-Pamphilj, Rome.

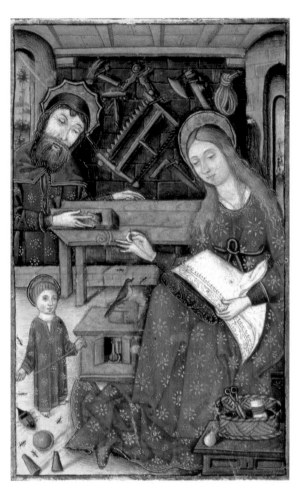

 The Holy Family in Joseph's Carpentry Shop. From a Spanish manuscript, 2d half of 15th century. The British Library, London.

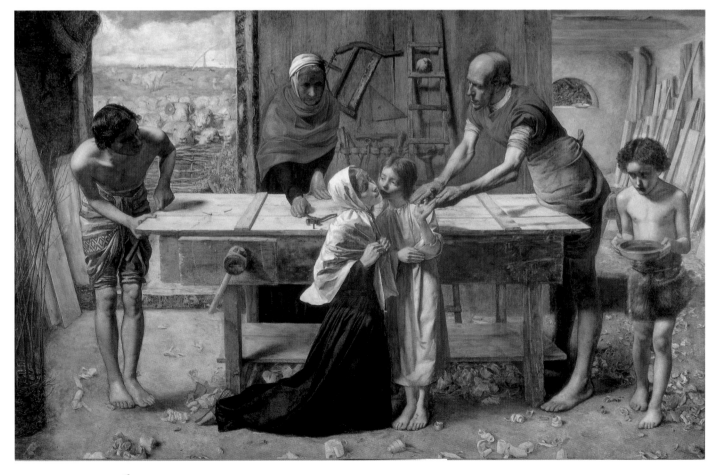

JOHN EVERETT MILLAIS (1829–1896). *Christ in the House of His Parents (The Carpenter's Shop),* 1849–50. Oil on canvas, 34 x 55 in. (86.4 x 139.7 cm). The Tate Gallery, London.

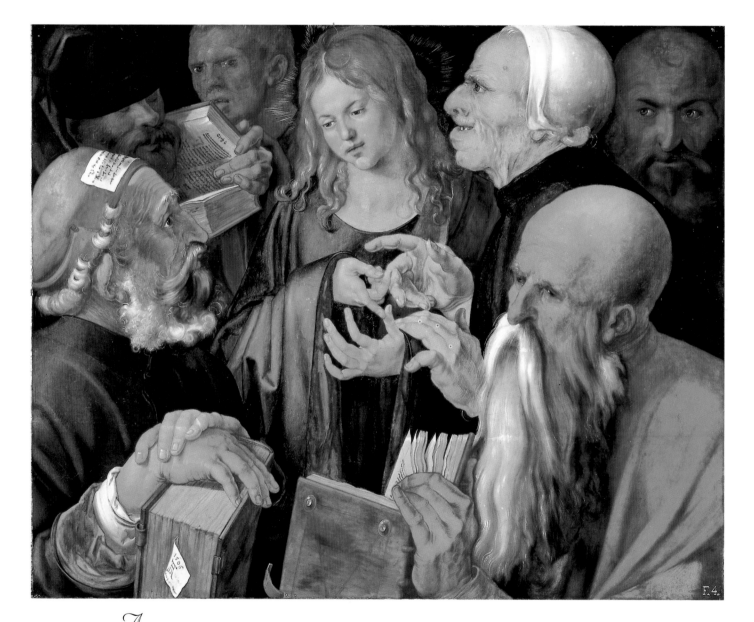

*A*LBRECHT DÜRER (1471–1528). *Christ among the Doctors*, 1506. Oil on wood, 25½ x 31⅜ in. (65 x 80 cm).
Thyssen-Bornemisza Museum, Madrid.

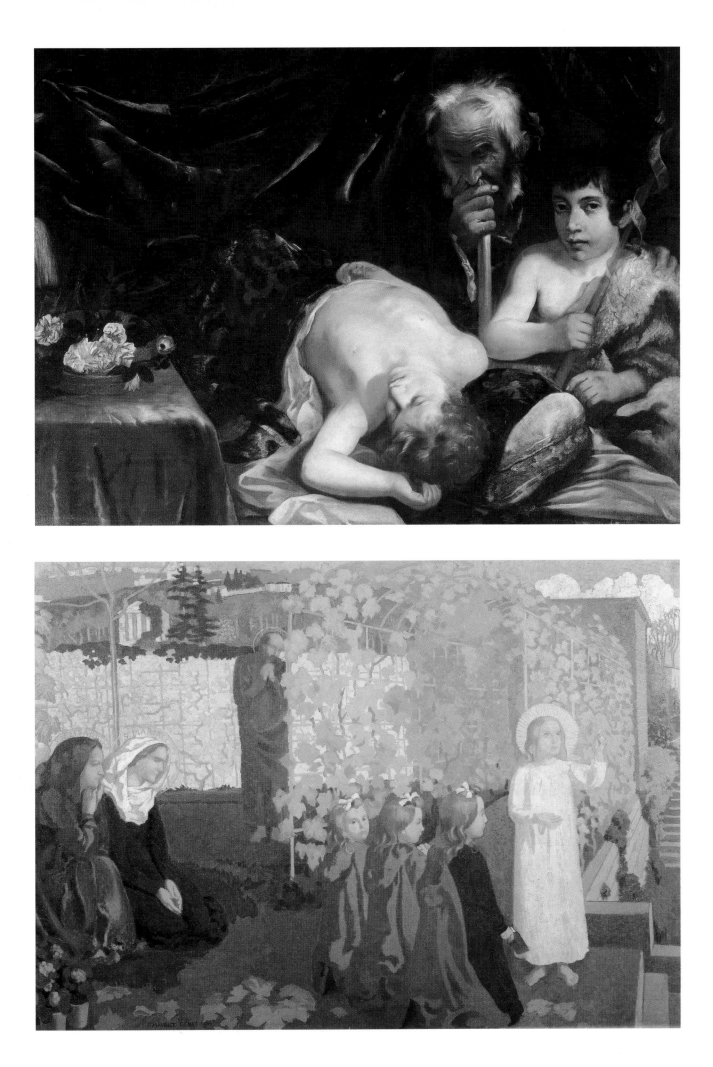

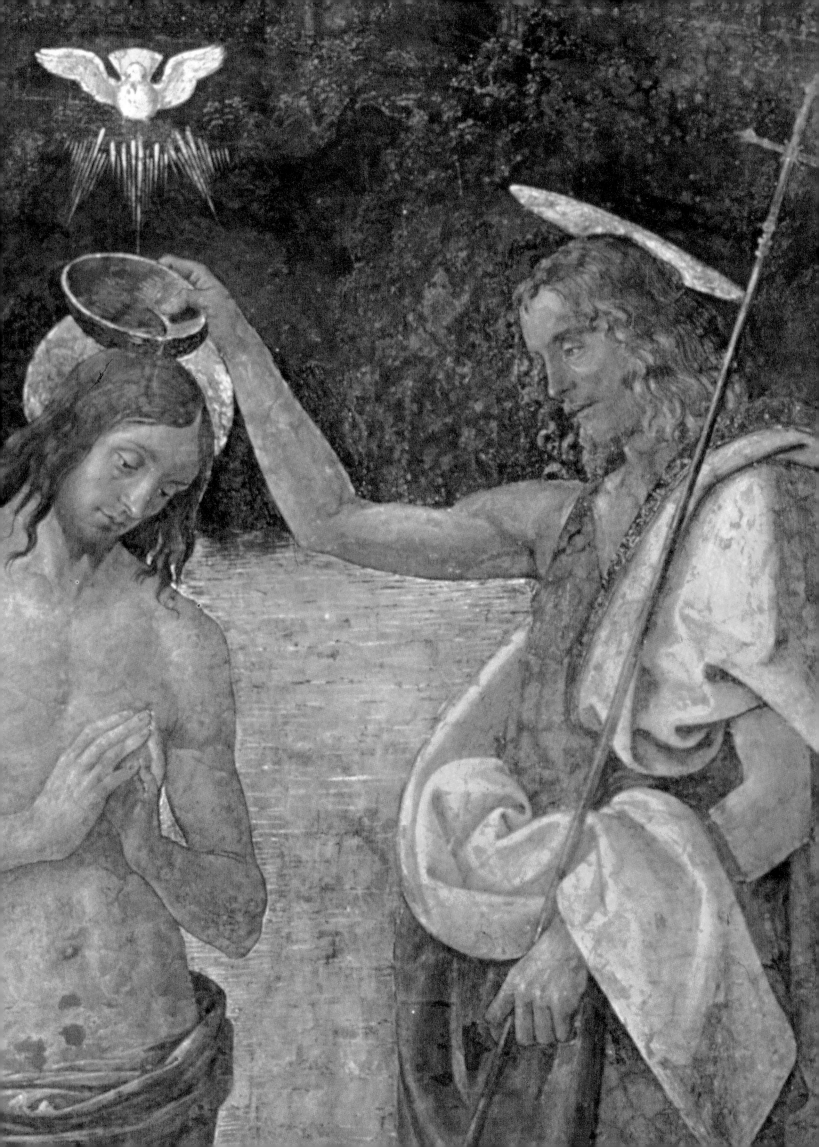

MILESTONES AND MIRACLES

And Jesus, when he was baptized, went up straightway out of the water: and, lo, the heavens were opened unto him, and he saw the Spirit of God descending like a dove, and lighting upon him: And lo a voice from heaven, saying, This is my beloved Son, in whom I am well pleased.

MATTHEW 3:16-17

Christ's baptism signaled his adulthood and the start of his public ministry. Even more important, it was one of the epiphanies of his life—a moment when his identity as God was made evident to the world. The significance of baptism not only in Christ's life but also as a pivotal rite in the lives of his followers meant that it was much represented by artists. Early versions were generally simplified to the three scriptural participants: Jesus, Saint John the Baptist, and God the Father; the Jordan River might be represented by a few opaque ripples modestly covering the lower part of Christ's body (page 60). His nudity symbolizes his washing away of humanity's sin, which eliminated the need for the fig leaves worn in shame by Adam and Eve. Later, particularly in Renaissance and Baroque painting, the baptism might be witnessed by a throng of worshipers; in Giovanni Battista Tiepolo's elaborate image (page 62), an angel stands nearby, ready to offer a towel to Jesus as he emerges from the river.

Another epiphany was Christ's first miracle, the changing of water to wine at the wedding feast in Cana, and this too was frequently depicted. Other miracles, such as his many cures and exorcisms, were less favored by artists, except in painting cycles documenting the entire life of Christ. Most often painted of all the miracles is his raising of Lazarus from the dead, a miracle that resonates with one of the central beliefs of the Church—the bodily resurrection of Christ after his crucifixion and that of all humanity at Judgment Day. The central characters in this scene are Jesus, Lazarus, and the dead man's sisters Martha and Mary, but artists often added a cluster of witnesses, including at least one who recoils from the newly opened tomb and covers her nose to block out the stench of death.

Of all the biblical scenes of Christ with his disciples—the calling of the apostles, Christ's calming of the seas, his multiplication of the loaves and fishes—none was more

PERUGINO (1445/50–1523). Detail of *The Baptism of Christ*, c. 1482. Fresco, 11 ft. x 17 ft. 8½ in. (3.35 x 5.4 m), overall. Vatican Palace, Vatican City.

consistently popular with artists than the Last Supper. No doubt the most famous version is Leonardo da Vinci's much-restored wall painting (page 84), but the poignancy and intrigue of the final gathering of Christ with all his apostles—one of whom would soon betray him—was effectively captured by artists ranging from Dieric Bouts to Salvador Dalí (pages 83 and 85).

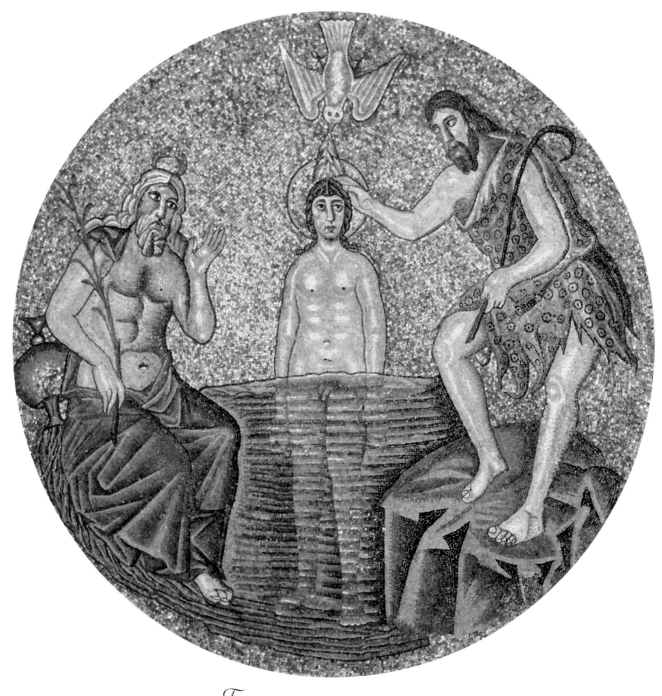

The Baptism of Christ. Byzantine mosaic, c. 520.
Baptistery of Arians, Ravenna, Italy.

MILESTONES AND MIRACLES

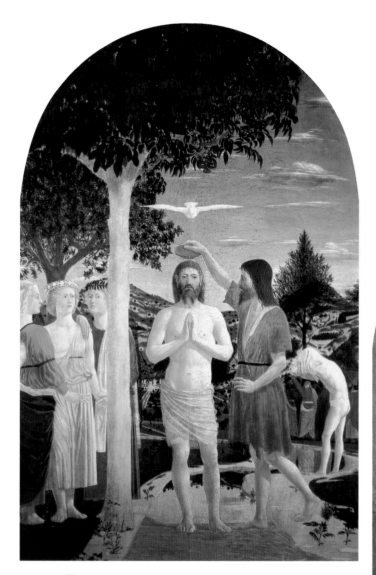

\mathcal{P}IERO DELLA FRANCESCA (active 1439–died 1492).
The Baptism of Christ, 1450s. Tempera on poplar, 65¾ x 45¾ in.
(167 x 116 cm). National Gallery, London.

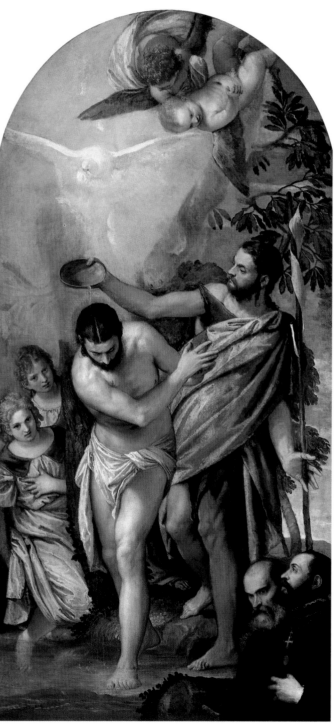

\mathcal{P}AOLO VERONESE (1528–1588).
The Baptism of Christ, c. 1561. Oil on canvas, 80⅜ x 40⅛ in.
(204 x 102 cm). Sacristy Giudecca, Il Redentore, Venice.

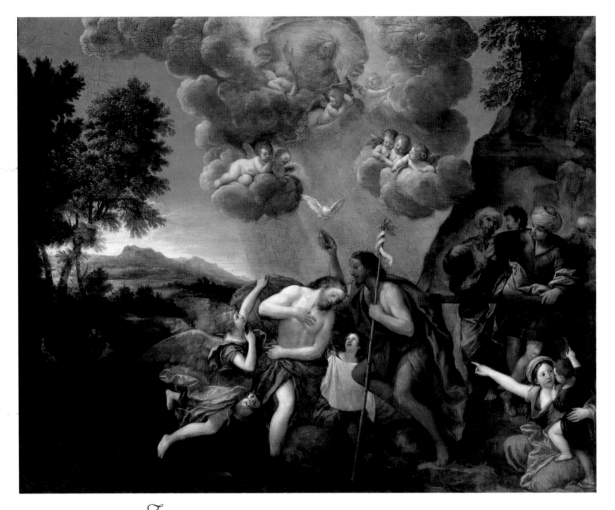

\mathcal{F}RANCESCO ALBANI (1575–1660). *The Baptism of Christ*, c. 1630–35.
Oil on canvas, 30⅜ x 38½ in. (77 x 98 cm). Musée des Beaux-Arts, Lyons, France.

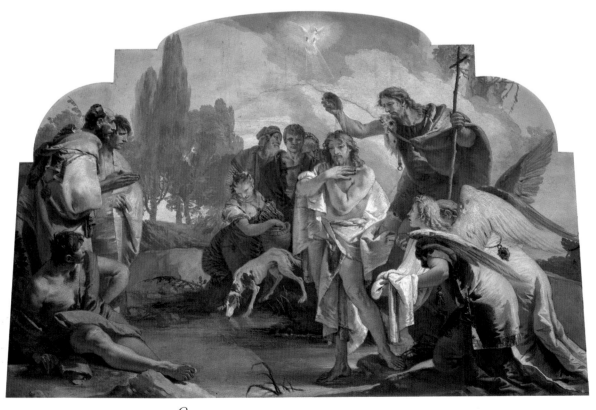

\mathcal{G}IOVANNI BATTISTA TIEPOLO (1696–1770).
The Baptism of Christ, 1732–33. Fresco. Cappella Colleoni, Bergamo, Italy.

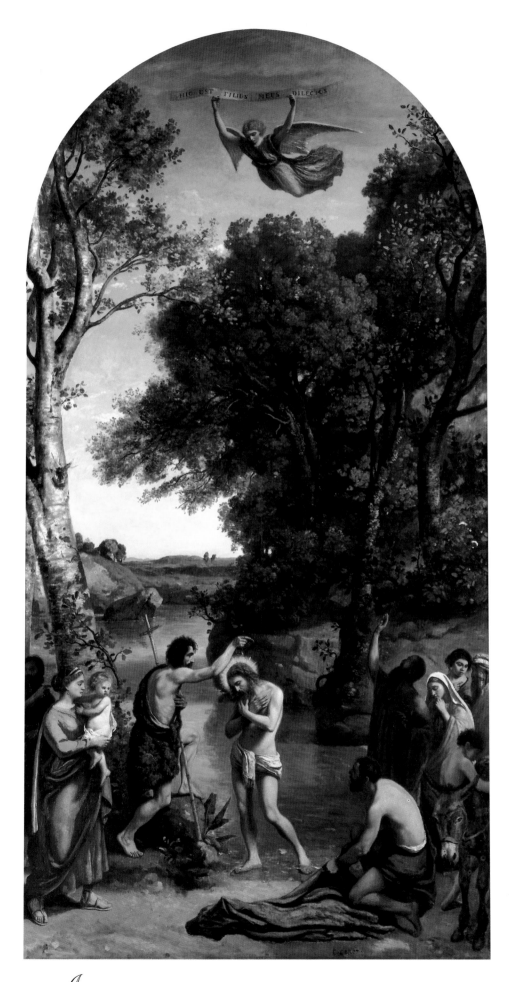

\mathcal{J}EAN-BAPTISTE-CAMILLE COROT (1796–1875). *The Baptism of Christ*, 1845–47.
Oil on canvas, 12 ft. 9½ in. x 6 ft. 10⅝ in. (3.9 x 2.1 m). Eglise Saint Nicolas du Chardonneret, Paris.

And the devil, taking him up into an high mountain, shewed unto him all the kingdoms of the world in a moment of time. And the devil said unto him, All this power will I give thee, and the glory of them: for that is delivered unto me; and to whomsoever I will I give it. If thou therefore wilt worship me, all shall be thine. And Jesus answered and said unto him, Get thee behind me, Satan: for it is written, Thou shalt worship the Lord thy God, and him only shalt thou serve.

LUKE 4:5–8

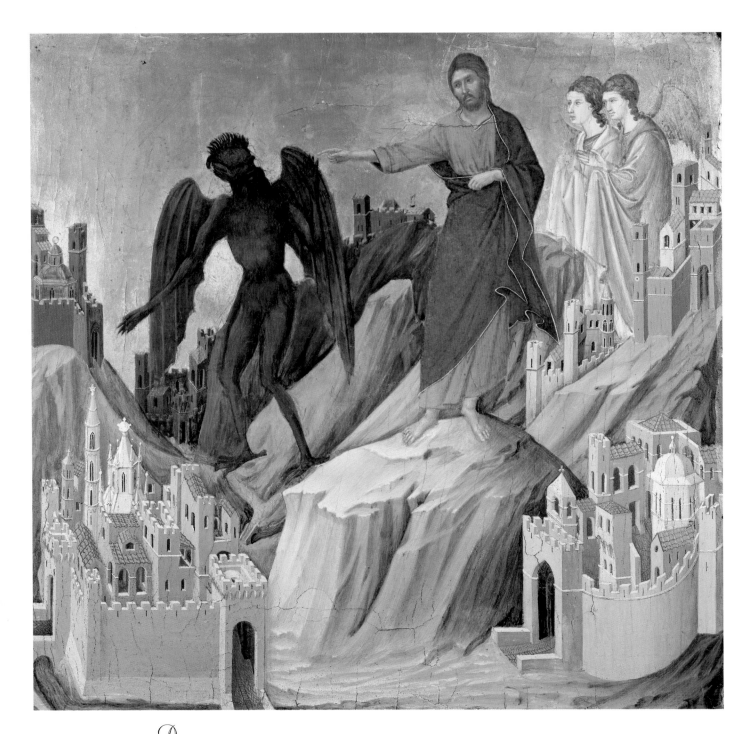

DUCCIO DI BUONINSEGNA (c. 1255–1319). *The Temptation of Christ on the Mountain*, c. 1308.
Tempera on wood, 17 x 18⅛ in. (43.2 x 46 cm). The Frick Collection, New York.

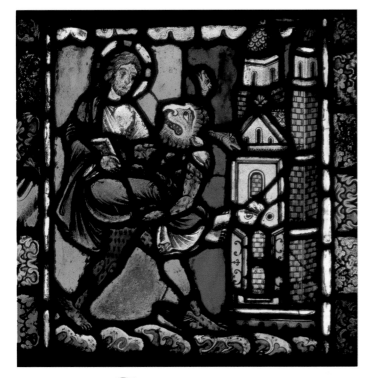

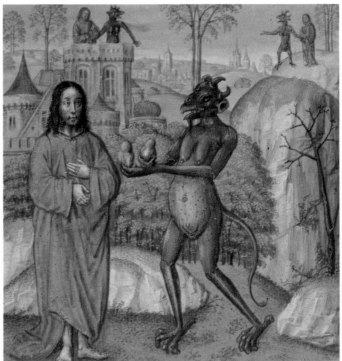

The Temptation in the Wilderness.
French, 13th century. Stained glass.
Victoria and Albert Museum, London.

The Temptation of Christ, from *The Mirror of Human Salvation,*
Flemish, 15th century. Musée Condé, Chantilly, France.

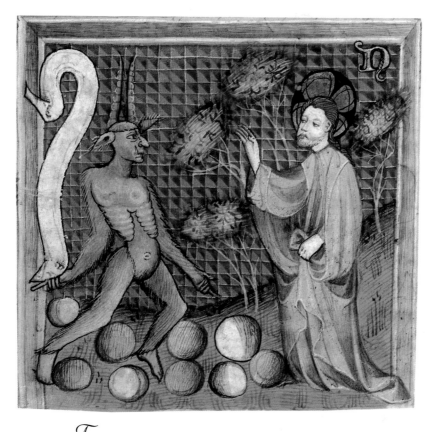

The Temptation of Christ in the Desert, from *The Life of Christ,*
German, 15th century. Musée Condé, Chantilly, France.

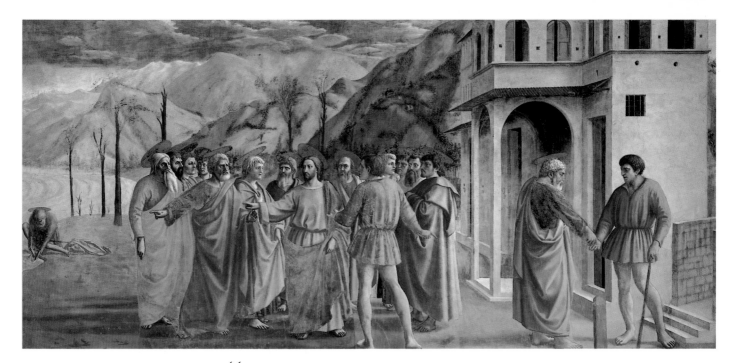

\mathcal{M}ASACCIO (1401–probably 1428). *The Tribute Money*, 1425–27.
Fresco, 8 ft. 4⅛ in. x 19 ft. 7½ in. (2.55 x 5.98 m). Brancacci Chapel, Santa Maria del Carmine, Florence.

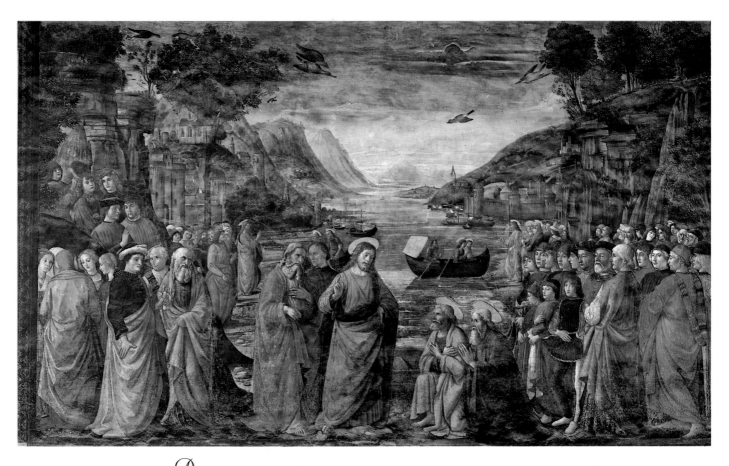

\mathcal{D}OMENICO GHIRLANDAIO (1449–1494). *The Calling of the First Apostles*, 1481.
Fresco. Sistine Chapel, Vatican Palace, Vatican City.

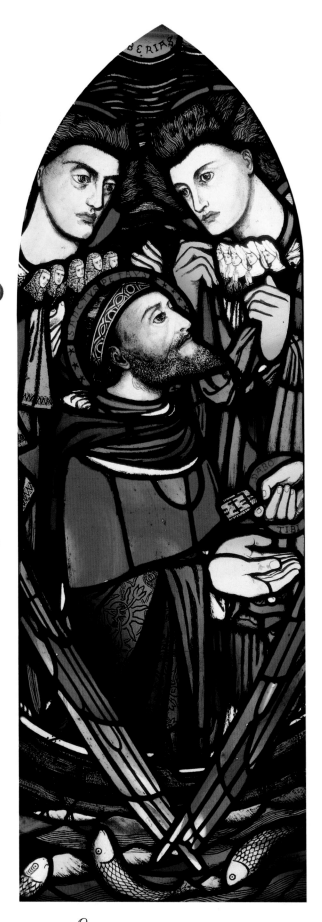

Initial E with Christ Sending out the Apostles,
from an Italian antiphonary, 3d quarter of 15th century.
The Pierpont Morgan Library, New York.

*And Jesus, walking by the sea of Galilee, saw two brethren,
Simon called Peter, and Andrew his brother, casting a net into the
sea: for they were fishers. And he saith unto them, Follow me,
and I will make you fishers of men.*

MATTHEW 4:18–19

*E*DWARD BURNE-JONES (1833–1898).
The Calling of Saint Peter, 1857. Stained glass, executed by James
Powell and Sons. Victoria and Albert Museum, London.

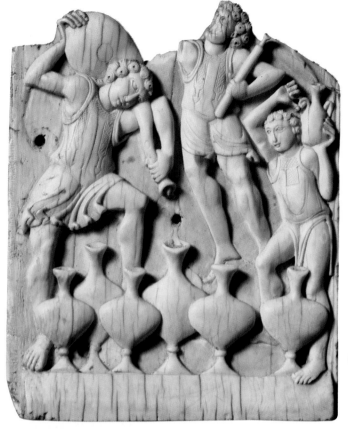

The Miracle of Cana.
South Italian, late 11th century.
Ivory, 4½ x 3 x ⅝ in.
(12 x 9.5 x 1.6 cm). Victoria and
Albert Museum, London.

OPPOSITE, TOP
LORENZO LOTTO (1480–1556).
Christ and the Adulteress, 1530–35.
Oil on canvas, 48⅜ x 61⅜ in.
(124 x 156 cm). Musée du
Louvre, Paris.

OPPOSITE, BOTTOM
JOBST HARRICH (c. 1586–1617).
The Woman Taken in Adultery, n.d.
Oil on copper, 28⅝ x 33⅛ in.
(73 x 84 cm). Musée du
Louvre, Paris.

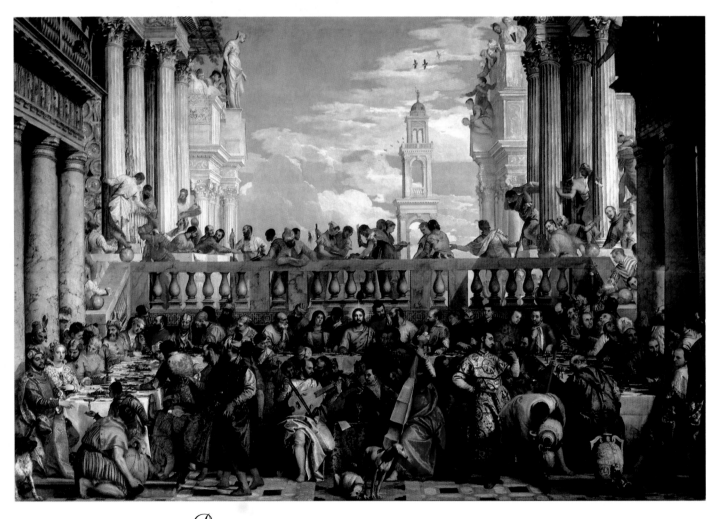

PAOLO VERONESE (1528–1588). *The Wedding Feast at Cana,* 1562–63.
Oil on canvas, 21 ft. 10¾ in. x 32 ft. 5¾ in. (6.66 x 9.9 m). Musée du Louvre, Paris.

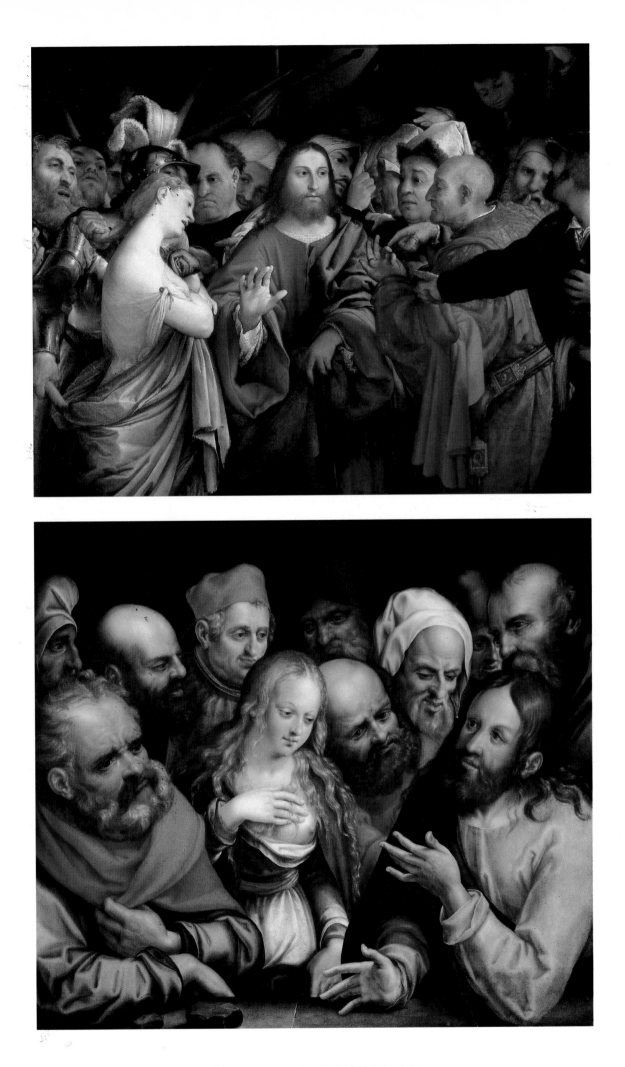

*He cried with a loud voice, Lazarus, come forth.
And he that was dead came forth, bound hand and foot with graveclothes.*

JOHN 11:43–44

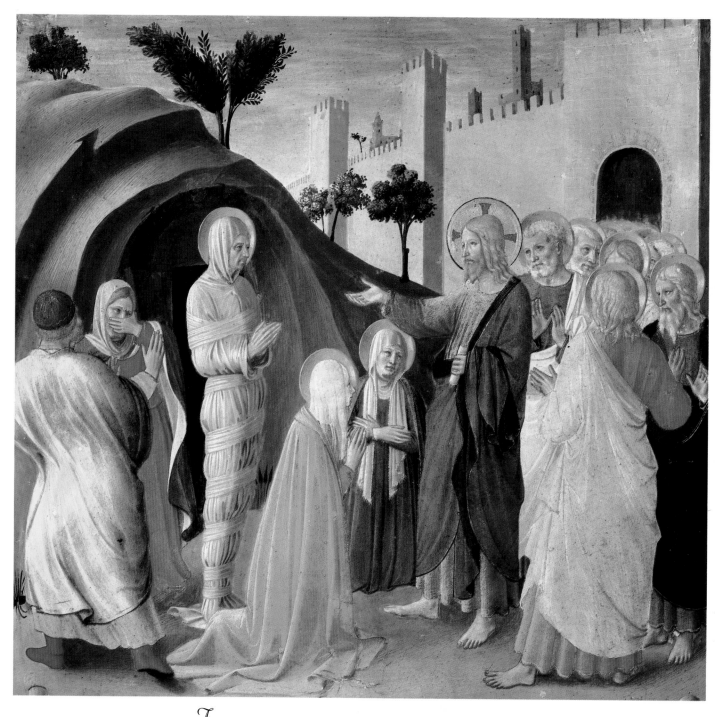

FRA ANGELICO (c. 1400–1455). *The Resurrection of Lazarus*, c. 1450.
Tempera on wood. Museo di San Marco, Florence.

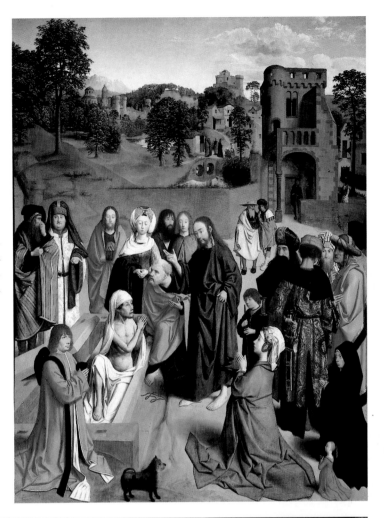

GEERTGEN TOT SINT JANS (1460/65–1488/93).
The Raising of Lazarus, 1480. Unknown medium
on wood, 50 x 38¼ in. (127 x 97 cm).
Musée du Louvre, Paris.

JACOPO TINTORETTO (1518–1594).
The Resurrection of Lazarus,
c. 1574. Private collection, Great Britain.

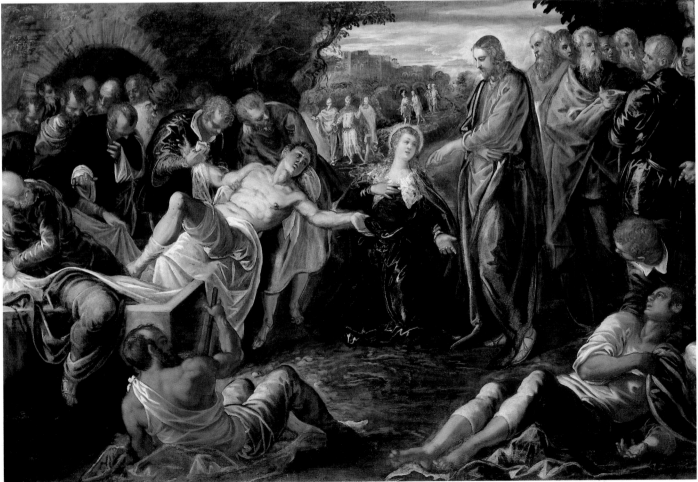

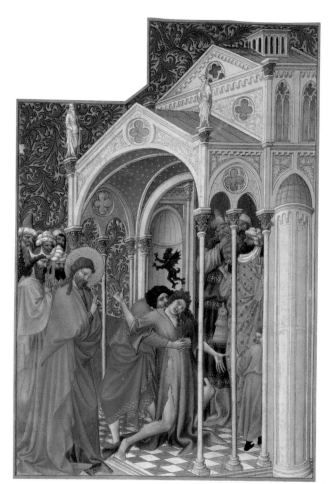

LIMBOURG BROTHERS
(15th century).
Exorcism of the Possessed, from
*Les Très Riches Heures du Duc de
Berry*, c. 1413. Musée Condé,
Chantilly, France.

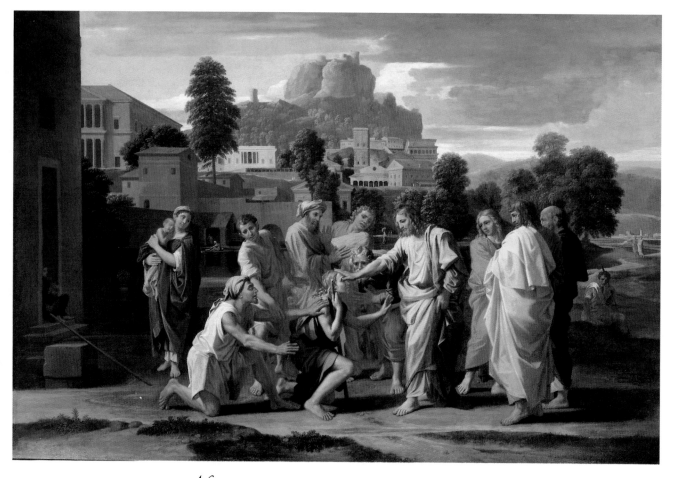

NICOLAS POUSSIN (1594–1665). *Christ Healing the Sick*, 1650.
Oil on canvas, 46¾ x 69¼ in. (119 x 176 cm). Musée du Louvre, Paris.

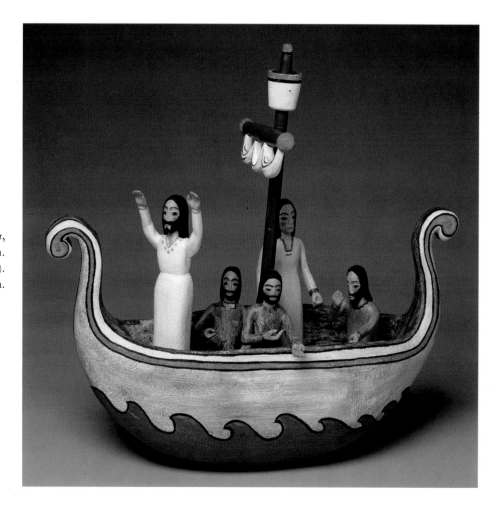

LUIS TAPIA (b. 1950). *Christ Calming the Sea*,
c. 1988. Painted wood, 20 x 21 x 9 in.
(50.8 x 53.4 x 22.8 cm).
Jorge Luis and Barbara Cervera.

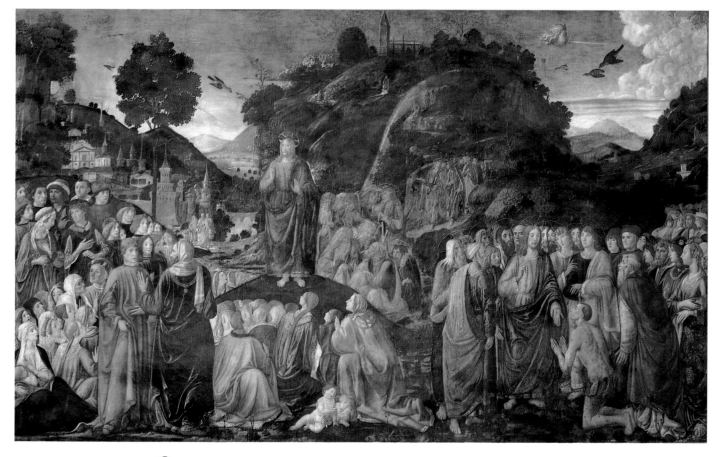

COSIMO ROSSELLI (1439–1507). *Sermon on the Mount and the Healing of the Leper*, 1481.
Fresco. Sistine Chapel, Vatican Palace, Vatican City.

And they brought young children to him, that he should touch them: and his disciples rebuked those that brought them. But when Jesus saw it, he was much displeased, and said unto them, Suffer the little children to come unto me, and forbid them not: for of such is the kingdom of God. Verily I say unto you, Whosoever shall not receive the kingdom of God as a little child, he shall not enter therein. And he took them up in his arms, put his hands upon them, and blessed them.

MARK 10:13–16

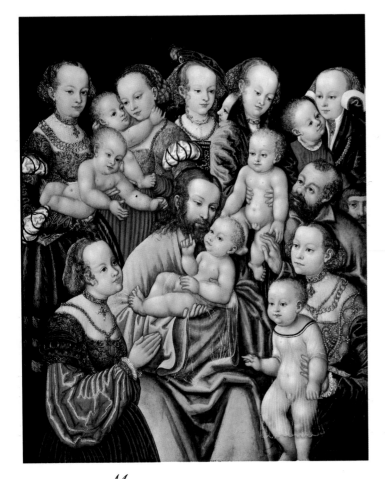

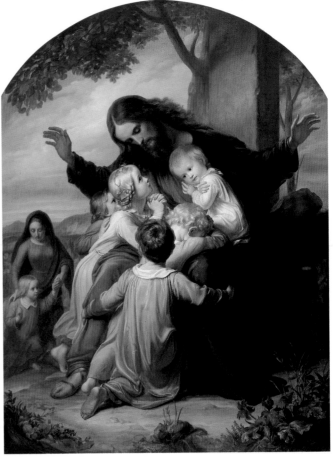

MASTER HB OF THE GRIFFIN HEAD.
Christ Blessing the Children, 1548. Unknown medium on wood,
28⅝ x 23½ in. (73 x 59.8 cm). Musée du Louvre, Paris.

Vogel von Vogelstein (n.d.).
Suffer the Little Children, n.d. Galleria d'Arte Moderna, Florence.

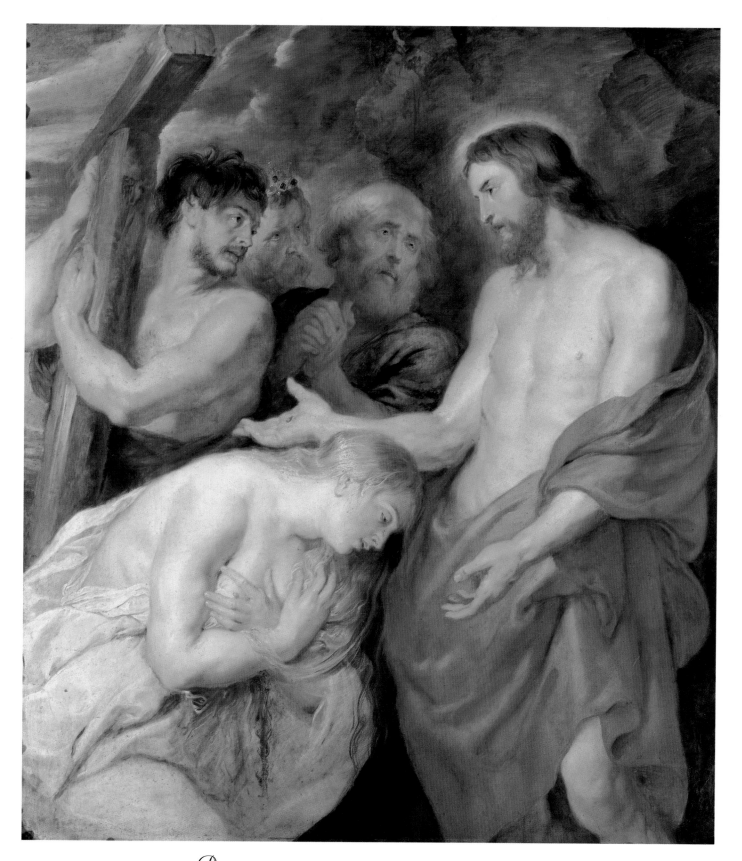

𝒫ETER PAUL RUBENS (1577–1640). *Christ and Mary Magdalene*, c. 1618.
Oil on oak, 58 x 51¼ in. (147.4 x 130.2 cm). Alte Pinakothek, Munich.

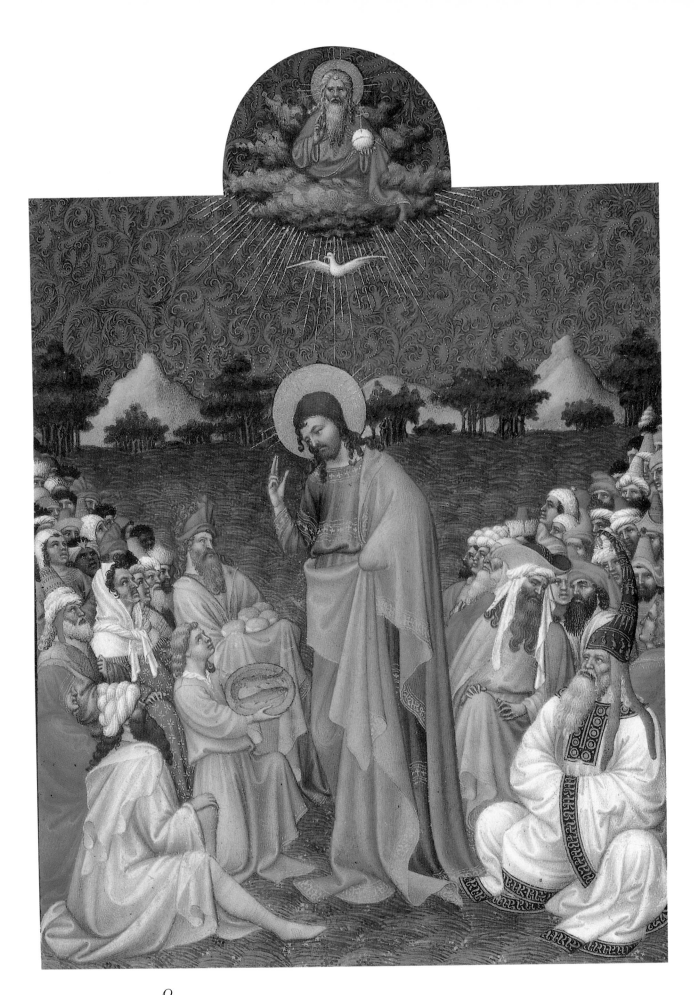

L IMBOURG BROTHERS (15th century). *The Multiplication of the Loaves and Fishes,*
from *Les Très Riches Heures du Duc de Berry,* c. 1413. Musée Condé, Chantilly, France.

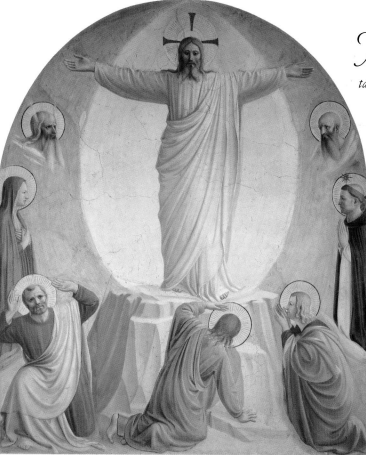

FRA ANGELICO
(c. 1400–1455)
and workshop.
The Transfiguration,
late 1430s–early 1440s.
Fresco, 74⅜ x 62½ in.
(189 x 159 cm). Monastery
of San Marco, Florence.

*And after six days Jesus
taketh Peter, James, and John
his brother, and bringeth them
up to an high mountain
apart. And was
transfigured before them:
and his face did shine as
the sun, and his raiment was
white as the light. And,
behold, there appeared unto
them Moses and Elias
talking with him.*

MATTHEW 17:1-3

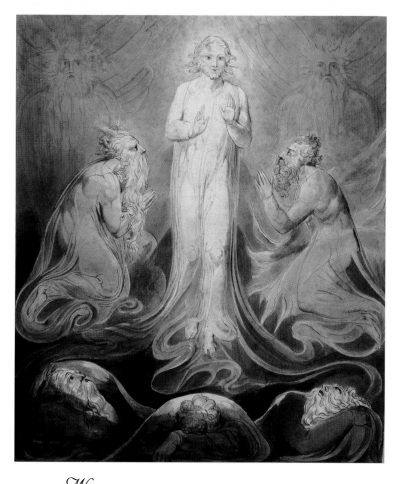

WILLIAM BLAKE (1757–1827). *The Transfiguration*, n.d.
Watercolor on paper, 14¾ x 12⅝ in. (37.7 x 32.2 cm). Victoria and Albert Museum, London.

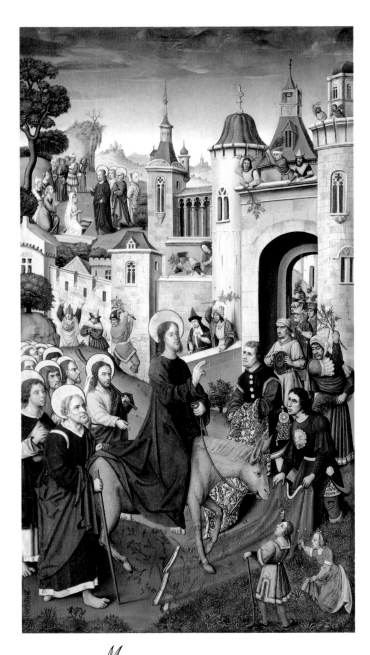

Master of the Monogram A.H.
The Entry of Christ into Jerusalem, c. 1500. Oil on wood mounted on canvas, 47⅜ x 27½ in. (120.5 x 70 cm). Musée des Beaux-Arts, Lyons, France.

Tilman Riemenschneider (c. 1460–1531).
Christ's Entry into Jerusalem, left wing of the *Holy Blood Altar*, 1501. Limewood, approximately 29 ft. 6 in. (9 m) long, overall. Saint Jacob's Church, Rothenburg ob der Tauber, Germany.

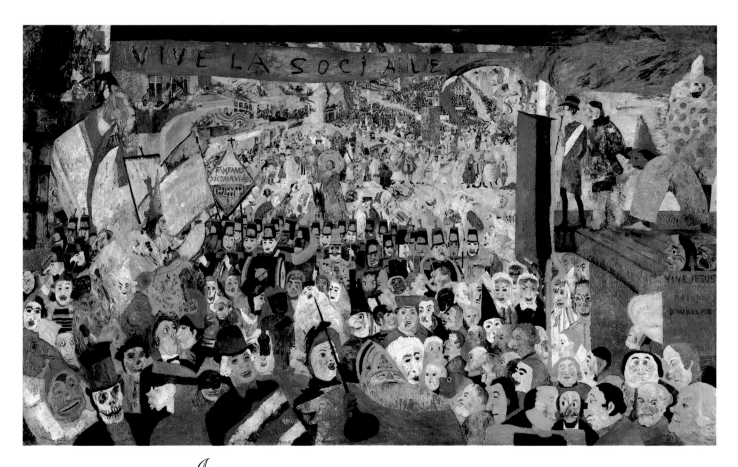

*J*AMES ENSOR (1860–1949). *The Entry of Christ into Brussels in 1889*, 1888.
Oil on canvas, 8 ft. 3½ in. x 14 ft. ½ in. (2.52 x 4.3m). J. Paul Getty Museum, Los Angeles, California.

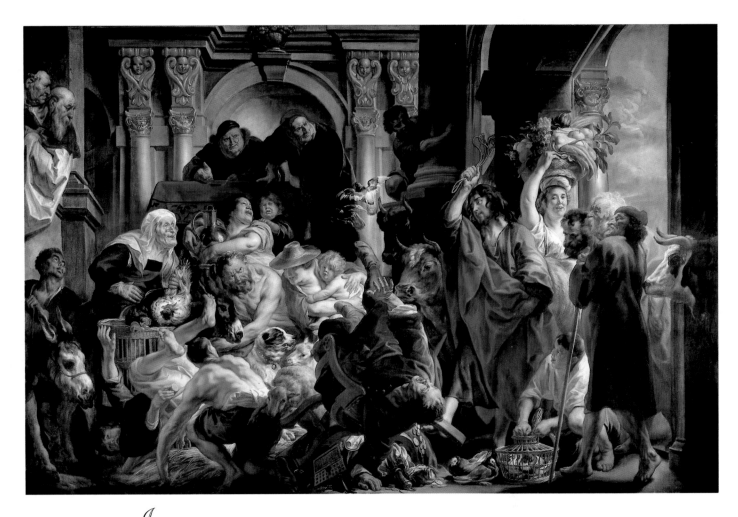

\mathcal{J}ACOB JORDAENS (1593–1678). *Christ Driving the Merchants from the Temple*, 1650. Oil on canvas,
9 ft. 5⅜ in. x 14 ft. 3⅜ in. (2.88 x 4.36 m). Musée du Louvre, Paris.

OPPOSITE
\mathcal{F}ORD MADOX BROWN (1821–1893).
Jesus Washing Peter's Feet, 1852–56.
Oil on canvas, 42⅝ x 52⅜ in. (108.2 x 133.3 cm).
The Tate Gallery, London.

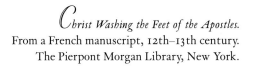
*C*hrist *Washing the Feet of the Apostles.*
From a French manuscript, 12th–13th century.
The Pierpont Morgan Library, New York.

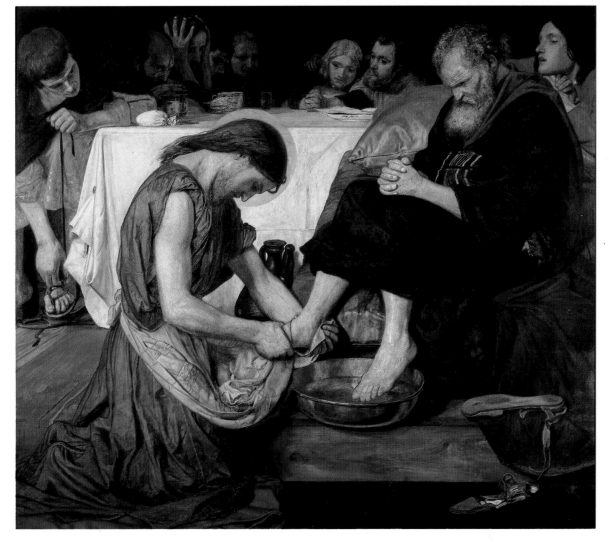

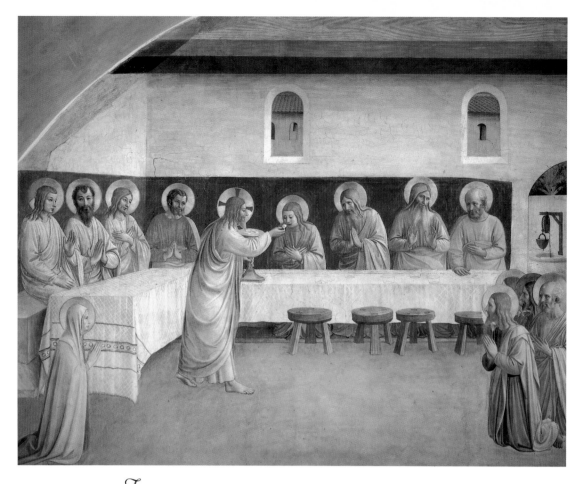

*F*RA ANGELICO (c. 1400–1455) and workshop. *The Eucharist*, 1438–45.
Fresco, 78⅝ x 97¼ in. (200 x 247 cm). Monastery of San Marco, Florence.

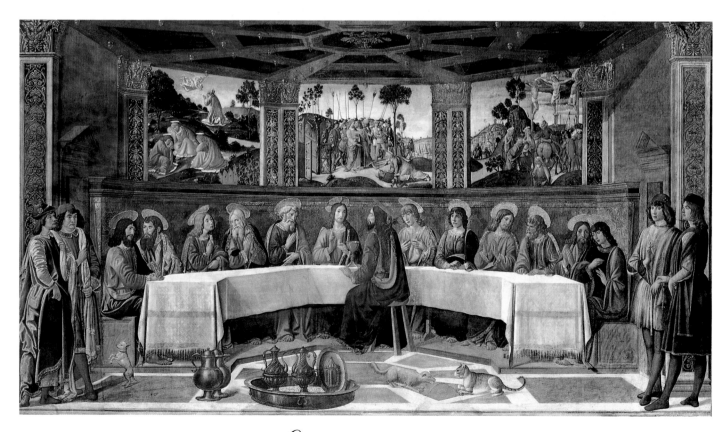

*C*OSIMO ROSSELLI (1439–1507).
The Last Supper, 1481. Fresco. Sistine Chapel, Vatican Palace, Vatican City.

And he took bread, and gave thanks, and brake it, and gave unto them, saying,
This is my body which is given for you: this do in remembrance of me.

LUKE 22:19

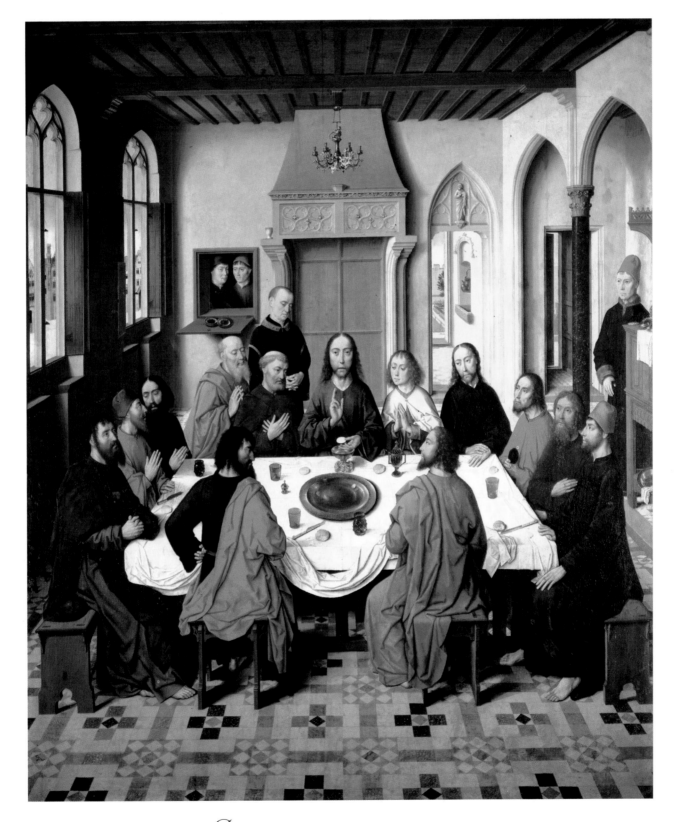

DIERIC BOUTS (1415–1475). *The Lord's Supper,* 1468.
Oil on canvas, 70¾ x 59 in. (180 x 150 cm). Saint Peter's Collegiate Church, Louvain, Belgium.

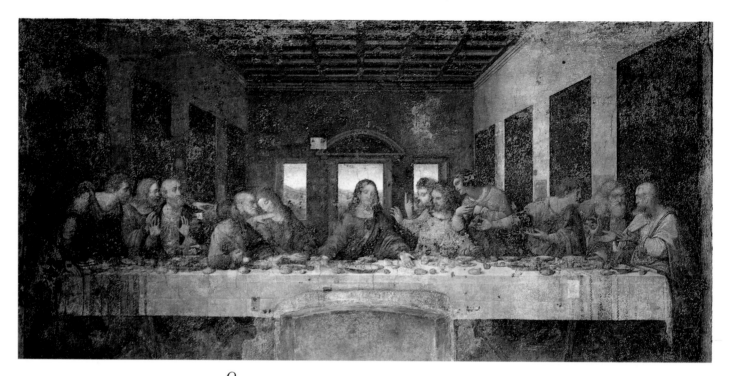

LEONARDO DA VINCI (1452–1519). *The Last Supper*, 1495–97.
Fresco, 15 ft. 1⅛ in. x 28 ft. 10⅜ in. (4.6 x 8.8 m). Santa Maria della Grazie, Milan.

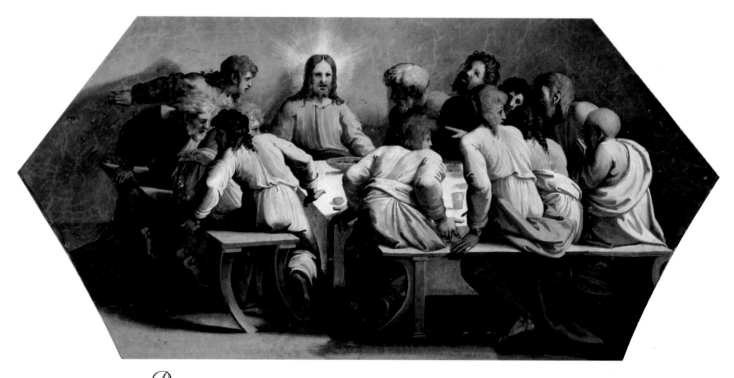

RAPHAEL (1483–1520). *The Last Supper*, 1518–19. Fresco. Vatican Palace, Vatican City.

Verily, verily, I say unto you, that one of you shall betray me.

JOHN 13:21

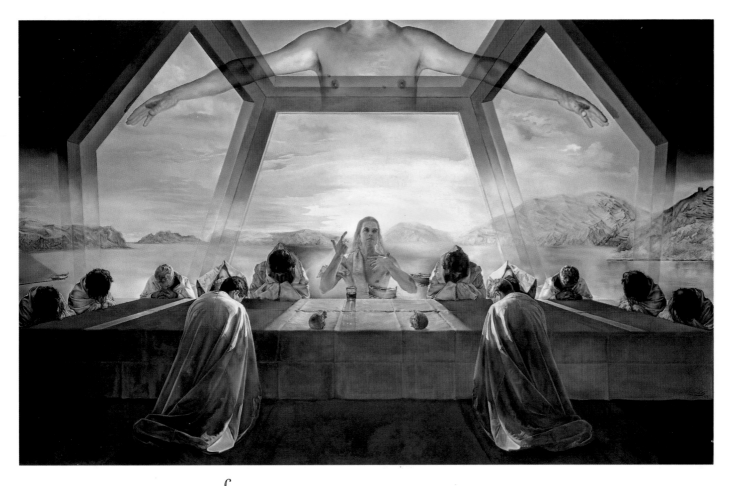

SALVADOR DALÍ (1904–1989). *Sacrament of the Last Supper*, 1955.
Oil on canvas, 65⅝ x 105⅛ in. (166.7 x 267 cm). National Gallery of Art, Washington, D.C.; The Chester Dale Collection.

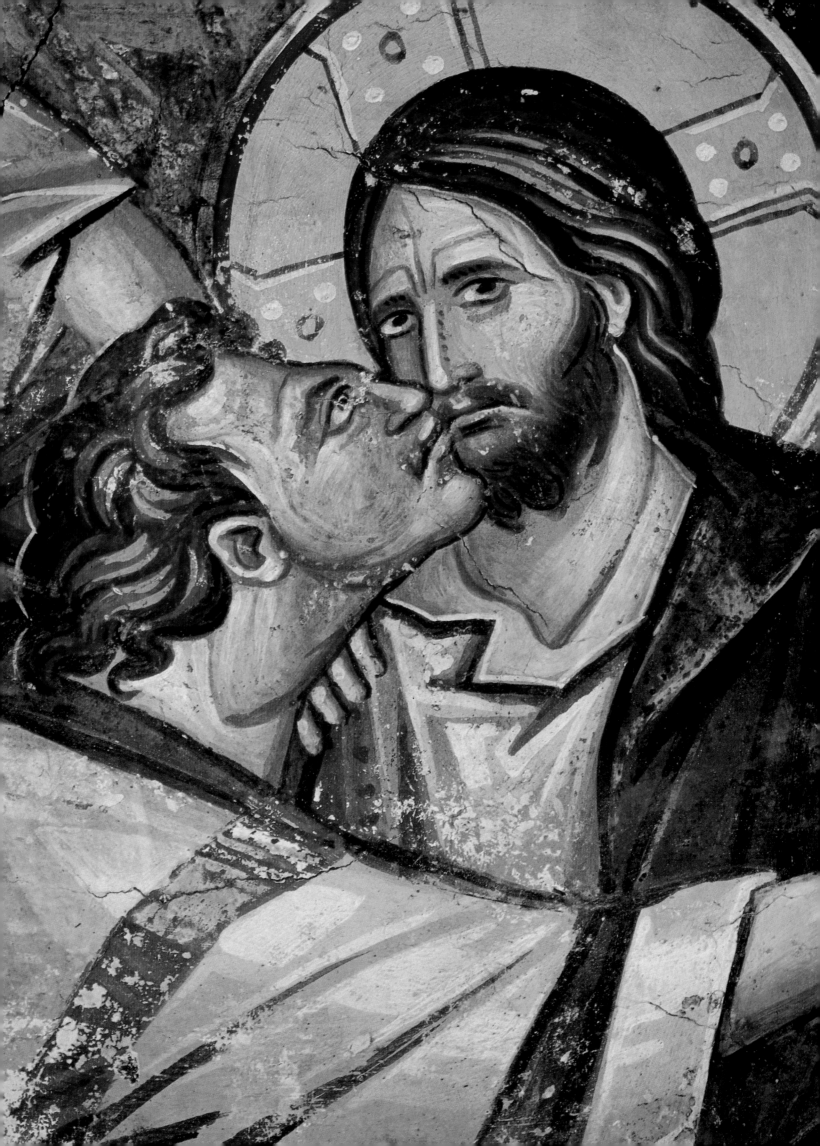

THE BETRAYAL,
ARREST, AND TRIALS

The hour is come; behold, the Son of man is betrayed into the hands of sinners.

MARK 14:41

For thirty pieces of silver Judas led armed soldiers to the Garden of Gethsemane, where Jesus knelt in agonized prayer, and then identified his master with a kiss on the cheek. Many painters have made this traitorous embrace the still center of a whirlwind of battle between the military men and the disciples. In counterpoint to it, artists often have shown a furious Peter slicing off the ear of one of the enemy's servants; reproaching his hotheaded disciple, Christ quickly healed the wounded man.

The two court appearances that followed have been portrayed only infrequently, generally in manuscript illuminations. At Christ's first hearing, the high priests Annas and Caiaphas quickly condemned him to death on charges of blasphemy. Before their sentence could be carried out, he also had to appear before Pontius Pilate, the Roman governor. Having concluded that Christ was innocent, Pilate attempted to persuade the masses gathered in town for Passover to grant him the traditional holiday pardon; when they instead cried for the release of the bandit Barrabas, the governor washed his hands of the whole affair—a moment depicted in elegant detail by Mathias Stomer (page 95).

Next Christ was flogged by the soldiers—the Roman Empire's standard preexecution punishment for noncitizens. In Piero della Francesca's eerily still version (page 96), the scourging takes place at a far remove from the viewer, in contrast to the empathy-eliciting close-up by Caravaggio (page 97). The subsequent mocking of Christ by the soldiers, who sardonically crowned him with thorns and wrapped him in a borrowed purple robe, has been wrenchingly portrayed by Hieronymus Bosch (page 99) and other northern artists, who painted the hate-twisted faces of the tormentors with relish. Pilate then displayed Christ to the bloodthirsty crowd (a scene often entitled *Ecce Homo*—Latin for "behold the man") before having him taken away to be crucified.

Judas and Jesus, c. 1295.
Fresco. Monastery Church, Ohrid, Republic of Macedonia.

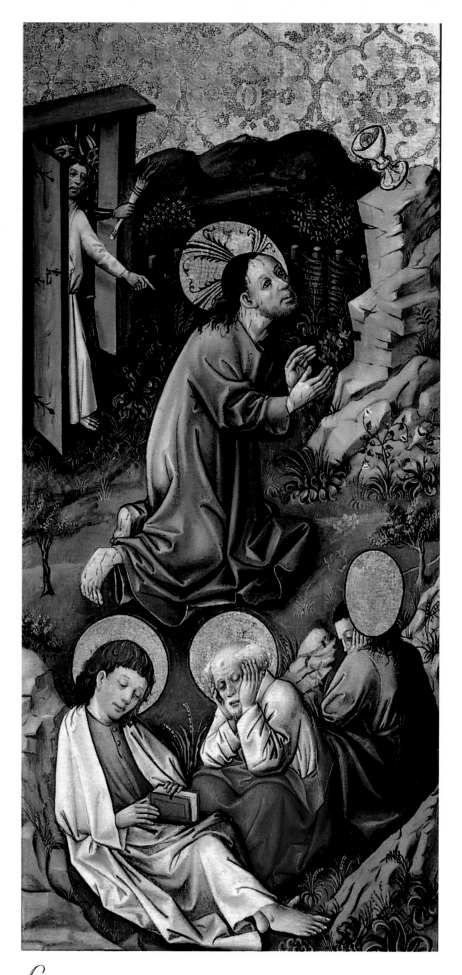

Christ in the Garden of Olives, Upper Rhine (Lake Constance), c. 1460. Oil on wood, 43⅛ x 20⅝ in. (109.5 x 52.5 cm). Musée des Beaux-Arts, Lyons, France.

Father, if thou be willing, remove this cup from me: nevertheless not my will, but thine, be done. And there appeared an angel unto him from heaven, strengthening him. And being in an agony he prayed more earnestly: and his sweat was as it were great drops of blood falling down to the ground.

LUKE 22:42–44

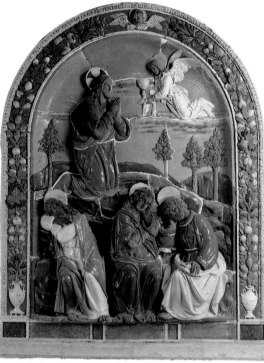

ATTRIBUTED TO
LUCA DELLA ROBBIA (1475–1548).
Christ on the Mount of Olives, n.d.
Terra-cotta, 90½ x 33½ in. (230 x 85 cm). Musée du Louvre, Paris.

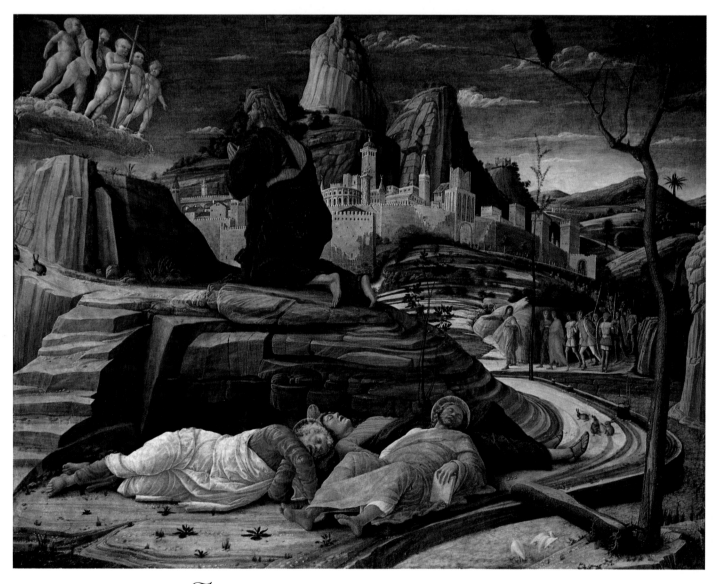

ANDREA MANTEGNA (c. 1431–1506). *The Agony in the Garden*, c. 1460.
Tempera on wood, 24¾ x 31⅜ in. (63 x 80 cm). National Gallery, London.

THE BETRAYAL, ARREST, AND TRIALS

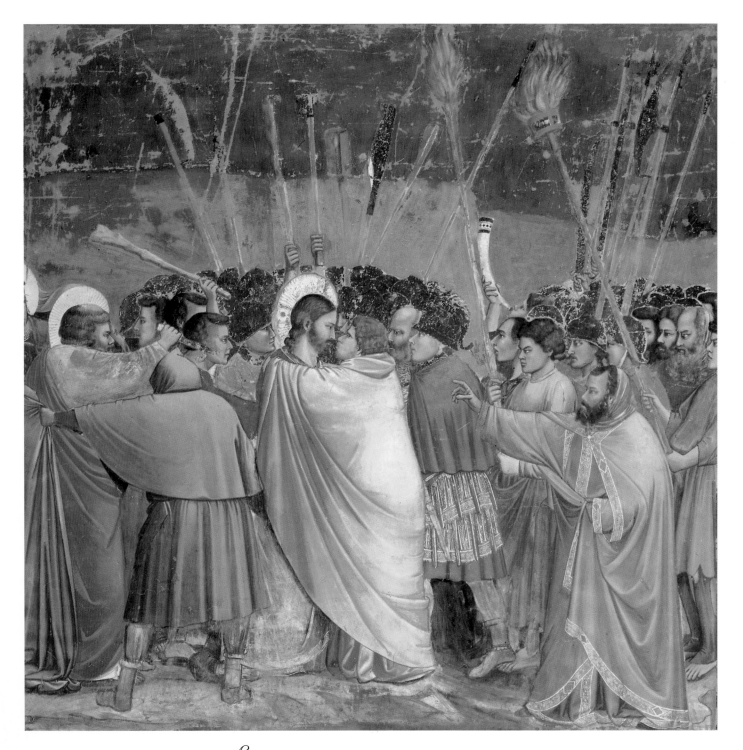

GIOTTO (1266/67–1337). *The Betrayal of Christ*, c. 1305.
Fresco, 72¾ x 78⅝ in. (185 x 200 cm). Scrovegni Chapel, Padua, Italy.

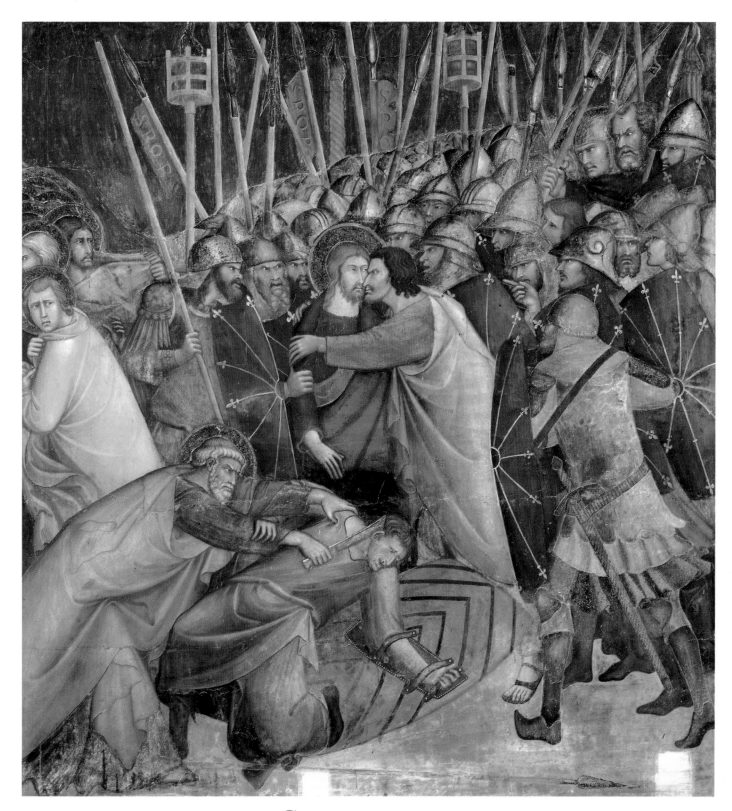

*B*ARNA DA SIENA (active c. 1350/56).
The Kiss of Judas, c. 1350/56. Fresco. Collegiata, San Gimignano, Italy.

*And they all condemned him
to be guilty of death.*

MARK 14:64

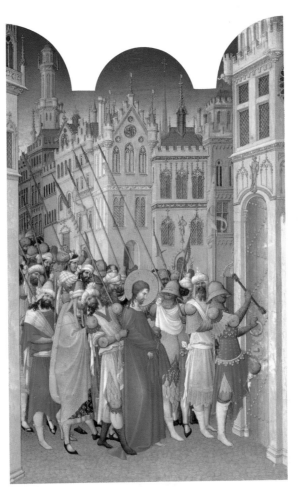

LIMBOURG BROTHERS
(15th century).
Christ Brought to the Praetorian,
from *Les Très Riches Heures du Duc
de Berry,* c. 1413. Musée Condé,
Chantilly, France.

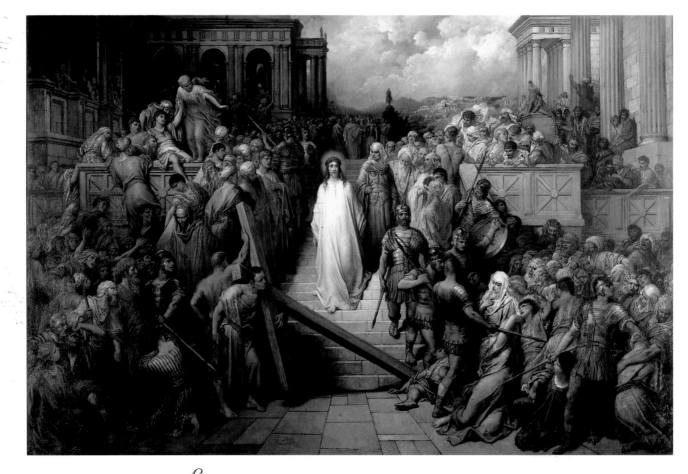

GUSTAVE DORÉ (1832–1883). *Christ Leaving the Praetorian,* 1874–80.
Oil on canvas, 15 ft. 7 in. x 23 ft. 5 in. (4.75 x 7.15 m). Musée des Beaux-Arts, Nantes, France.

THE BETRAYAL, ARREST, AND TRIALS

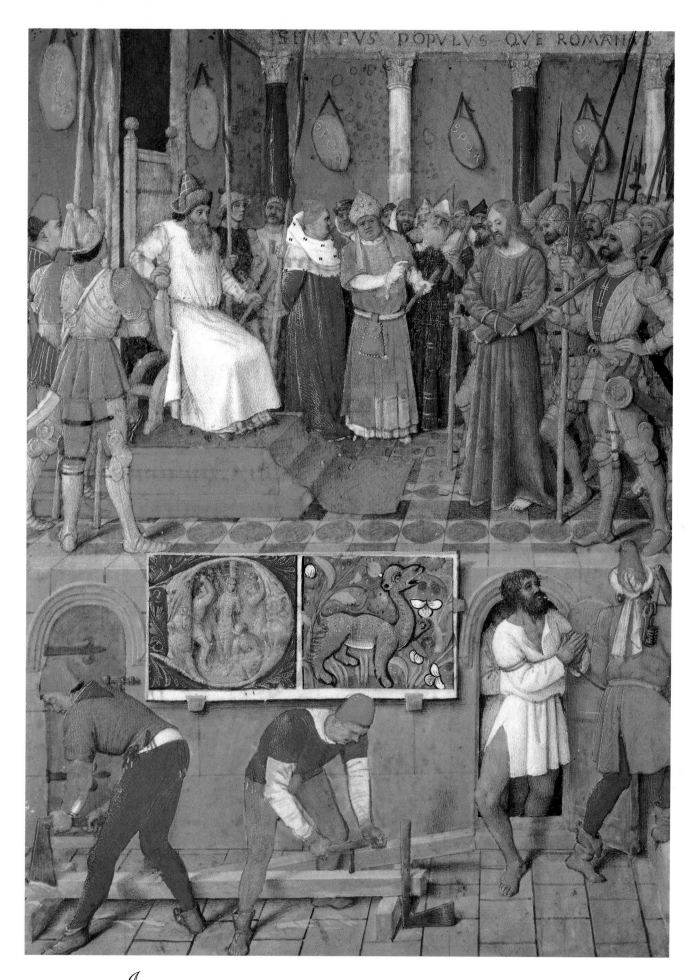

*J*EAN FOUQUET (c. 1420–1481 or before). *Jesus before Pilate,* from *The Hours of Etienne Chevalier,*
c. 1445. Musée Condé, Chantilly, France.

THE BETRAYAL, ARREST, AND TRIALS

When Pilate saw that he could prevail nothing, but that rather a tumult was made,
he took water, and washed his hands before the multitude, saying, I am innocent
of the blood of this just person.

MATTHEW 27:24

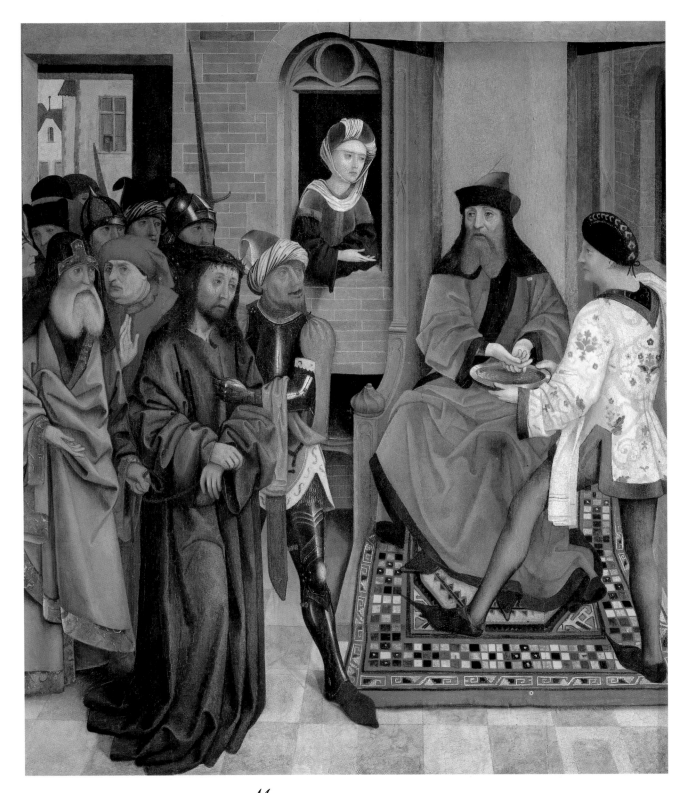

MASTER OF SCHOTTEN (15th century).
Jesus before Pilate; Pilate Washes His Hands, from the *Altar of Schottenkirche*, 1470–80.
Tempera on oak, 31⅜ x 31⅜ in. (80 x 80 cm). Schottenstift, Vienna.

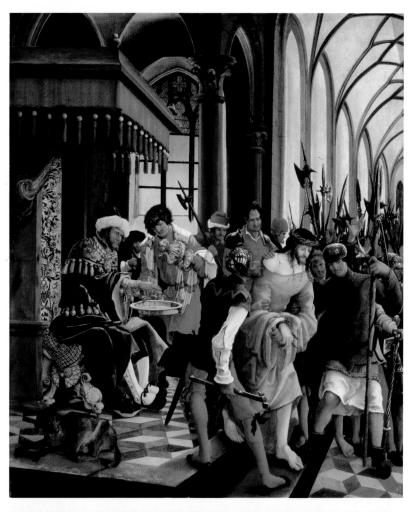

ALBRECHT ALTDORFER
(1480–1539).
Christ before Pilate, from the
Saint Sebastian Altar, 1518.
Oil on wood, 44¾ x 37⅝ in.
(114 x 96 cm). Abbey,
Saint Florian, Austria.

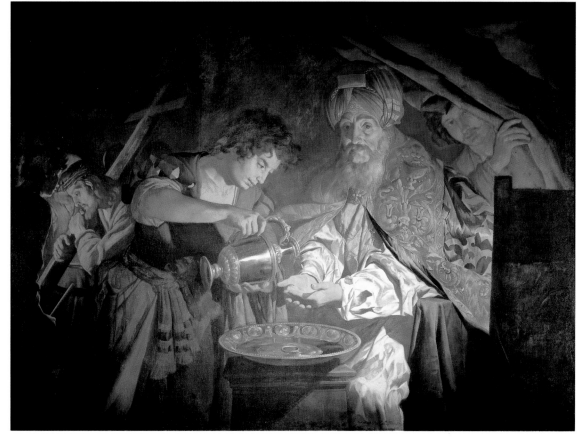

MATHIAS STOMER (1600–1650). *Pontius Pilate Washing His Hands,* n.d. Oil on canvas,
60¼ x 80⅝ in. (153 x 205 cm). Musée du Louvre, Paris.

OPPOSITE

*J*AIME HUGUET (c. 1415–1492).
The Flagellation of Christ, c. 1450. Unknown medium on wood,
36¼ x 61⅜ in. (92 x 156 cm).
Musée du Louvre, Paris.

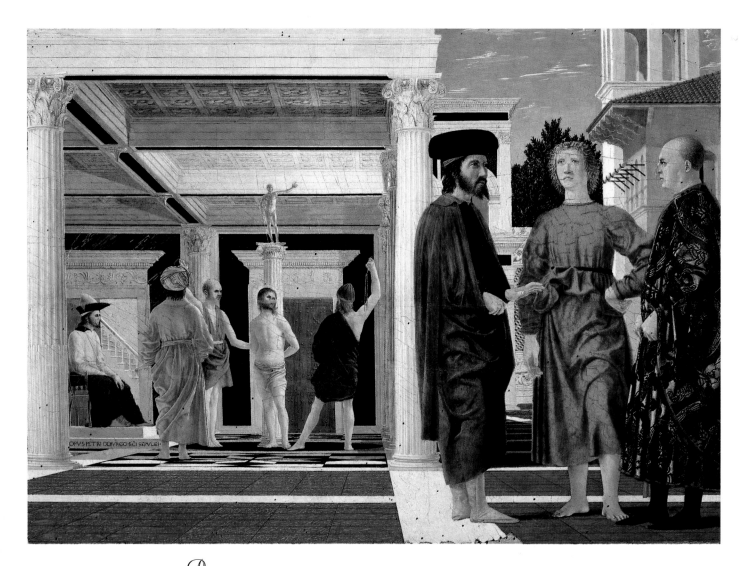

*P*IERO DELLA FRANCESCA (1410/20–1492). *The Flagellation of Christ*, c. 1455.
Tempera on wood, 27½ x 36¼ in. (70 x 92 cm). Galleria Nazionale delle Marche, Urbino, Italy.

OPPOSITE

*C*ARAVAGGIO (1571–1610).
The Flagellation of Christ at the Column, c. 1606–7.
Oil on canvas, 52⅝ x 69 in. (134 x 175.5 cm).
Musée des Beaux-Arts, Rouen, France.

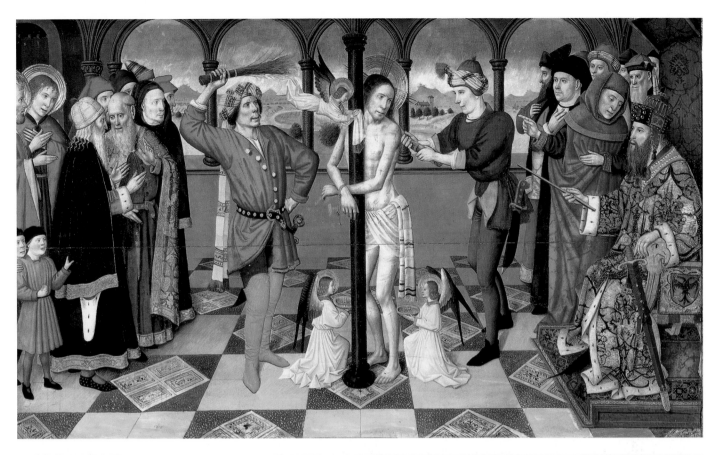

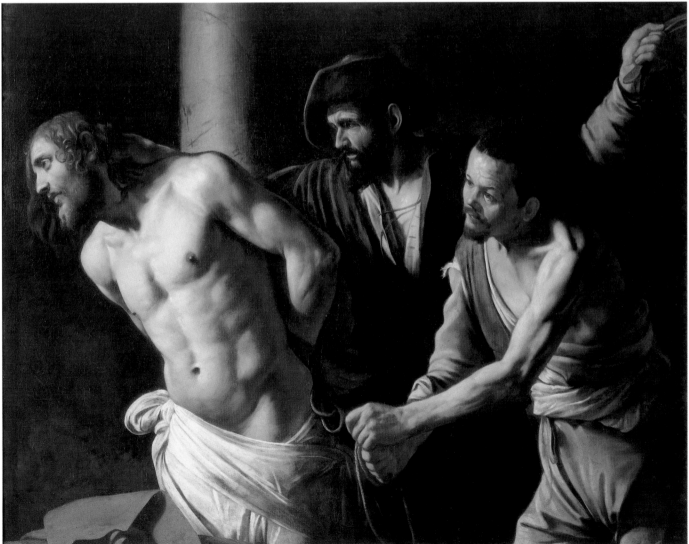

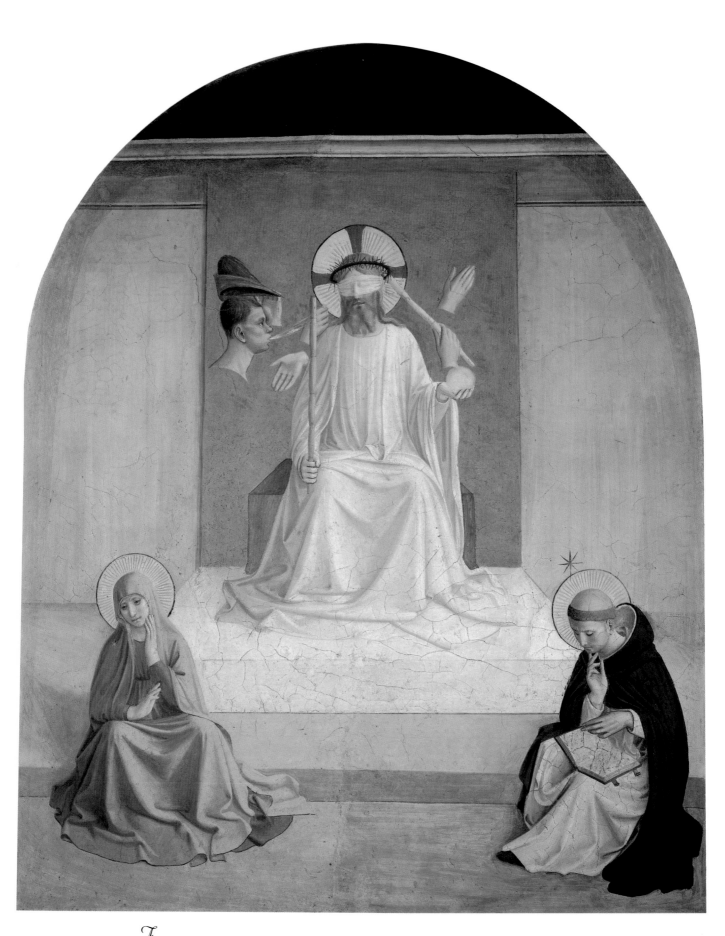

FRA ANGELICO (c. 1400–1455) and workshop. *The Mocking of Christ*, late 1430s–early 1440s.
Fresco, 76⅝ x 62½ in. (195 x 159 cm). Monastery of San Marco, Florence.

*T*hen Pilate therefore took Jesus and scourged him. And the soldiers platted a crown of thorns, and put it on his head, and they put on him a purple robe. And said, Hail, King of the Jews! . . . Then came Jesus forth, wearing the crown of thorns, and the purple robe. And Pilate saith unto them, Behold the man!

JOHN 19:1–3, 5

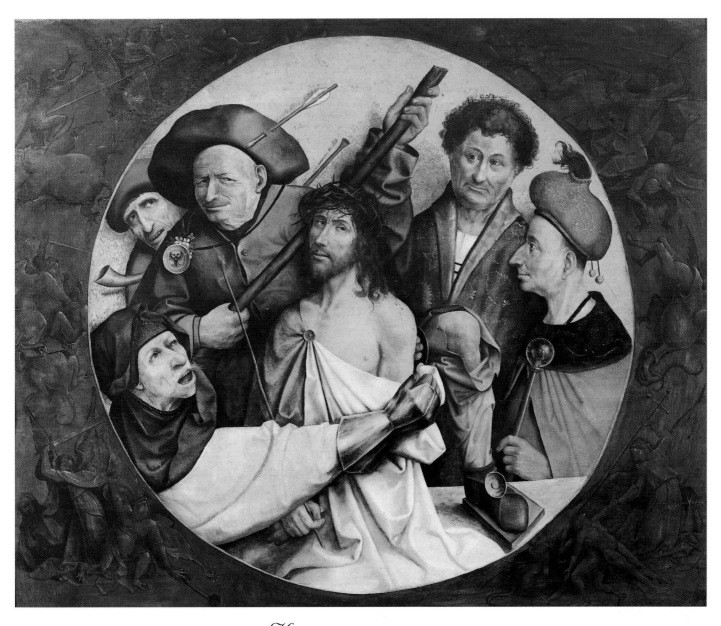

*H*IERONYMUS BOSCH (c. 1450–1516).
Ecce Homo, 1508–9. Oil on wood, 23¼ x 28⅝ in. (59 x 73 cm). El Escorial, Madrid.

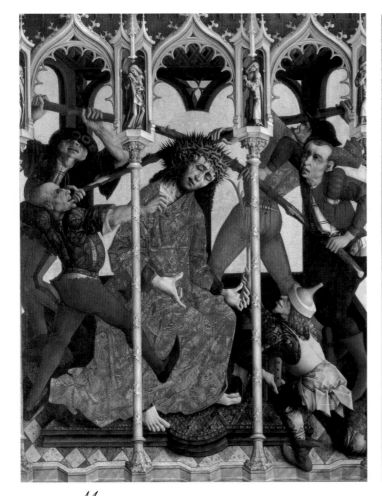

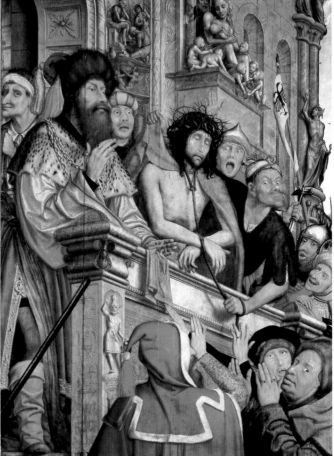

MASTER OF THE REGLER ALTAR (15th century).
Coronation with the Crown of Thorns, 1445–50. Oil on wood.
Reglerkirche, Erfurt, Germany.

QUENTIN MASSYS (c. 1466–1530).
Ecce Homo, c. 1515. Oil on panel, 62⅞ x 47¼ in.
(160 x 120 cm). Museo del Prado, Madrid.

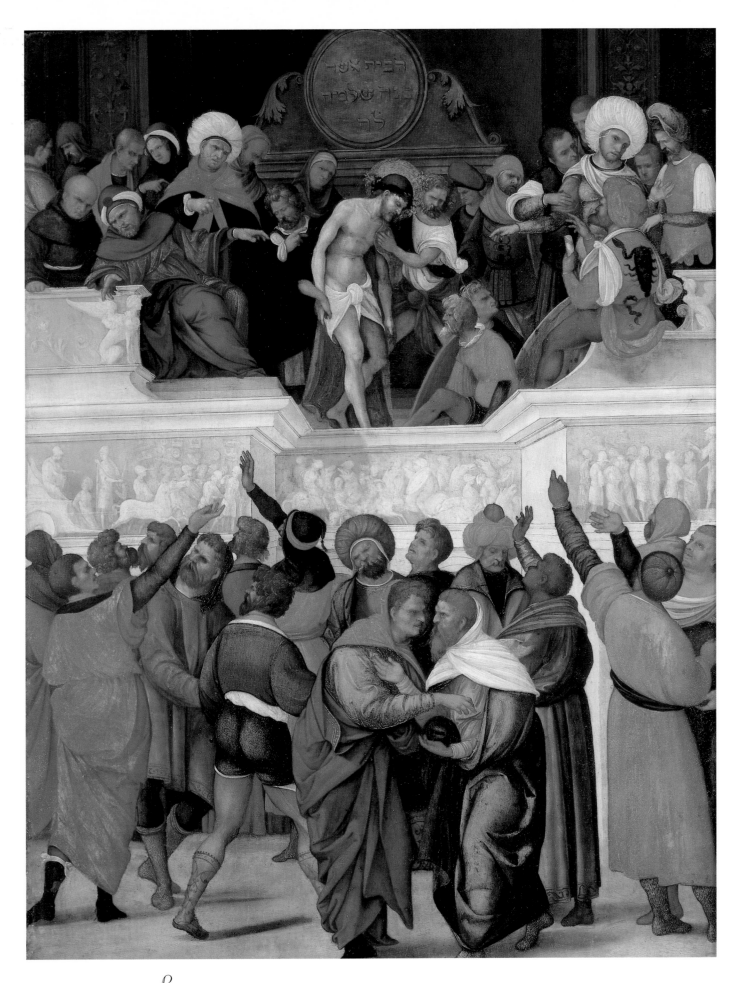

L̲udovico Mazzolino (1480–1528). *Ecce Homo*, c. 1524–25. Unknown medium on wood,
20¾ x 16⅞ in. (53 x 43 cm). Musée Condé, Chantilly, France.

The Betrayal, Arrest, and Trials

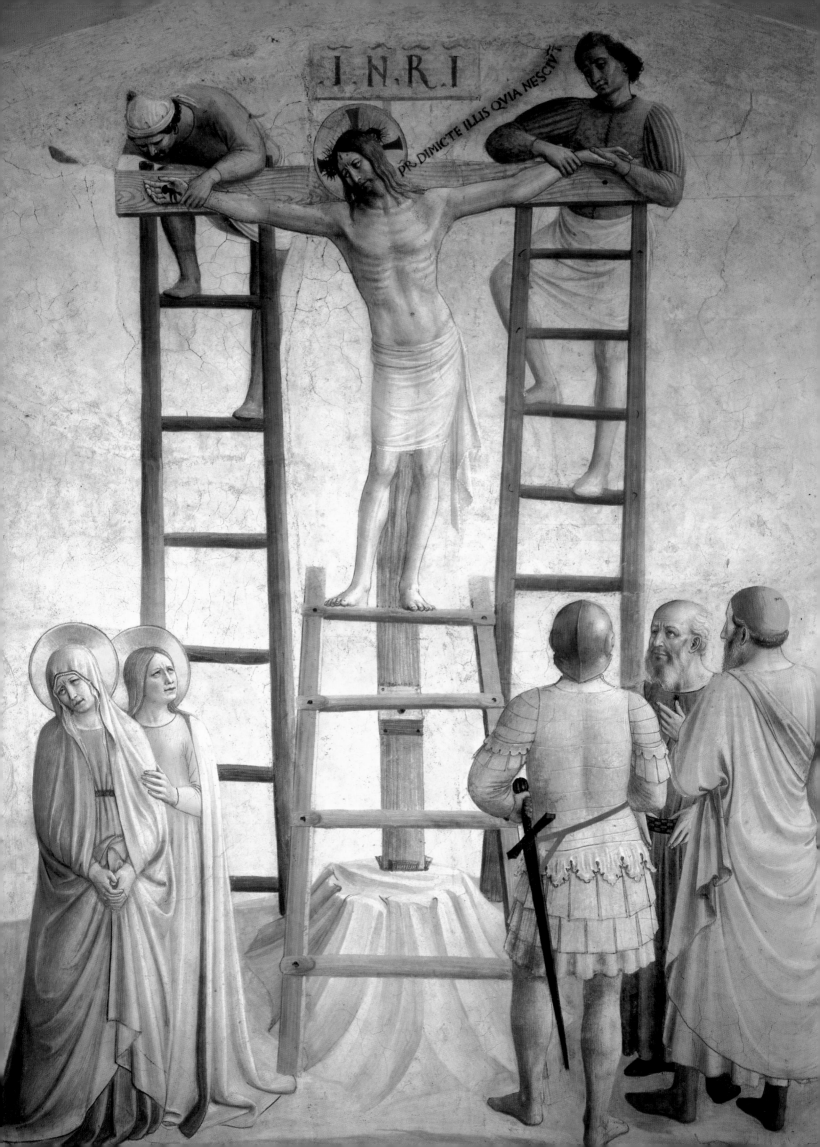

THE CRUCIFIXION

*And he bearing his cross went forth into a place called the place of a skull, which is called
in the Hebrew Golgotha: Where they crucified him, and two other with him, on either side one,
and Jesus in the midst.*

JOHN 19:17–18

As the climactic event in Christ's life on earth, the crucifixion has been frequently
and fervently depicted. The painful procession from Jerusalem to Calvary was
divided by Church ritual into fourteen precisely defined Stations of the Cross. Of these,
artists favored Christ's encounter with Saint Veronica—who offered him a cloth to wipe
the sweat from his face and found his image miraculously imprinted on it—and scenes of
his carrying the cross amidst a crowd of jeering tormentors and sorrowing supporters. In
Christ Walking to Calvary (page 108), one member of the mob kicks Jesus while another
pummels him; in Barna da Siena's version (page 104), a scowling soldier brandishes
a hammer with which the nails will soon be driven into Christ's hands and feet.

In portraying the crucifixion itself, medieval and Renaissance artists often included
elements mentioned in pious legends as well as the Bible. The witnesses almost invariably
included the blue-robed Virgin Mary (sometimes with her sister Mary Cleophas and
Mary Magdalene), being comforted by John the Evangelist, usually clad in red; the
Roman soldiers gambling for Christ's seamless garment in the foreground; and Longinus,
the centurion who thrust his lance into Christ's side and who, according to tradition,
was converted at the foot of the cross and eventually became Saint Longinus. Skulls scat-
tered on the ground signify not only the Hebrew meaning of the site's name ("place of
the skull") but also the traditional belief that the crucifixion took place on the exact
spot where Adam was buried. Christ is often shown flanked by the two thieves men-
tioned in the Gospels; the one on the left was usually depicted as the unbelieving "bad
thief," the one on the right, the "good thief," to whom Christ promised paradise—in
some paintings small airborne devils and angels reinforce their identities.

In contrast to such incident-filled scenes, some artists concentrated on Christ alone.
Such simple compositions, stripped of distracting details, would have been more suited

FRA ANGELICO (c. 1400–1455) and workshop. *Christ Being Nailed to the Cross*, late 1430s–early 1440s.
Fresco, 74 x 59 in. (188 x 150 cm). Monastery of San Marco, Florence.

for meditation, as were the three-dimensional crucifixes that were often the visual focal point of worship in cathedrals, private chapels, and the spartan cells of monks and nuns.

In the early centuries of the faith, Christ was most often represented alive on the cross, with his head upright in calm triumph over death and his steadfast gaze directed out to his worshipers. Later, as the emphasis shifted to Christ's suffering and sacrifice, he was shown twisted in physical agony, bleeding from his thorn-pierced head, hands, feet, and side (often water flows from his side as well—a symbol of baptism).

The events that followed the crucifixion, like those leading up to it, were divided into certain traditional scenes. The deposition—a frequent subject for sculptors as well as painters—showed Joseph of Arimathaea removing Christ's body from the cross, often accompanied by the Virgin Mary, Mary Magdalene, John, and other mourners. Next came the lamentation, with the faithful weeping over the body of Christ; a variant of this is the pietà (so movingly interpreted by Michelangelo; see page 125), in which the dead Christ is held by his mother, in mournful parallel to the Madonna and Child images. Finally, in the entombment, Christ's body is laid to rest in a rocky tomb, to be sealed behind a stone whose magnitude suggests the ponderous weight of death.

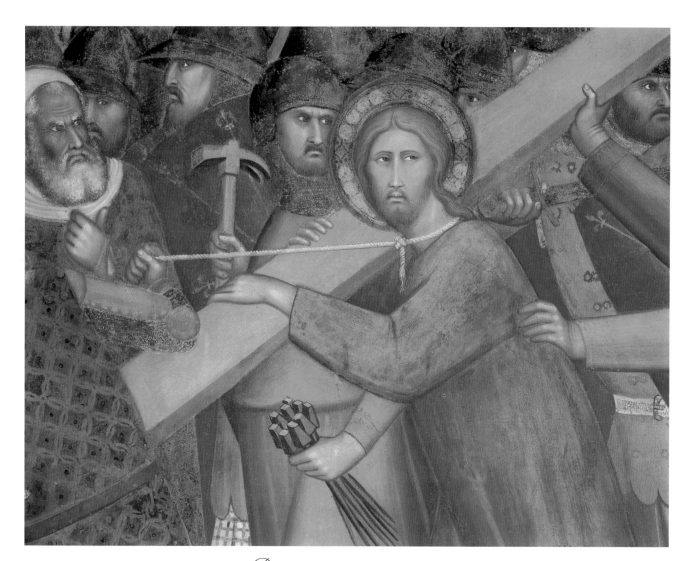

*B*ARNA DA SIENA (active c. 1350/56).
Detail of *Christ on the Way to Calvary*, c. 1350/56. Fresco. Collegiata, San Gimignano, Italy.

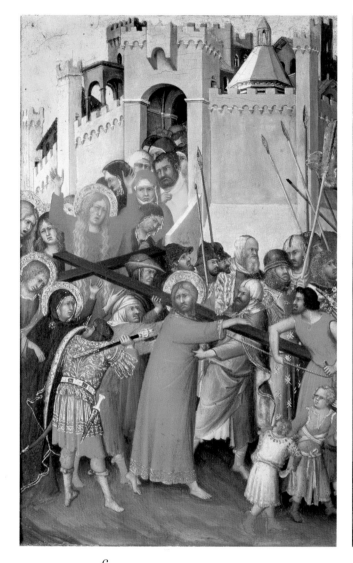

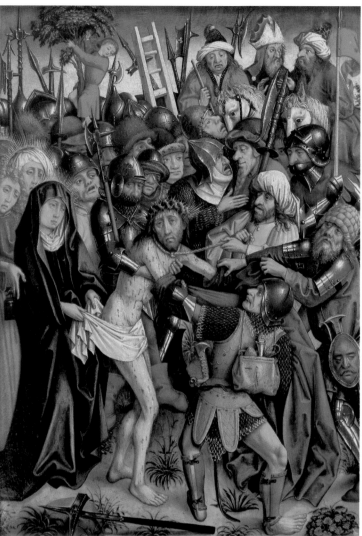

\mathcal{S}IMONE MARTINI (c. 1284–1344).
The Carrying of the Cross, c. 1325–35. Tempera on wood,
11 x 6⅜ in. (28 x 16 cm). Musée du Louvre, Paris.

\mathcal{M}ASTER OF THE KARLSRUHE PASSION.
Christ Taken to Golgotha, 1480. Oil on wood, height: 26⅜ in. (67 cm).
Staatliche Kunsthalle, Karlsruhe, Germany.

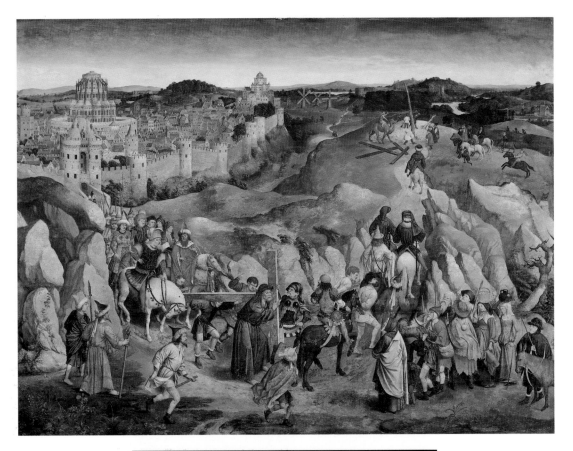

THE CRUCIFIXION

OPPOSITE
Copy after JAN VAN EYCK (1390–1441).
The Crucifixion, c. 1420–24.
Oil on wood, 38½ x 51⅛ in. (98 x 130 cm).
Museum of Fine Arts, Budapest.

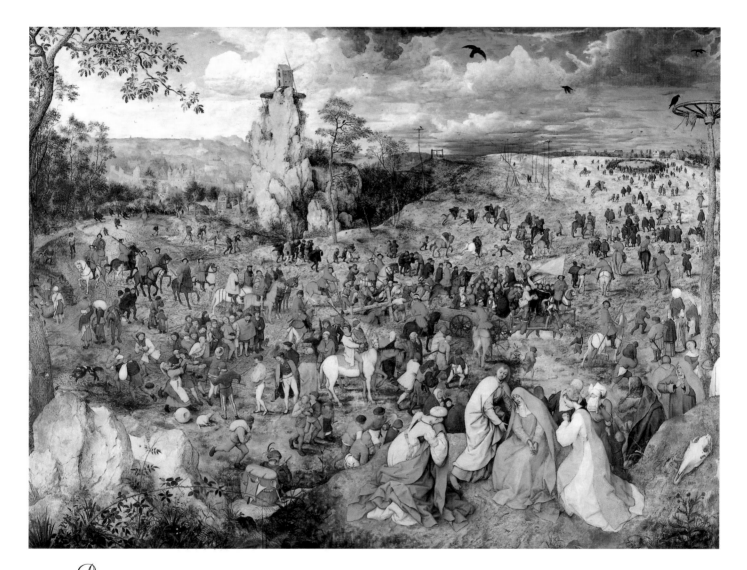

PIETER BRUEGEL THE ELDER (c. 1525/30–1569). *Christ Carrying the Cross,* 1564. Oil on oak, 48¾ x 66⅞ in. (124 x 170 cm).
Kunsthistorisches Museum, Gemäldegalerie, Vienna.

OPPOSITE
The Carrying of the Cross. French,
c. 1500. Stained glass, 28⅝ x 16⅛ in. (73 x 41 cm).
Musée National du Moyen Age, Thermes de Cluny, Paris.

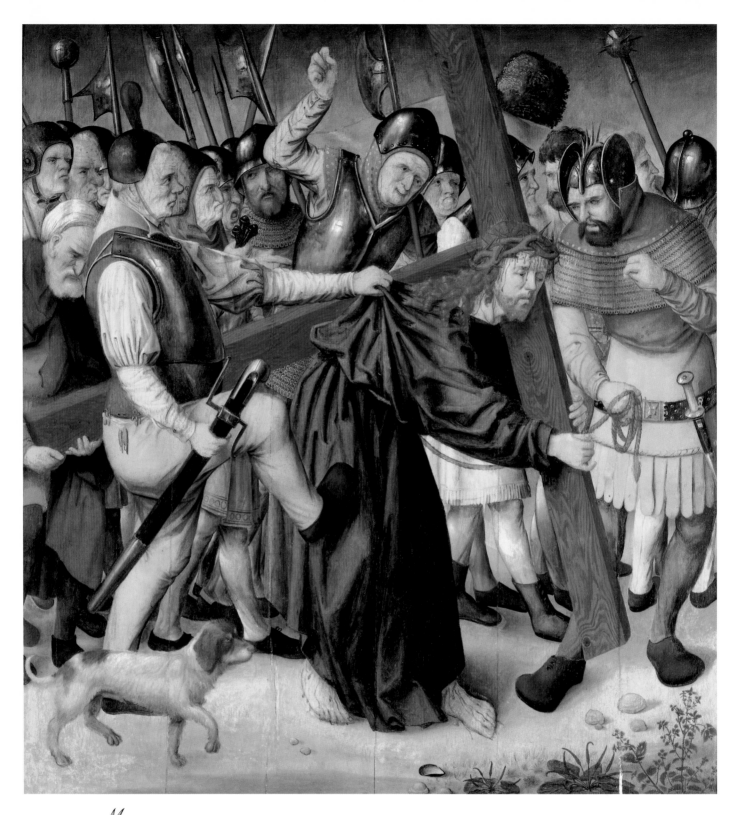

Master of the Saint-Germain-des-Prés Pietà (active before 1502–c. 1505). *Christ Walking to Calvary*, n.d. Oil on wood, 40½ x 37¾ in. (103.7 x 96.2 cm). Musée des Beaux-Arts, Lyons, France.

OPPOSITE
Claude Vignon (1593–1670).
Two Angels Presenting the Holy Face, c. 1640.
Oil on canvas, 48¾ x 66⅞ in. (124 x 170 cm).
Musée des Beaux-Arts, Rouen, France.

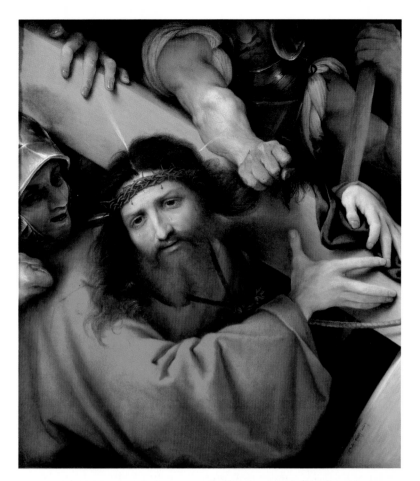

LORENZO LOTTO (1480–1556/57).
Christ Carrying the Cross, 1526.
Oil on canvas, 26 x 23⅝ in. (66 x 60 cm).
Musée du Louvre, Paris.

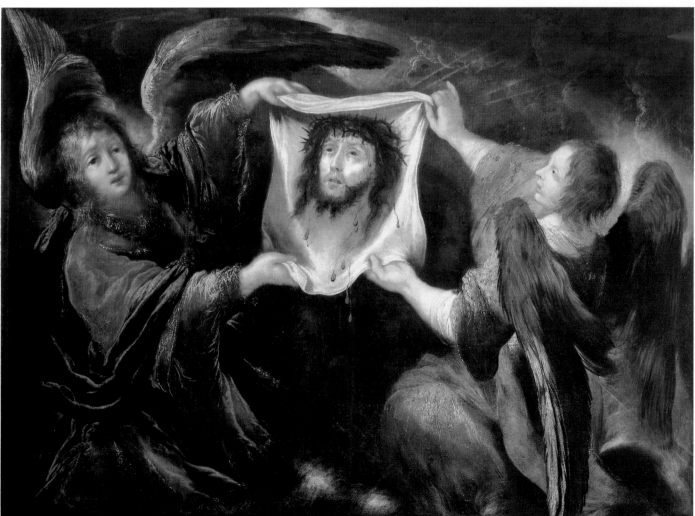

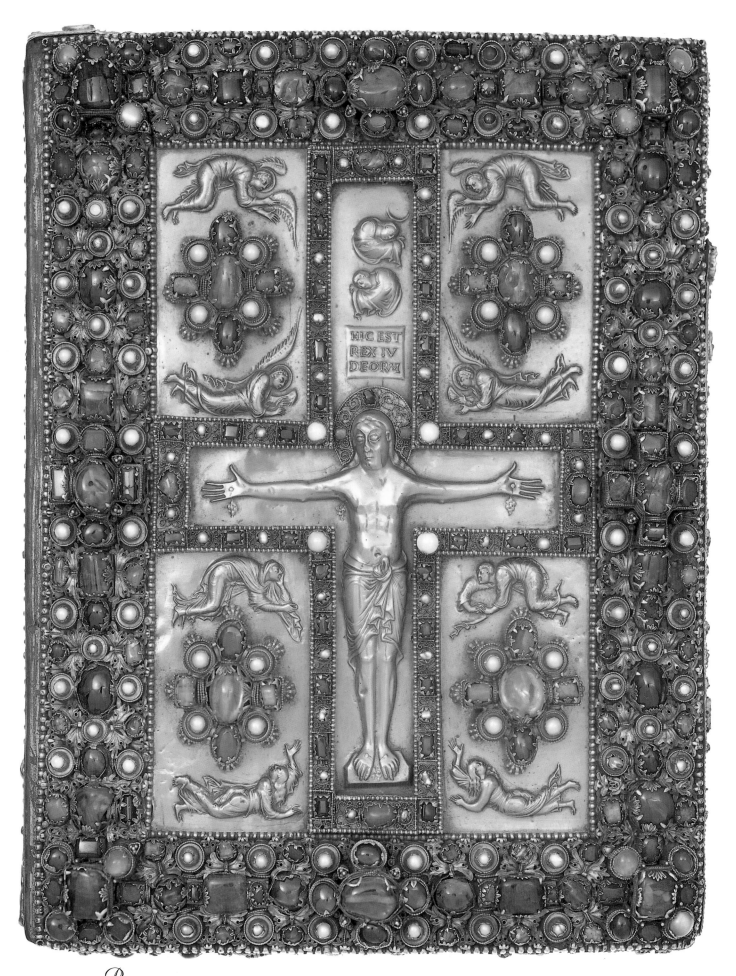

Repoussé Gold and Jeweled Bookcover. Court School of Charles the Bald, c. 880. Front cover of the *Lindau Gospels.* 13¾ x 10¾ in. (35 x 27.5 cm). The Pierpont Morgan Library, New York; Purchased by Pierpont Morgan, 1899.

THE CRUCIFIXION

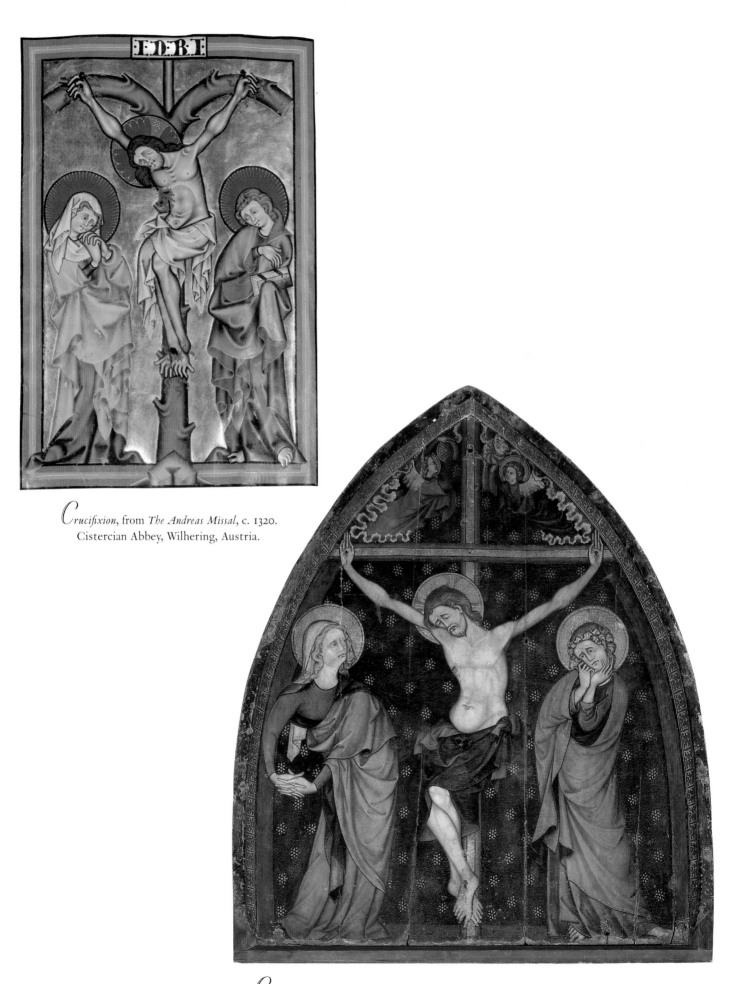

Crucifixion, from *The Andreas Missal*, c. 1320.
Cistercian Abbey, Wilhering, Austria.

Crucifixion. Auvergne, 2d quarter of 14th century. Oil on wood, 57 x 48 in. (145 x 122 cm).
Musée National du Moyen Age, Thermes de Cluny, Paris.

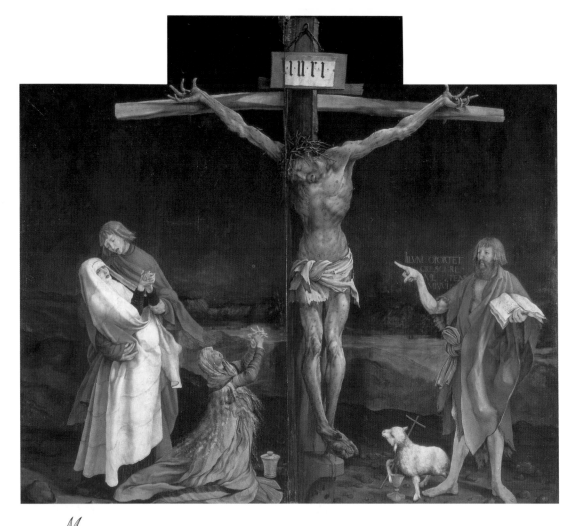

*M*ATTHIAS GRÜNEWALD (c. 1470/80–1528). *The Crucifixion*, from the *Isenheim Altar*, c. 1512–16.
Oil on wood, 105⅞ x 120¾ in. (269 x 307 cm). Musée d'Unterlinden, Colmar, France.

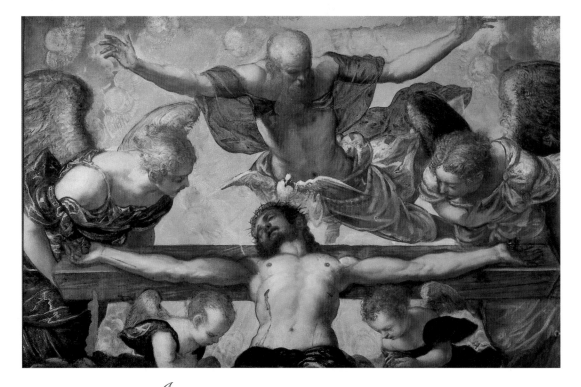

*J*ACOPO TINTORETTO (1518–1594). *The Trinity*, c. 1574.
Oil on canvas, 48 x 71¼ in. (122 x 181 cm). Galleria Sabauda, Turin, Italy.

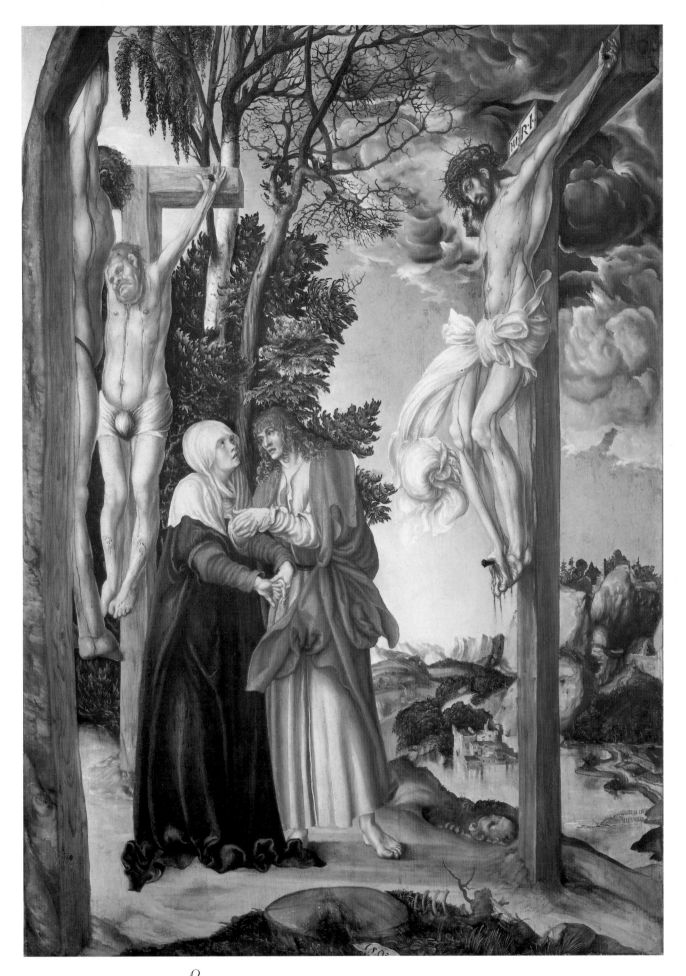

LUCAS CRANACH THE ELDER (1472–1553). *Christ on the Cross*, 1503.
Oil on pine, 52⅜ x 38⅞ in. (138 x 99 cm). Alte Pinakothek, Munich.

There they crucified him. . . . Then said Jesus, Father, forgive them;
for they know not what they do.

LUKE 23:33–34

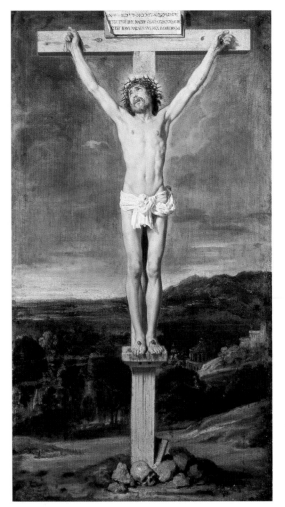

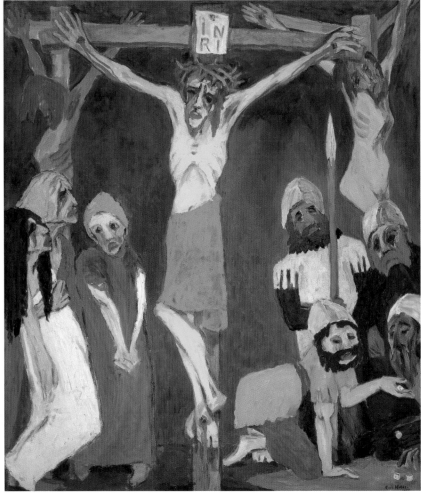

DIEGO VELÁZQUEZ (1599–1660).
Christ on the Cross, c. 1632. Oil on canvas,
97⅝ x 66½ in. (248 x 169 cm).
Museo del Prado, Madrid.

EMIL NOLDE (1867–1956). *The Crucifixion*, central panel of *The Life of Christ*
triptych, 1911–12. Oil on canvas, 86¾ x 76⅛ in. (220.5 x 193.5 cm).
Ada and Emil Nolde Foundation, Seebüll, Germany.

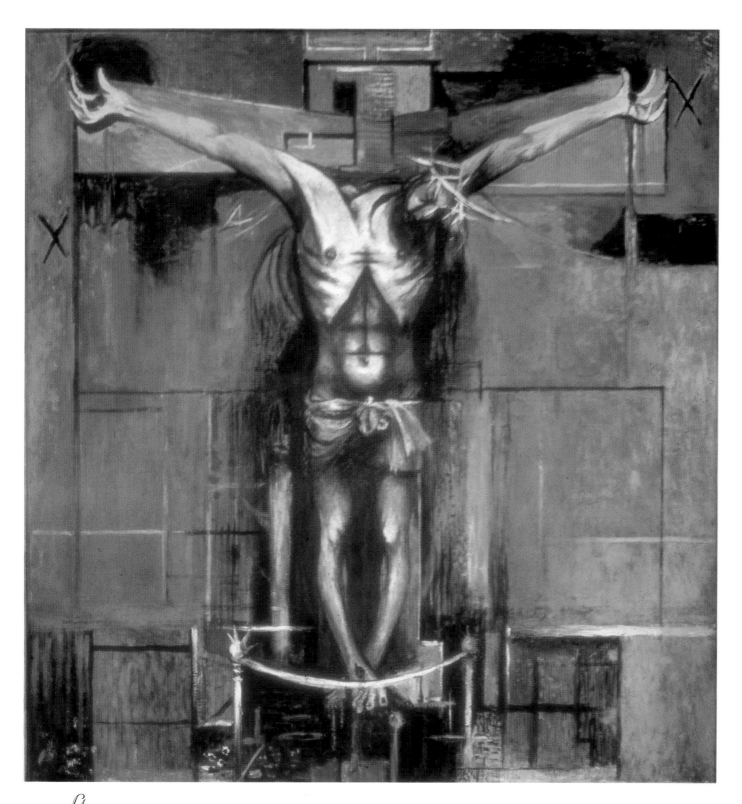

GRAHAM SUTHERLAND (1903–1980). *The Crucifixion*, commissioned 1946. Oil on hardboard, 96 x 90 in. (243.8 x 228.6 cm). Saint Matthew's Church, Northampton, England.

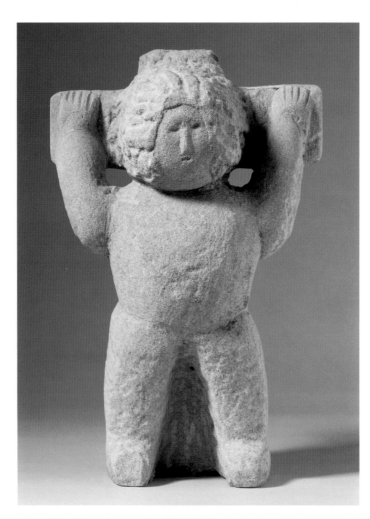

WILLIAM EDMONDSON (1882–1951).
Crucifixion, 1932–37. Limestone,
18⅛ x 12 x 6⅛ in. (46.1 x 30.5 x 15.5 cm).
National Museum of American Art,
Smithsonian Institution, Washington, D.C.

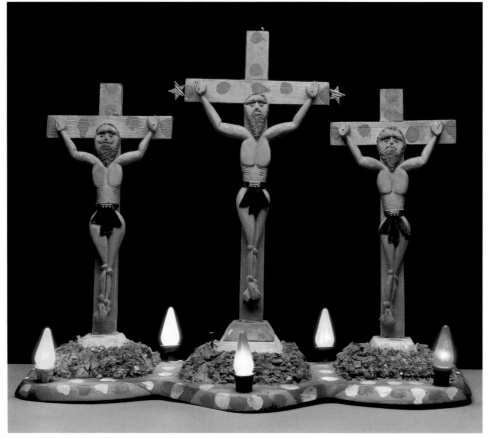

CHARLIE FIELDS (1883–1966). *Polka-Dotted Crucifixion*, c. 1960. Wood, leather, paint, electric
lights, chips of glass, and nails, 14½ x 16 x 5 in. (36.8 x 40.6 x 12.7 cm). Private collection.

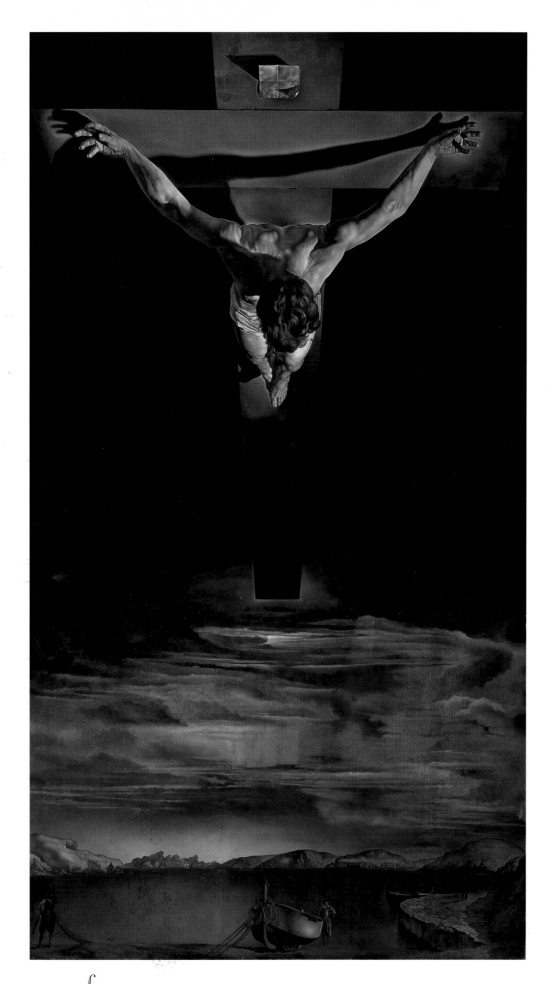

\mathcal{S}ALVADOR DALÍ (1904–1989). *Christ of Saint John of the Cross*, 1951. Oil on canvas,
80⅝ x 45⅝ in. (204.8 x 115.9 cm). Glasgow Art Gallery and Museum.

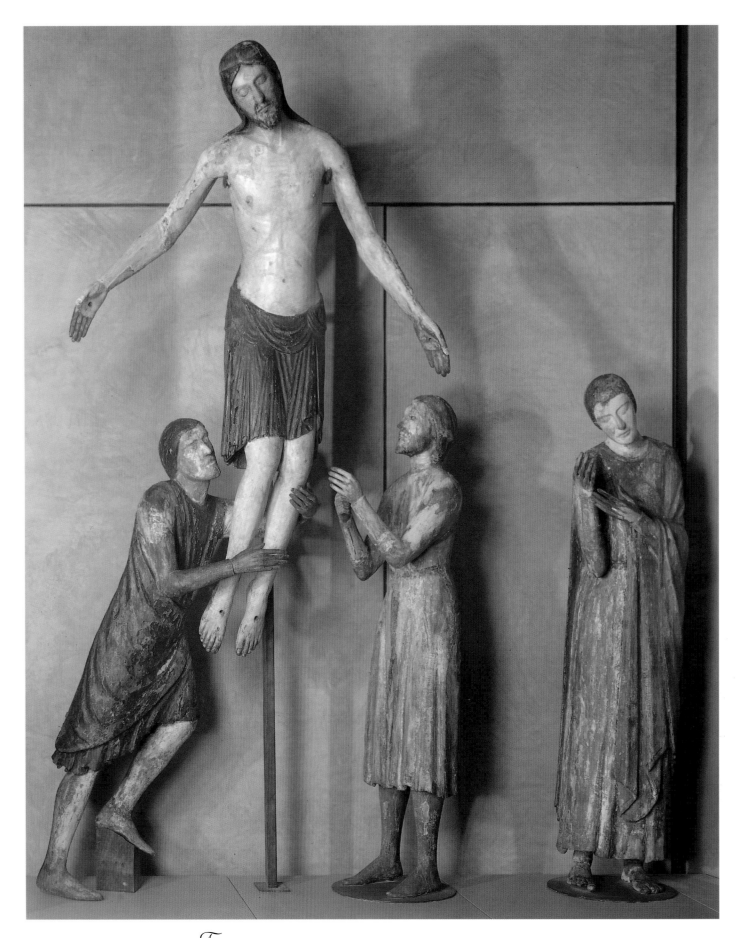

The Descent from the Cross. Umbria or Latium, 2d quarter of 13th century.
Painted wood, 73⅜ x 47⅝ x 14⅛ in. (186 x 121 x 36 cm). Musée du Louvre, Paris.

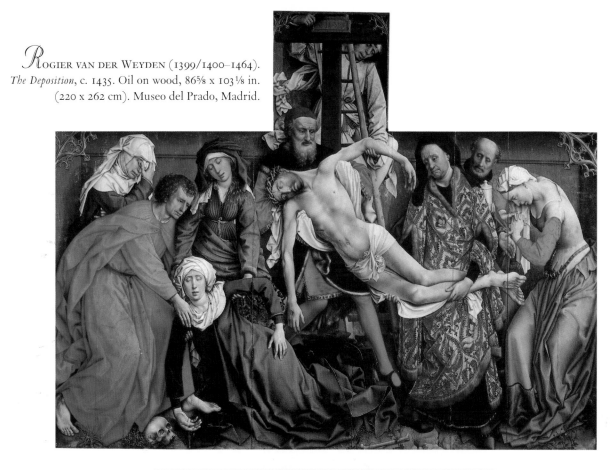

ROGIER VAN DER WEYDEN (1399/1400–1464).
The Deposition, c. 1435. Oil on wood, 86⅝ x 103⅛ in.
(220 x 262 cm). Museo del Prado, Madrid.

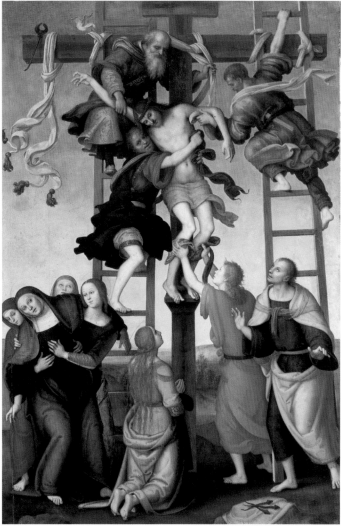

PERUGINO
(1445/50–1523)
with FILIPPINO LIPPI
(1457/58–1504).
The Deposition from the Cross,
c. 1507. Oil on wood,
11 ft. 9 in. x 7 ft. 1¾ in.
(3.33 x 2.18 m).
Accademia, Florence.

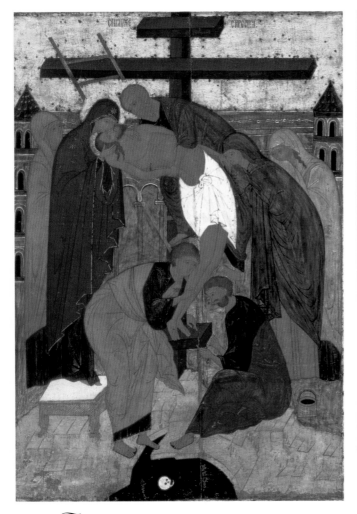

The Deposition. Novgorod School icon, 15th century.
Tretyakov Gallery, Moscow.

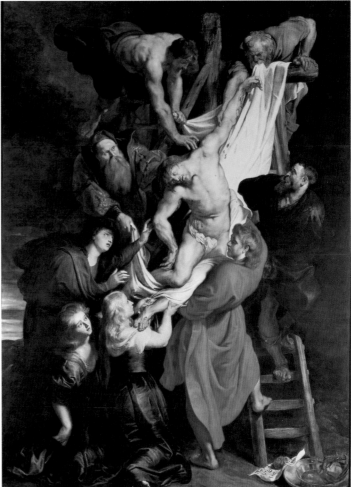

PETER PAUL RUBENS (1577–1640). *The Deposition*, 1612. Oil on wood,
13 ft. 9 in. x 10 ft. (4.2 x 3.1 m). Cathedral, Antwerp, Belgium.

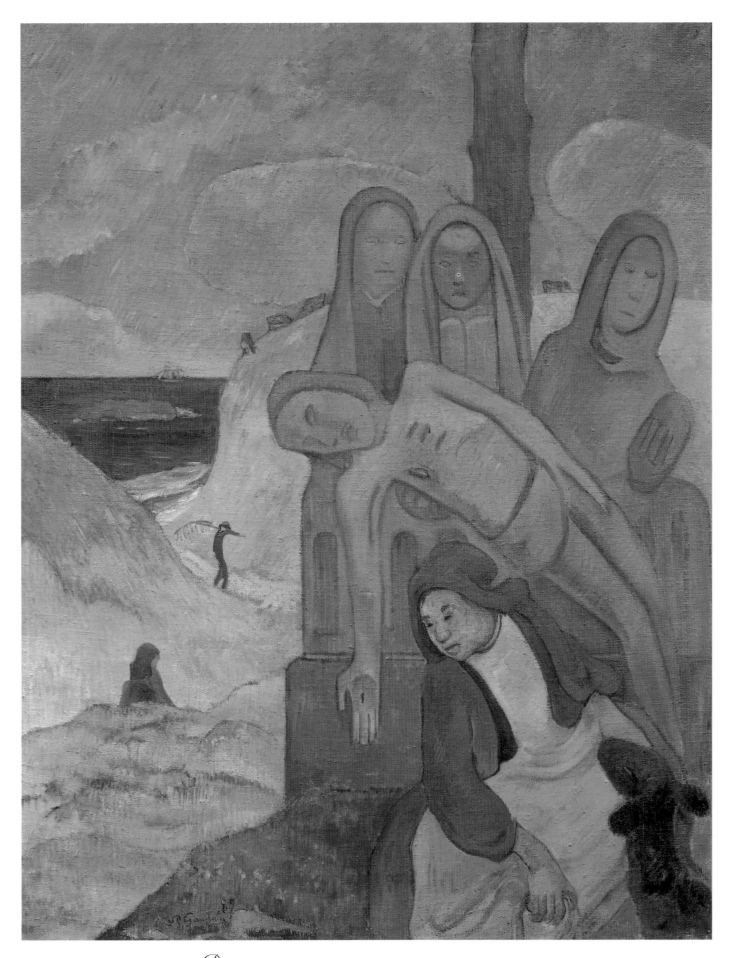

PAUL GAUGUIN (1848–1903). *Breton Calvary: The Green Christ*, 1889.
Oil on canvas, 36¼ x 28⅞ in. (92 x 73.5 cm). Musées Royaux des Beaux-Arts, Brussels.

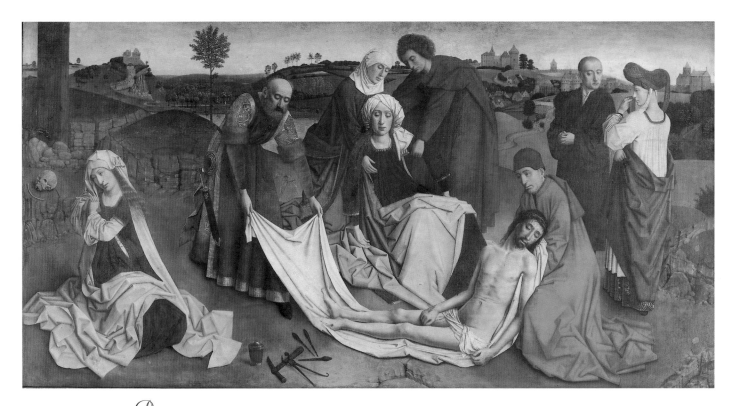

Petrus Christus (1420–1472/73). *Pietà*, c. 1450. Oil on wood, 39¾ x 75⅝ in. (101 x 192 cm). Musées Royaux des Beaux-Arts, Brussels.

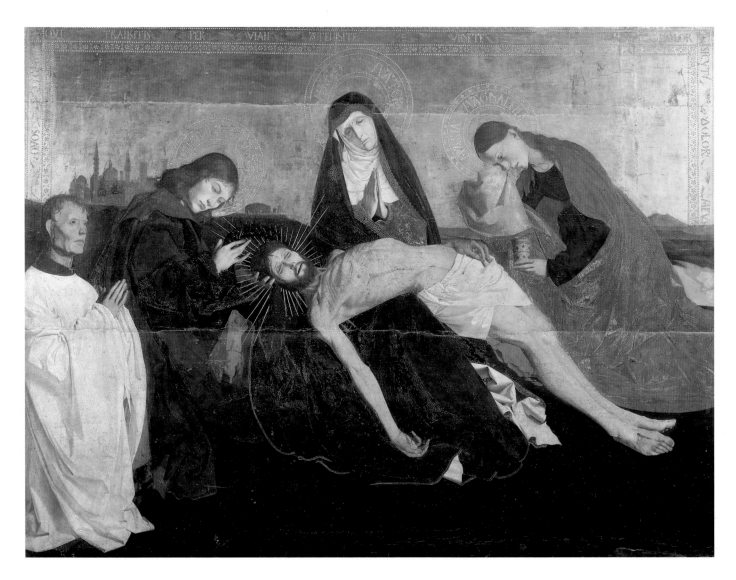

Ye shall weep and lament, but the world shall rejoice: and ye shall be sorrowful,
but your sorrow shall be turned into joy.

JOHN 16:20

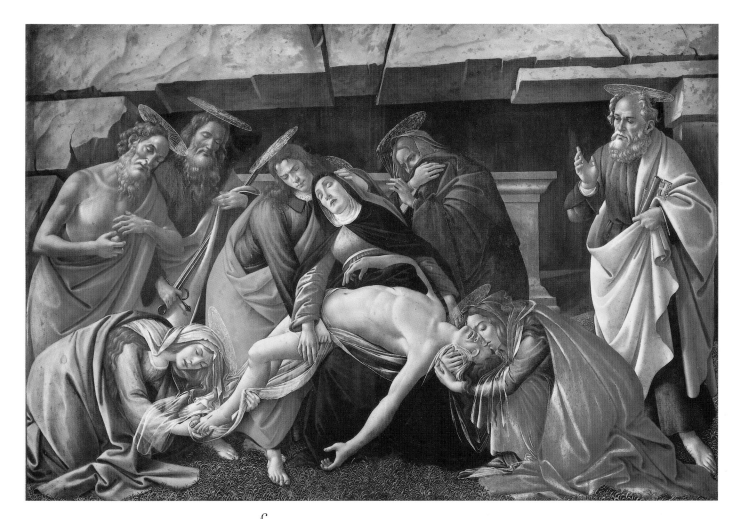

SANDRO BOTTICELLI (c. 1445–1510). *Pietà*, c. 1495.
Tempera on poplar, 55⅛ x 81⅜ in. (140 x 207 cm). Alte Pinakothek, Munich.

OPPOSITE
ENGUERRAND QUARTON (active 1444–66).
The Villeneuve-lès-Avignon Pietà, 1455.
Unknown medium on wood, 64¼ x 86 in. (163 x 218.5 cm).
Musée du Louvre, Paris.

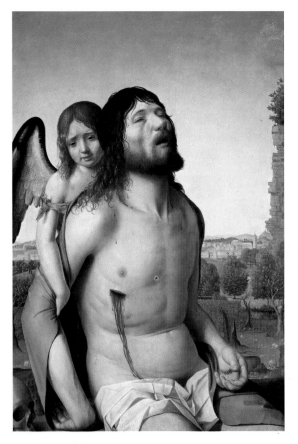

OPPOSITE
Michelangelo (1475–1564). *Pietà*,
1498–99. Marble, height: 68½ in. (174 cm).
Basilica of Saint Peter, Vatican City.

Antonello da Messina (1430–1479).
Pietà, c. 1475. Oil on wood, 29⅛ x 20 in.
(74 x 51 cm). Museo del Prado, Madrid.

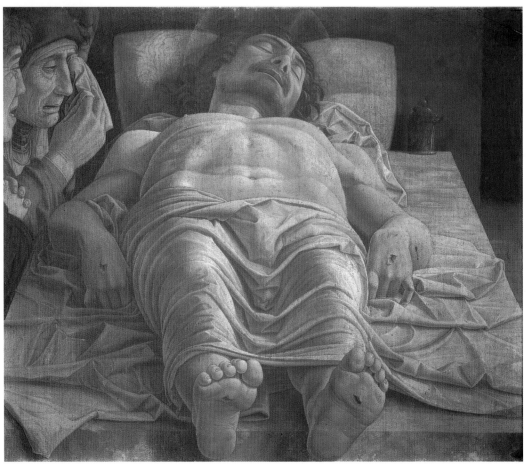

Andrea Mantegna (c. 1431–1506). *Dead Christ*, after 1466.
Tempera on canvas, 25⅞ x 31¾ in. (66 x 81 cm). Pinacoteca di Brera, Milan.

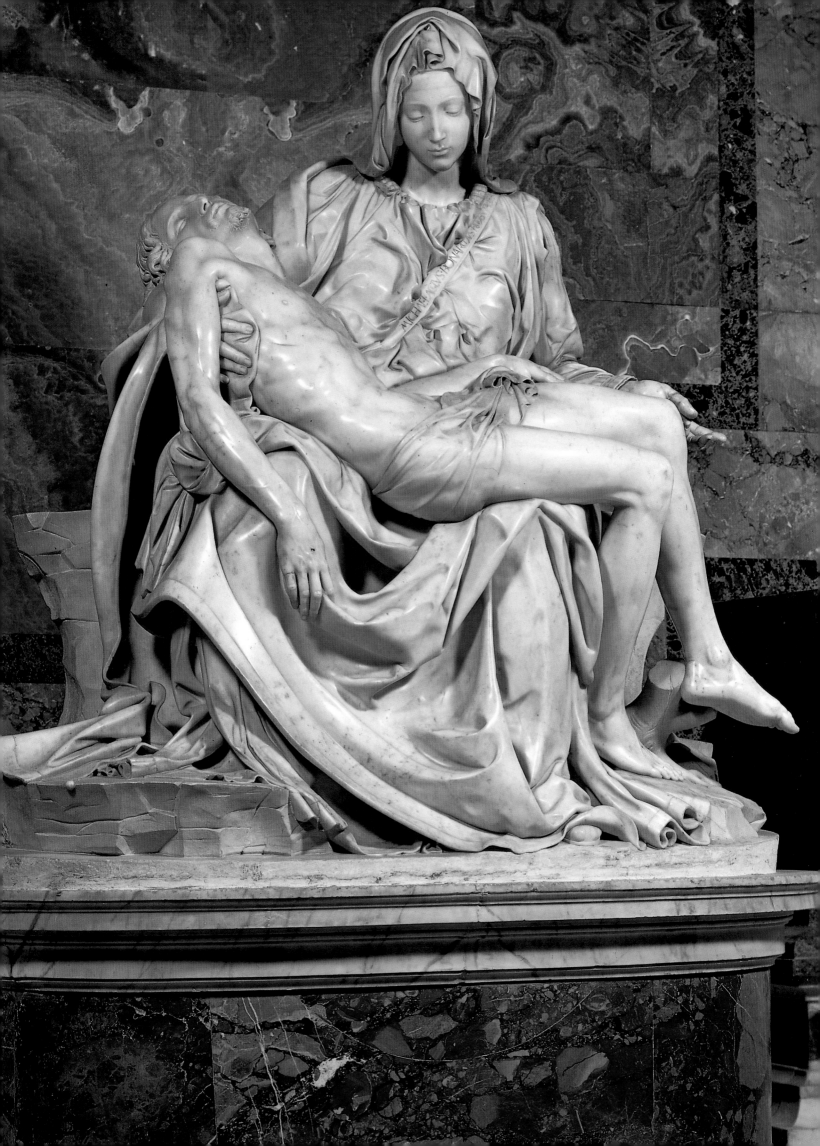

*And when Joseph had taken the body, he wrapped it in a clean linen cloth,
and laid it in his own new tomb, which he had hewn out in the rock: and he rolled
a great stone to the door of the sepulchre, and departed.*

MATTHEW 27:59–60

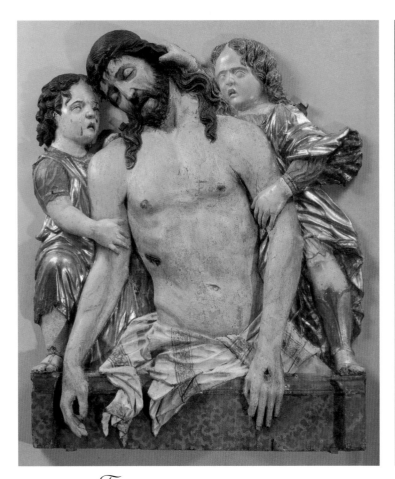

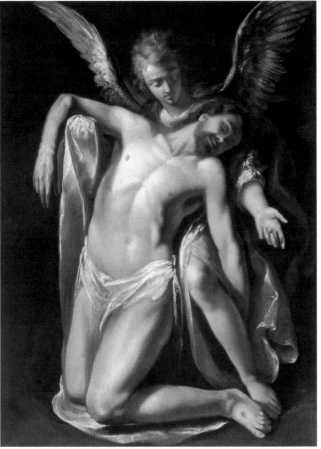

The Dead Christ Supported by Two Angels.
Northern Italy, end of 15th century. Painted wood,
32⅜ x 26¾ in. (82.5 x 68 cm). Musée du Louvre, Paris.

ATTRIBUTED TO DANIELE CRESPI (c. 1600–1630).
The Dead Christ Supported by an Angel, n.d.
Oil on canvas, 59 x 45⅝ in. (150 x 116 cm).
Musée des Beaux-Arts, Rouen, France.

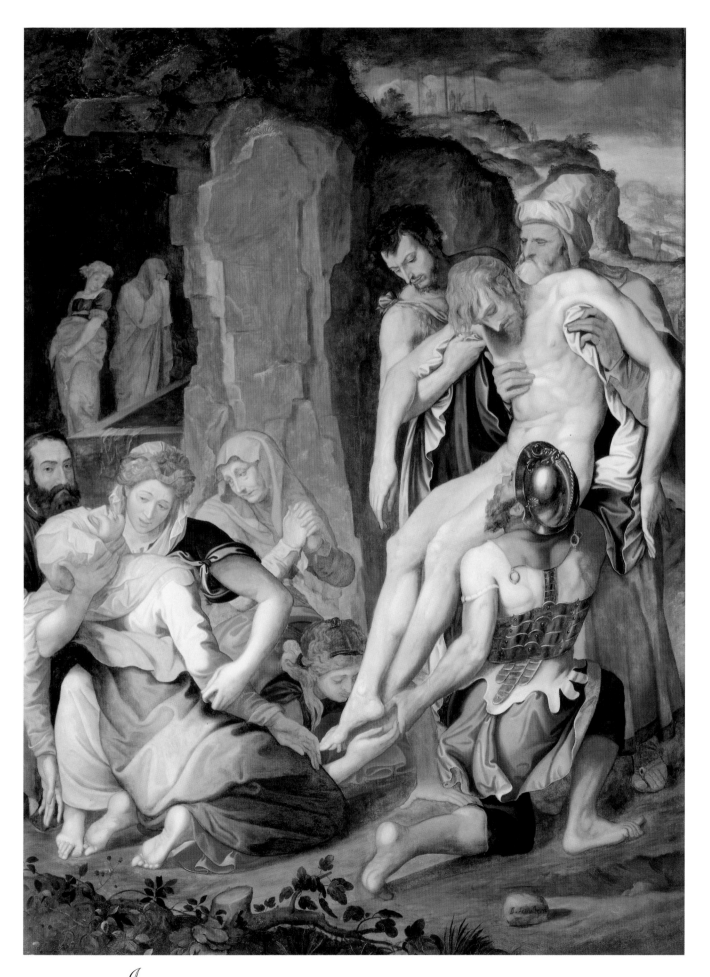

Jacopino del Conte (1510–1598). *The Entombment*, c. 1545–50. Unknown medium on poplar, 101⅛ x 75½ in. (257 x 192 cm). Musée Condé, Chantilly, France.

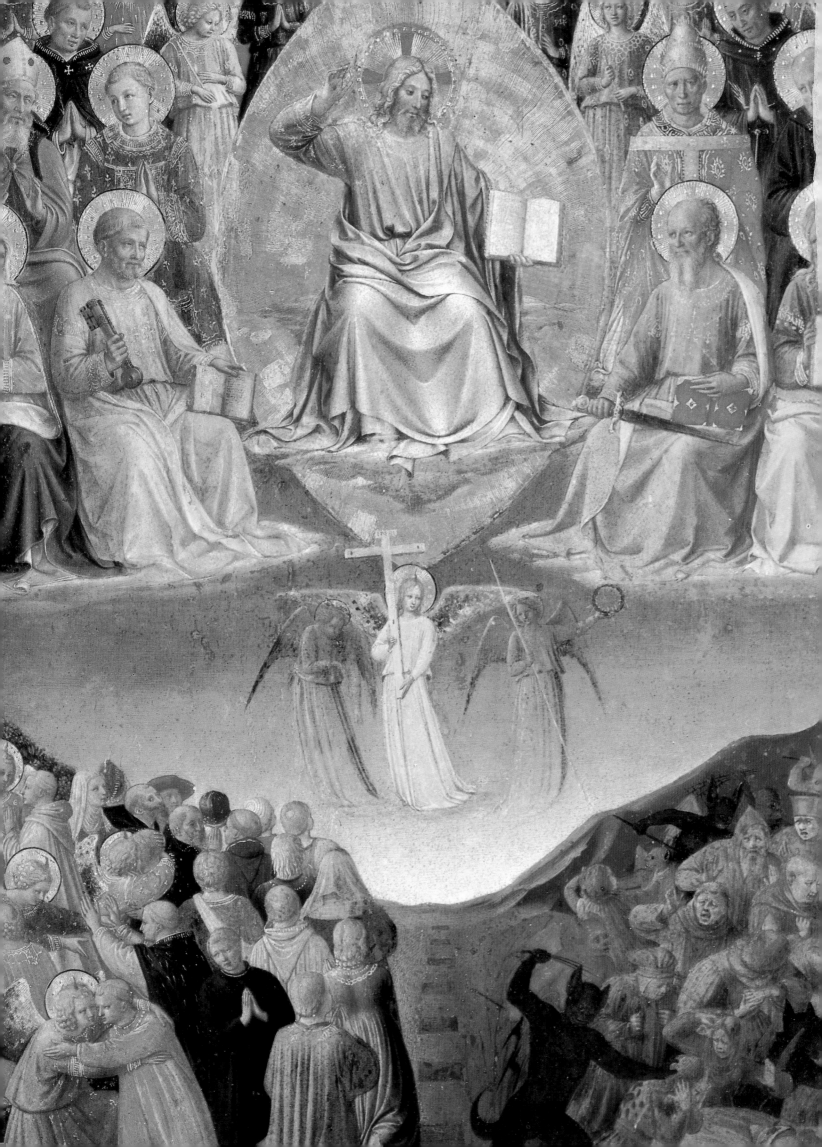

THE RESURRECTED CHRIST

*So then after the Lord had spoken unto them, he was received up into heaven,
and sat on the right hand of God.*

MARK 16:19

The grief of the crucifixion was followed by the joy of the resurrection. During the three intervening days, Christ is said to have descended into limbo to free the righteous (Adam and Eve, the prophets, infants, and others), who had long awaited his arrival; before his death and resurrection, according to Christian doctrine, there had been no salvation and hence no heaven. Like Christ's temptation by the devil, this was a scene that piqued artists' imaginations, and they often envisioned the cavernous mouth of hell as a toothy maw gorged with the dead.

Another favorite scene for artists was that of the three holy women at the tomb on Easter morning. Having arrived to tend to Christ's body, they discover an angel at the empty tomb, who tells them that Christ has risen from the dead. This resurrection, and the eternal life it promises, is at the heart of Christian belief, and artists were careful to convey its solemn significance. At times Christ himself was shown rising from the tomb in triumph, brandishing a battle flag (often a red cross on a white background) as a sign of his victory over death. Frequently, as in the paintings by Titian and Salvator Rosa (pages 133 and 135), he is suspended in midair to suggest his supernatural powers.

Artists also depicted the resurrected Christ's encounters with his followers, who often were slow to recognize him. First was his meeting with Mary Magdalene, whom he warned not to touch him (in Latin, *noli me tangere*), "because I am not yet ascended to my Father." Later that Easter afternoon, while walking along the road from Jerusalem to Emmaus, he joined two of his disciples, to whom he did not reveal himself as the risen Christ until he broke bread with them that evening. Representations of this supper at Emmaus served as symbols of the Last Supper and of the sacrament of Communion.

FRA ANGELICO (c. 1400–1455). Detail of *Triptych with the Ascension of Christ, the Last Judgment, and Pentecost* (central panel), 1447. Tempera on wood, 21⅝ x 15 in. (55 x 38 cm), overall. Galleria Nazionale d'Arte Antica, Rome.

After forty days on earth the resurrected Christ ascended into heaven. This miraculous event has often been depicted as a crowd scene, with the central figure of Christ shown rising above a multitude of his awestruck followers; usually prominent among them is the Virgin Mary. In many depictions, particularly from the Middle Ages, just the feet of the ascended Christ remain visible at the top of the picture.

In scenes of the Last Judgment—which the Church predicts will mark the end of this world—Christ separates the saints from the sinners, both living and dead. Often he is shown flanked by his mother and Saint John the Baptist, who try to intercede for humankind while Saint Michael scrupulously weighs souls below. Several artists have depicted a kingly Christ encircled by a rainbow, faithfully illustrating the book of Revelation: "There was a rainbow round about the throne, in sight like unto an emerald." Surrounded by this heavenly light, Christ reigns in glory, ushering in the new millennium.

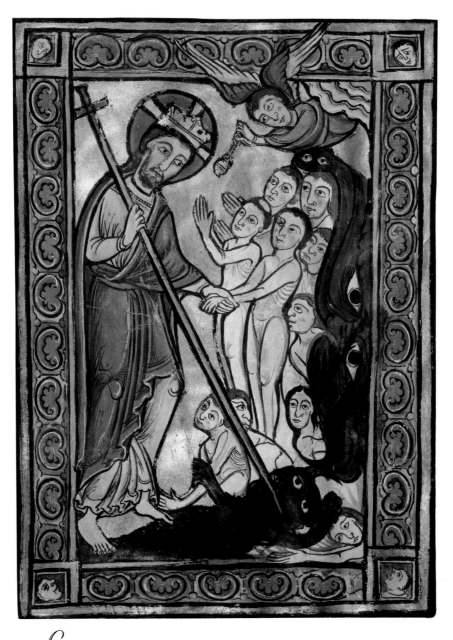

Christ's Descent into Limbo. From a French manuscript, 12th–13th century.
The Pierpont Morgan Library, New York.

THE RESURRECTED CHRIST

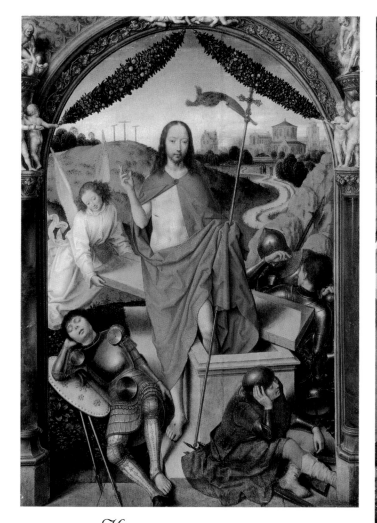

\mathcal{H}ANS MEMLING (c. 1430/40–1494).
The Resurrection, from the *Triptych of the Resurrection with Saint Sebastian*, n.d. Unknown medium on wood, 24⅛ x 17½ in.
(61.3 x 44.5 cm). Musée du Louvre, Paris.

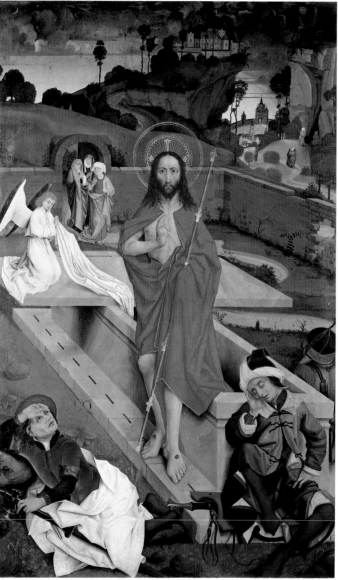

\mathcal{H}ANS PLEYDENWURFF (c. 1420–1472).
The Resurrection of Christ, n.d. Oil on pine, 69⅝ x 44 in.
(177 x 112 cm). Alte Pinakothek, Munich.

Thus it is written, and thus it behoved Christ to suffer, and to rise from the dead the third day. . . . And ye are witnesses of these things.

LUKE 24:46, 48

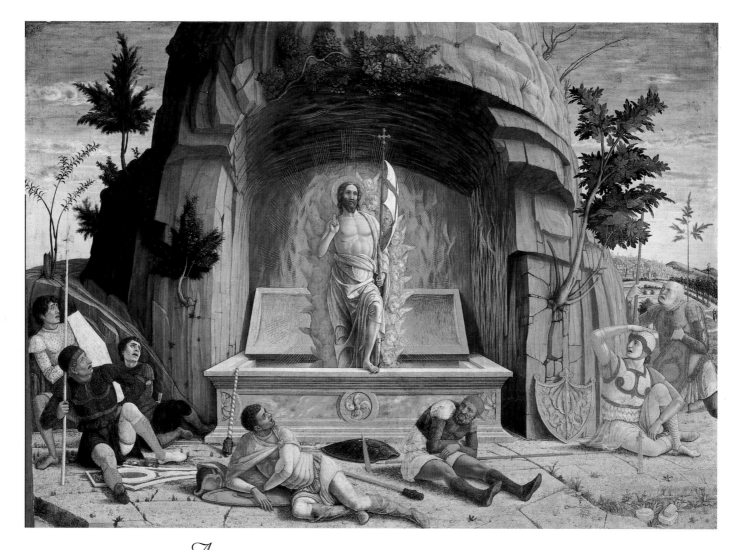

ANDREA MANTEGNA (c. 1431–1506). *The Resurrection of Christ*, 1459–60.
Tempera on wood, 27½ x 36¼ in. (70 x 92 cm). Musée Municipal, Tours, France.

OPPOSITE
TITIAN (c. 1487/90–1576). *The Resurrection*, 1542–44.
Oil on canvas, 64⅛ x 40⅞ in. (163 x 104 cm).
Galleria Nazionale delle Marche, Urbino, Italy.

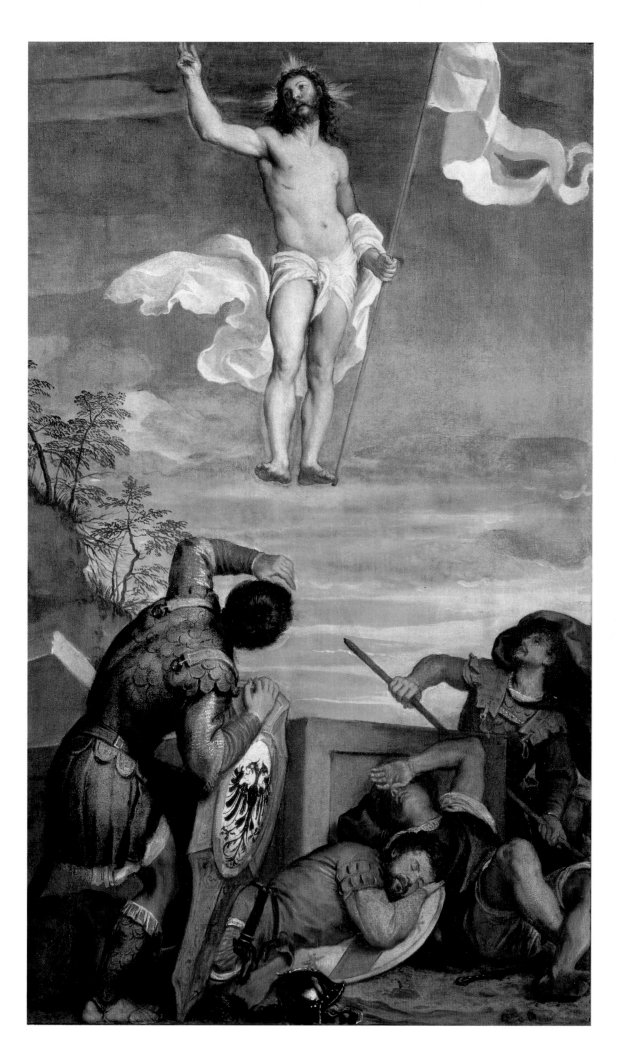

THE RESURRECTED CHRIST

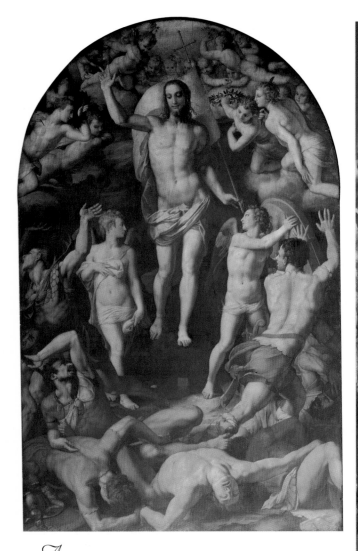

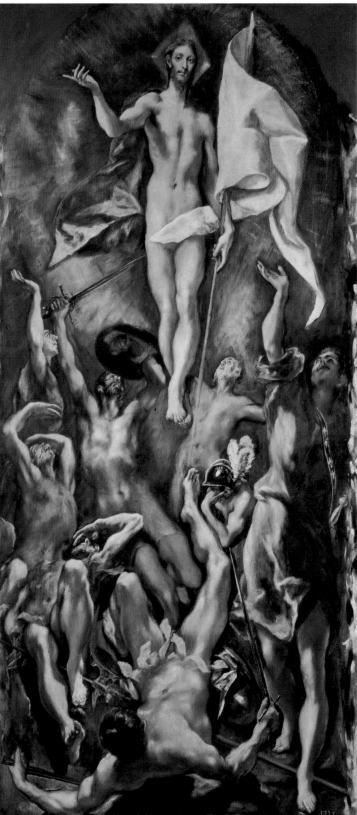

AGNOLO BRONZINO (1503–1572). *The Resurrection*, 1552.
Oil on wood, 14 ft. 7⅛ in. x 9 ft. 2¼ in. (4.45 x 2.8 m).
Santissima Annunziata, Florence.

EL GRECO (1541–1614). *The Resurrection of Christ*, 1605–10.
Oil on canvas, 108¼ x 50 in. (275 x 127 cm). Museo del Prado, Madrid.

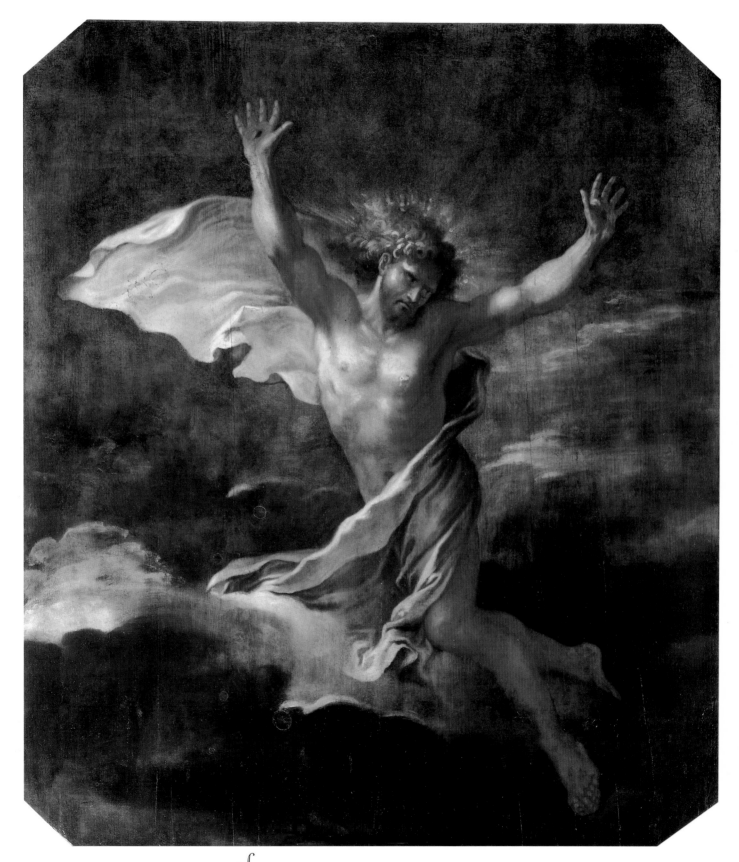

SALVATOR ROSA (1615–1673). *The Resurrected Christ,* n.d.
Oil on wood, 42⅞ x 37⅝ in. (109 x 96 cm). Musée Condé, Chantilly, France.

THE RESURRECTED CHRIST

135

EVANGELARIO DI ARIBERTO
(n.d.). *Angel and Mary
Magdalene at the Tomb*, n.d.
Enamel. Treasury of the
Cathedral, Milan.

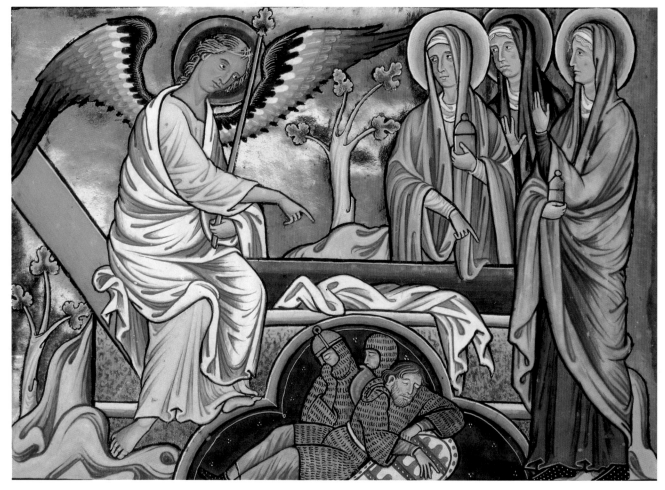

The Three Marys at the Tomb, from *The Psalter of Ingeburg of Denmark*,
French, 13th century. Musée Condé, Chantilly, France.

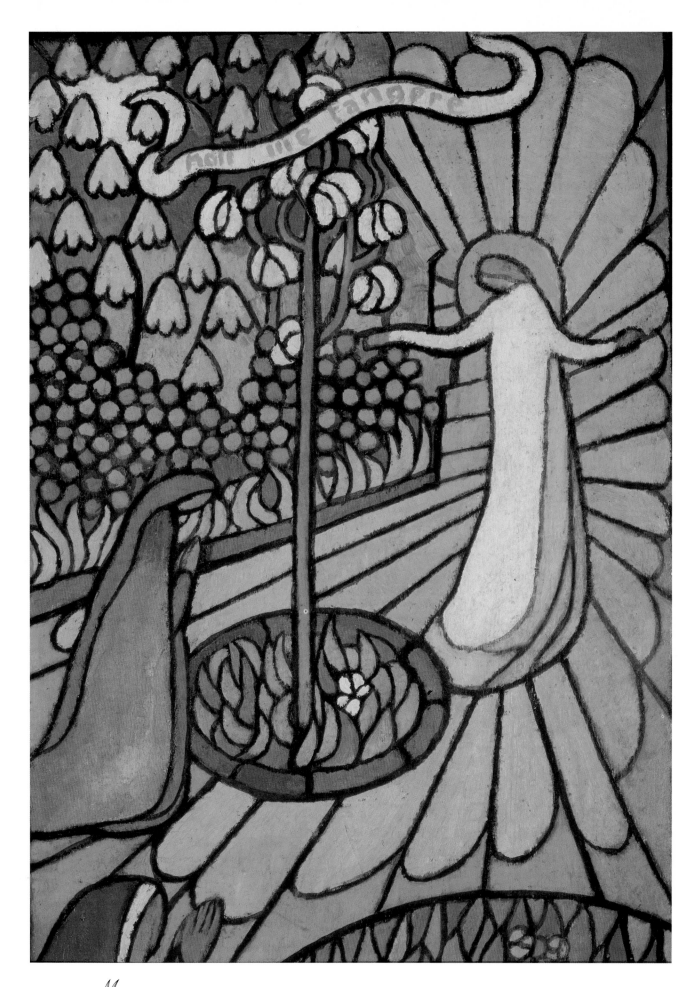

MAURICE DENIS (1870–1943). *Noli Me Tangere*, 1895–96. Sketch for a stained-glass window. Oil on board,
33⅛ x 13¾ in. (84 x 35 cm). Musée du Prieuré, Saint Germain-en-Laye, France.

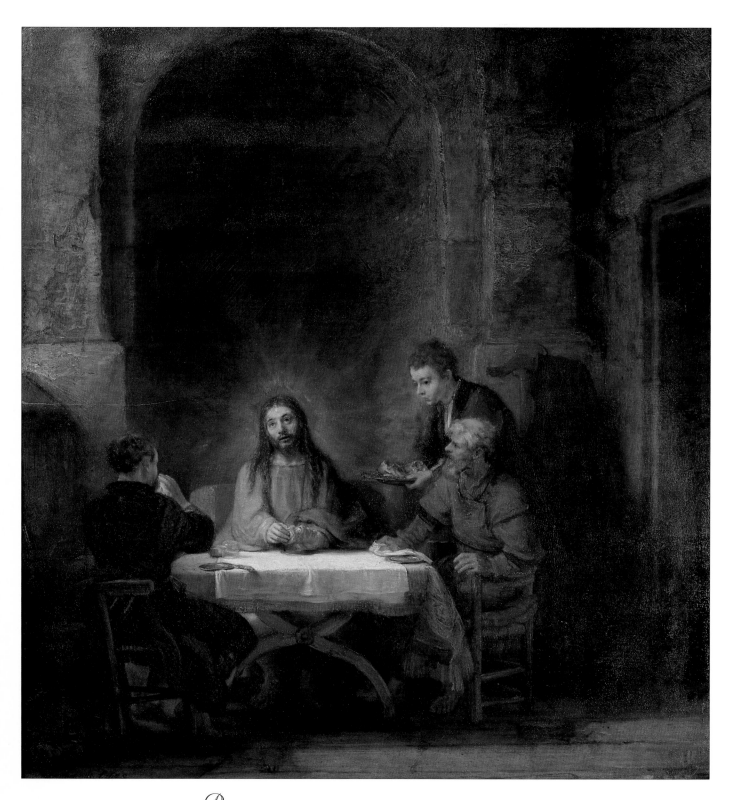

Rembrandt van Rijn (1606–1669). *The Supper at Emmaus*, 1648.
Oil on wood, 26¾ x 25⅜ in. (68 x 65 cm). Musée du Louvre, Paris.

*N*ICHOLAS OF VERDUN (c. 1150–1205). *The Ascension*, from the *Verdun Altar*, begun 1181. Champlevé enamel on gilded copper, height: 15 ft. 1⅛ in. (4.6 m), overall. Sammlungen des Stiftes, Klosterneuburg, Austria.

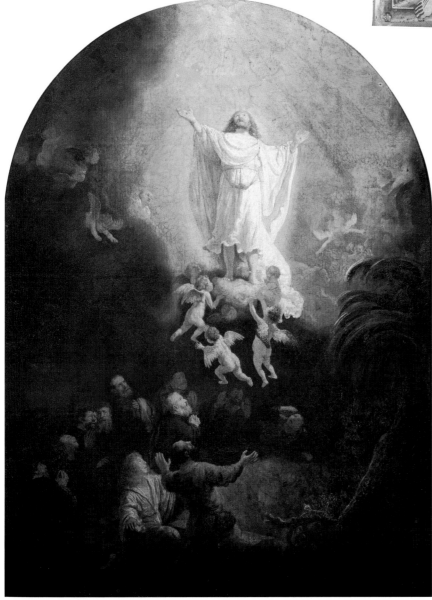

*R*EMBRANDT VAN RIJN (1606–1669). *The Ascension of Christ*, c. 1636. Oil on canvas, 36⅜ x 26⅞ in. (92.5 x 68.5 cm). Alte Pinakothek, Munich.

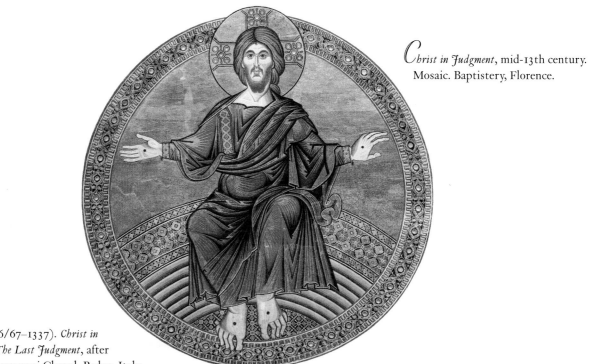

Christ in Judgment, mid-13th century. Mosaic. Baptistery, Florence.

GIOTTO (1266/67–1337). *Christ in Majesty*, from *The Last Judgment*, after 1305. Fresco. Scrovegni Chapel, Padua, Italy.

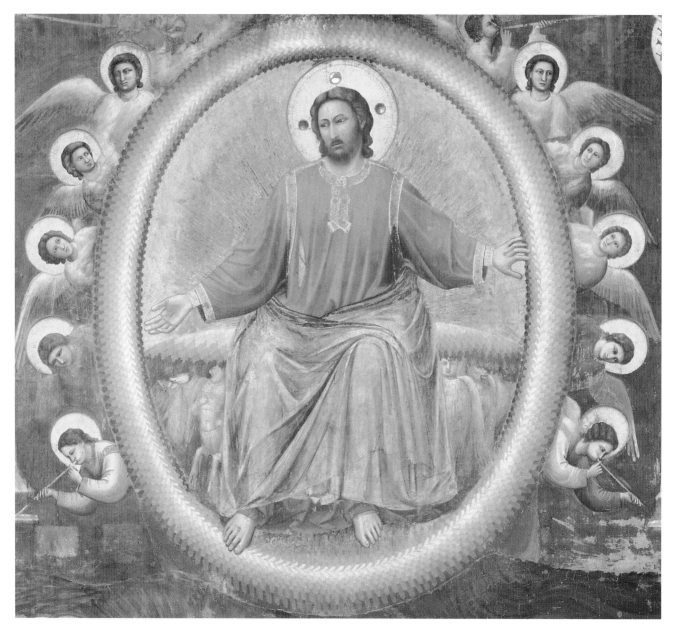

And they shall see the Son of man coming in the clouds of heaven with power and great glory. And he shall send his angels with a great sound of a trumpet, and they shall gather together his elect from the four winds, from one end of heaven to the other.

MATTHEW 24:30–31

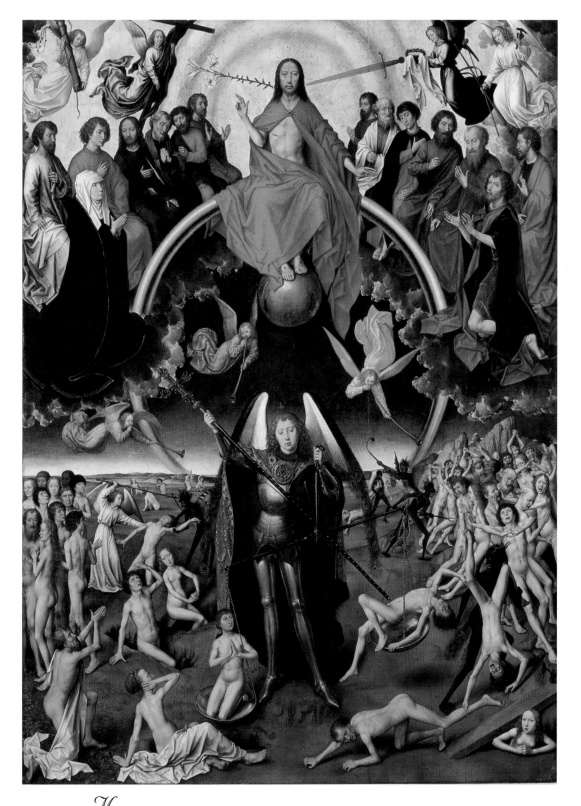

HANS MEMLING (c. 1430/40–1494). *The Last Judgment* (central panel), 1467–71.
Oil on wood, 87 x 63⅜ in. (221 x 161 cm). Pomorskie Museum, Gdansk, Poland.

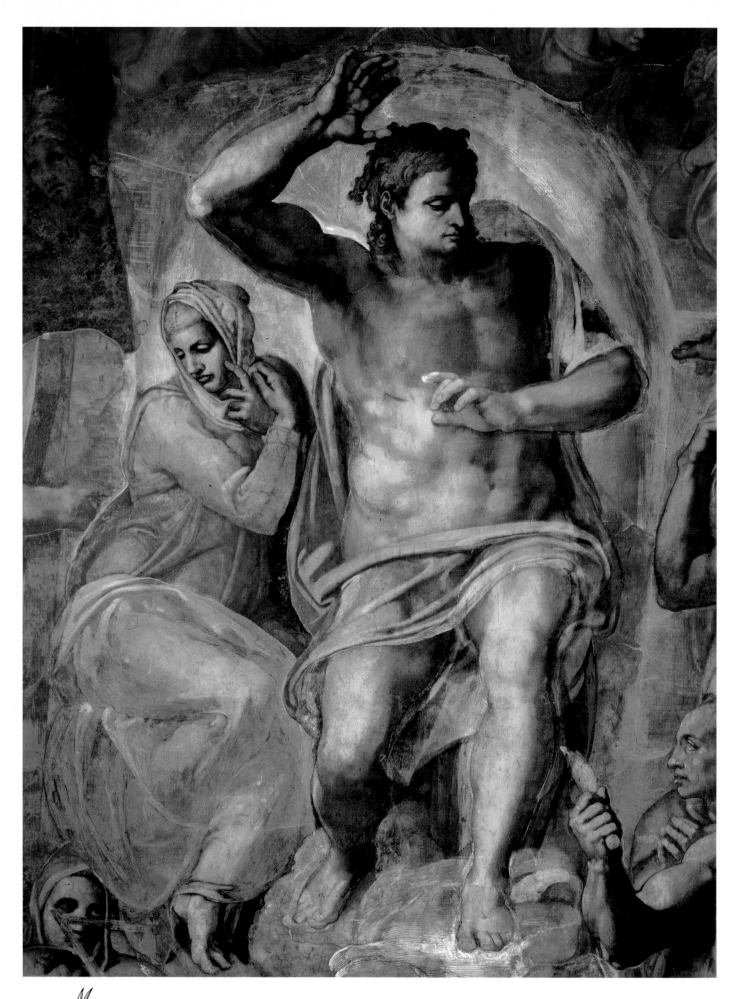

*M*ICHELANGELO (1475–1564). *Christ*, from *The Last Judgment*, 1536–41. Fresco. Sistine Chapel, Vatican Palace, Vatican City.

INDEX OF ILLUSTRATIONS

PHOTOGRAPHY CREDITS